COLLECTING PASSIONS

Collecting is a vice that brooks no competition from other vices. It is a passion that grows and dominates until you stand trembling before the object of your desire, determined to own it at all costs while earnestly striving to conceal your cupidity lest it affect the price.

William E. Groves (Martin and Margaret Wiesendanger, *19th Century Louisiana Painters and Paintings from the Collection of W. E. Groves* (New Orleans: The W. E. Groves Gallery, 1971)

Collecting Passions

HIGHLIGHTS FROM THE LSU MUSEUM OF ART COLLECTION

EDITED BY DONNA McALEAR

LSU MUSEUM OF ART

Copyright © 2005 by the LSU Museum of Art
Individual essays copyright © 2005 by each author

Published by LSU MOA in conjunction with *Collecting Passions: Highlights from the LSU Museum of Art Collection*, an exhibition presented from March 5 to August 28, 2005, to inaugurate the new LSU Museum of Art at the Shaw Center for the Arts, Baton Rouge, LA

LSU MUSEUM OF ART
Shaw Center for the Arts
100 Lafayette Street, Baton Rouge, Louisiana 70801
www.lsu.edu/lsumoa

Library of Congress Control Number: 2004118211

ISBN: 0-9763771-0-1

PUBLICATION CREDITS
Editor: Donna McAlear
Jacket and book design: Frank Reimer
Photography: David Humphreys
Editing: Marnie Butvin

EXHIBITION CREDITS
Curators: Donna McAlear, Maia Jalenak, Lara Gautreau, and Frances Huber
Curatorial Assistant: Sarah Morgan Griffith
Exhibition Designers: Gallagher & Associates, Bethesda, MD
Exhibition Production Supervisor: Carey Archibald
Exhibition Production Assistants: Nathaniel Lakin and Bobbie Floyd Young

Printed and bound in Canada by Friesens Corp., Altona, MB

CONTENTS

	Foreword MARK A. EMMERT & WILLIAM L. JENKINS	9
	LSU Museum of Art Advisory Board Message SUE TURNER	10
	Preface LAURA F. LINDSAY	12
	LSU Museum of Art: Collecting Origins and Advancement DONNA McALEAR & MAIA JALENAK	15
PART ONE	**The Anglo-American Art Museum: Particular Beginnings**	20
	Anglo-American Portraits BARBARA DAYER GALLATI	22
PART TWO	**Visual Records of Louisiana and its Cultural Progress**	38
	Portraiture, Landscapes, and Marine Scenes in Nineteenth-Century Louisiana JUDITH H. BONNER	40
	Louisiana Art in the Early to Mid-Twentieth Century CLAUDIA KHEEL	54
PART THREE	**Decorative Arts: A Collecting Focus**	64
	Early Louisiana Furniture and Other American Furniture H. PARROTT BACOT	66
	Pre-Electric Lighting Devices H. PARROTT BACOT	76
	New Orleans Silver H. PARROTT BACOT	84
	Newcomb Pottery and Crafts JESSIE POESCH	92
PART FOUR	**Passionate Collectors, Generous Donors: A Global Scope**	104
	The Dr. James R. and Ann A. Peltier Collection of Chinese Jade HELEN DELACRETAZ	106
	The Arnold Aubert Vernon Collection of Inuit Art INGO HESSEL	118
	The Charles E. Craig Jr. Collection of Gobal Art MAIA JALENAK	128
	The Lucille J. Evans Collection of Japanese Prints MAIA JALENAK	134
	Exhibition Checklist	142
	Contributors	152
	Acknowledgements DONNA McALEAR	157

Foreword

In 1959 an anonymous donor's magnificent gift started a chain of events that would ultimately lead to the creation of an art collection and a museum for Louisiana State University. The LSU Museum of Art's story is one of collectors' passion for great art, museum professionals' commitment to developing an extraordinary collection, and donors' perseverance in building a suitable facility to house and display the collection.

The museum holds a special place in the hearts and minds of LSU students, faculty, and staff, and it is a splendid complement to the teaching and research that advances our understanding of the world around us. By collecting, conserving, and exhibiting the works of art entrusted to its care and stewardship, the museum provides opportunities for education, research, interpretation, and enlightenment to students, scholars, and visitors alike. It sets itself apart by emphasizing the unique strengths of its collection, contributing to the teaching and research environment LSU offers, supporting Louisiana's wealth of arts and culture, and offering collaborative opportunities in its new home at the Shaw Center for the Arts. It is our sincere desire that, by serving as a resource for the study and appreciation of the visual arts, the museum will continue to enrich the lives of students, faculty, and community members all.

LSU is indebted to the many individuals and organizations that have supported the museum, contributed to its collections, and provided the capital that allowed us to build an outstanding facility for this outstanding collection. Some of these individuals are no longer with us, including Lois Bannon, one of the original champions of the museum. Other contributors include a long list of committed Friends and Endowment Society members, without whose help the museum would not have the opportunity it enjoys today. You will find their names associated with many of the artworks selected for the *Collecting Passions* exhibition as we recognize them for their vision, insight, and determination, and thank them for all they have done to make the LSU Museum of Art collection possible. We express our heartfelt gratitude to our anonymous donor who started it all, and to our most generous benefactor, Paula Garvey Manship, and her determined niece, Nadine Carter Russell, who provided support and inspiration whenever called upon.

The university is extremely proud of its captivating art collection, and takes great pleasure in presenting it for the enlightenment and enjoyment of all audiences. This is the first of many exhibitions that will unfold in our new galleries and rank the LSU Museum of Art with the finest public university art museums in the country.

Mark A. Emmert, Former Chancellor, LSU
William L. Jenkins, Interim Chancellor, LSU, and President, LSU System

16. **Jacques Guillaume Lucien Amans**
(Franco-American, 1801–88)
Portrait of a Gentlewoman, c. 1840–45
Oil on canvas
Gift of Mr. and Mrs. W.E. Groves, 60.2.1

LSU Museum of Art Advisory Board Message

To live in a community that values the arts is a great privilege, and to see Baton Rouge enriched by the addition of the Shaw Center for the Arts is an exciting event. The re-opening of the Louisiana State University Museum of Art at this new facility is truly a cause for celebration, as it brings collections gathered over many years to a home worthy of their excellence, where they can be cared for and displayed in ways that previously have not been possible.

The efforts and ambitions of many people have come to fruition in the center, and the museum is proud to be part of this new venue for engaging the public in the fine arts' myriad forms. In the center, the synergy resulting from the proximity of the LSU Museum of Art and the Douglas L. Manship Sr. Theater for the Visual and Performing Arts will benefit each institution and contribute to the enjoyment and enlightenment of Baton Rougeans, LSU students, and visitors alike.

To realize our vision of a new museum facility, an advisory board of community and faculty members worked with Interim Executive Director Laura Lindsay and her dedicated staff, and we received much support from the state and local governments. We have worked toward this goal for many years, and we invite you to share in our excitement and achievement. It has been a privilege to be part of this adventure.

All of us will celebrate the collections and exhibitions of the LSU Museum of Art, today and for many years to come.

Sue Turner
President, LSU Museum of Art Advisory Board

30. **Ben Earl Looney**
(American, 1904–81)
Downtown Baton Rouge, 1920
Oil on canvas
Gift of the Artist,
Transfer from Special Collections,
LSU Libraries, 2004.4.4

Preface

The Anglo-American Art Museum opened its doors to the public in 1962, a little over 100 years after the first work of art had been donated to the Louisiana Seminary of Learning in Pineville, Louisiana. The museum set forth its purpose to illustrate the British and continental influences on American art and culture. Over time, the collection mandate expanded to encompass visual arts from all cultures, places, and times. A little over thirty years later, the university initiated a capital campaign to raise funds to move the museum from its historic home in the LSU Memorial Tower to a grand new facility that would showcase the marvelous collection, developed through the care and hard work of its directors, curators, and donors.

With a building site in mind, the search began for architects who would best understand the vision of the museum's friends and the unique qualities of the collection. The selection committee, chaired by Executive Vice Chancellor and Provost Daniel Mark Fogel, chose Schwartz/Silver Architects of Boston, a firm whose projects regularly earned the American Institute of Architects' top awards. Schwartz/Silver's design included fifteen spacious galleries and generous collection storage. The museum would move its nearly 4,000 objects from several campus locations, displaying fine and decorative arts in a stunning exhibition space that would expand from less than 2,500 to 15,000 square feet.

In the midst of this exciting chain of events, key members of Plan Baton Rouge, a community effort to revitalize and make downtown Baton Rouge into a cultural center of activity, suggested that LSU join with the Baton Rouge Area Foundation and the Arts Council of Greater Baton Rouge to create an arts center that would be a cultural catalyst and economic driver for the city. LSU Chancellor Mark A. Emmert immediately embraced the idea and envisioned a unique collaboration between the LSU Museum of Art and the LSU School of Art. LSU System President William L. Jenkins (who had supported the development of a new museum facility during his previous roles as Provost and Chancellor of LSU) and the LSU System Board of Supervisors recognized the value of this alliance. The partners – LSU, the Baton Rouge Area Foundation, the City of Baton Rouge, and the State of Louisiana – crafted an agreement, which the LSU Foundation approved, to build a center for the visual and performing arts. The Shaw Center for the Arts would feature museum galleries bracketed by performing arts theaters and the historic Auto Hotel. The LSU Museum of Art would be a centerpiece of the new facility.

As the curatorial staff discussed the possibilities for the museum's opening exhibition, they decided to tell the story of the LSU Museum of Art by highlighting the finest pieces of the permanent collection and the collectors who made the museum possible. Curators and education staff interviewed collectors to gather their histories and perspectives. Consultants with knowledge of the museum's diverse collecting fields also shared their insights into the aesthetic and historical value of the collection, aiding curatorial selection for the exhibition and writing illuminating

essays for the catalogue. This collaboration has come to fruition in *Collecting Passions*.

Collecting Passions chronicles the growth and development of an exceptional museum, one whose collection was created solely through the contributions of friends of LSU. The result of their efforts is an extraordinary testimony to the insight and leadership of LSU museum directors, curators, and members of the community who believed that the fine and decorative arts should have a special place at LSU. It is my privilege to thank all who helped this museum become the invaluable resource it is today. The immeasurable time, energy, and passion they invested has ensured that this project reached its full potential.

In closing, I would be remiss not to thank Senior Associate Director Donna McAlear. At the very time we needed her most, she literally "arrived at our door." Her vision, determination, impressive talents, and exceptional leadership have been the key to making the museum's first exhibition and publication in its marvelous new space a splendid reality.

Laura F. Lindsay
Interim Executive Director, LSU Museum of Art

DONNA McALEAR

MAIA JALENAK

LSU Museum of Art:

Collecting Origins and Advancement

1. **Thomas Badger**
(American, 1792–1868)
*Portrait of Captain
Cleeves Symmes*, 1820
Oil on canvas
Anonymous Donor's
Purchase Fund, 59.7.2

Charting the history of an institution like the Louisiana State University Museum of Art is an imperative act: it honors the past while connecting the past to the present. As we move forward, we also look back on where the museum has been and how it has come to be the unique resource it is today. This reflection is key to understanding the museum's relation to audiences past, present, and future, and it lays a foundation for subsequent investigations of the museum's holdings.

Collecting Passions offers the first comprehensive survey of a rich collection that has largely been a mystery to scholars and the public alike. The museum's original home in the Memorial Tower on campus – described in 1971 by Dr. Joseph Brouillette as "the front door to the University" and "a beacon of welcome to all University visitors"[1] – was a going concern in its early years. Conceived in a period room presentation style, akin to historic home exhibitions, the museum's permanent displays situated a small number of collection objects in particular environments: the Jacobean, Colonial, Hacton, Greek Revival, and Shepherd-Salisbury rooms. This traditional presentation method was true to the museum's philosophical origins as the Anglo-American Art Museum, but as time passed, exhibition techniques changed and the collection grew in size and thematic scope. The limits of the Memorial Tower space could not be ignored. While the period rooms that acted as the public face of the museum were staid, the behind-the-scenes acquisition activities of curators and donors were spirited. Yet no space was available for the display and interpretation of the museum's growing collection. As Henry J. Hasselberg

observed in 1998, "there was no place for [the J. Lucille Evans] collection [of Japanese art] in the Anglo-American Art Museum."[2]

Avid collectors and donors like J. Lucille Evans envisioned the LSU Museum of Art's current developments. Along with her donation of Japanese prints and artifacts, Evans willed the LSU Foundation a generous cash gift to be used expressly for the construction of a new building that would "broaden the scope of the museum to include not just Anglo-American art, but world art as well."[3] The new museum responds to the liberal community vision of Evans and many others whose generosity made the new museum possible. Its large, contemporary exhibition spaces offer a vital opportunity for the breadth of the collection to be seen and appreciated, marking a new era in the museum's advancement.

Collecting is a deliberate act of selection. Institutions that collect help shape our understandings of culture, identity, and nationhood. The origins of the Anglo-American Art Museum illustrate these statements well. In 1959, an anonymous donor gave the university a purchase fund on the condition that it would establish a collection of British and American material culture. The collection preceded the museum, which opened in the Memorial Tower in 1962. The donor's "special interest in the Museum was to confirm in art … the close resemblance of Anglo-Americans in the United States … to the parent stock in Britain."[4] A former curator observed that this collecting mandate suited the historical, geographic, and political culture of the region:

> *Baton Rouge is an appropriate location for this Museum because the city is at the western edge of Louisiana's Florida Parishes. This area was not a part of the Louisiana Purchase, and was settled primarily by people of British extraction.*[5]

From 1959 to the late 1960s, early museum curators met the mandate by using the purchase fund to acquire British and American portrait paintings from the seventeenth to the nineteenth century, including work by American artists Rembrandt Peale, Benjamin West, and Ralph Earl, and British artists William Hogarth, Thomas Gainsborough, Sir Joshua Reynolds, and Sir Nathaniel Dance. The founding donor's desire to remind Baton Rouge citizens "that people of British extraction had a major role in shaping American culture"[6] was also served by acquiring furniture and original architectural elements from room interiors, such as oak paneling and a c. 1620 stone chimney, bought in 1959 to construct the Jacobean Room in the Memorial Tower.

The museum's original mandate and its curators' purchases resonated with the community. An early curator, James Key Reeve, reported in 1966 that "the Museum has become a vital part of the cultural activities of this area" as shown by "the active response we get from our citizens." The specific examples of community involvement he noted remain benchmarks for museum performance today:

We are now being offered gifts of first-class paintings and furniture which are needed for the collections. Another is that local collectors have begun to refer to the collections and library of the Museum to ascertain the consequence of their own holdings. Yet another is that local dealers have begun to improve the quality of their artistic merchandise, since prospective purchasers can check high quality pieces of similar kind in the Museum collection. We have seemed to make the people begin to take notice of the quality of cultural objects and be more aware of their origins.[7]

Enthusiasm for the museum ran high, and despite the clear mandate to concentrate on British and Anglo-American acquisitions, artwork reflecting Louisiana in all its cultural diversity was collected at the same time. Important paintings were given in 1960 by William E. Groves, a 1928 graduate of LSU and the owner of the established W.E. Groves Gallery, New Orleans: *Portrait of a Gentlewoman* (c. 1840–45) (fig. 16), by the Franco-American Jacques Guillaume Lucien Amans, and significant works by artists George Peter Alexander Healy and Richard Clague. The stage was set early for the museum to expand its mission and more fully represent the cultural heritage of all Louisianians.

It was perhaps inevitable that the museum's collecting practices failed to exclude cultures and nationalities outside the scope of the anonymous donor's wishes. The museum's very location in Louisiana, with its mix of Native American, French, Spanish, Acadian, African, German, West Indian, Italian, Irish, and British communities, was bound from the start to divert the Anglo-American focus. In 1967, H. Parrott Bacot joined the museum as curator, and his zeal for Louisiana history, and especially the decorative arts, motivated private collectors to donate a wide variety of items. The museum began amassing Louisiana paintings, furniture, silverware, and Newcomb pottery and crafts. Aware of Louisiana's private collector and donor culture, Bacot knew that the museum's long-term future lay in diversification.

Louisianians interested in the state's heritage championed the museum's goal to develop a collection representing the region's accomplished historical artists. During this period the museum became a repository entrusted to care for collections that prominent families had grown over time, and it now holds notable ancestral portraits donated by Mrs. George Gammon, Jules and Frances Landry, Mrs. Joyce P. O'Connor, and Dr. O.M. Thompson Jr. The museum has also received many gifts from the families of Louisiana artists. The fine collection of paintings by Marie Adrien Persac was established in 1975 with a donation from Mrs. Mamie Persac Lusk. Longstanding museum supporters, the family also helped to purchase subsequent acquisitions of Persac's work. Many Newcomb Pottery and Crafts pieces were gifts from family members, including work by Pauline Wright Irby Nichols, donated in 1984 by her daughter, Nina Nichols Pugh.

Important Louisiana artists, some with ties to LSU, have gifted their artwork to the museum, as well. Conrad Albrizio, one of LSU's first art instructors, and Caroline Durieux, founder of the printmaking program at the LSU School of Art, gave paintings and drawings. These holdings were augmented by donations from Mr. and Mrs. Victor A. Sachse Jr. and the estate of Mrs. Ernestine H. Eastland Lowery, who gave work by Albrizio, and by Charles P. Manship Jr., who in 1991 purchased a major Durieux piece for the museum: *Café Tupinamba* (1934) (fig. 32). Because the museum holds the most comprehensive collection of Durieux prints, in 2000 Paula Garvey Manship generously gifted the museum a 1929 portrait of Durieux painted by the renowned Mexican muralist Diego Rivera.

For over thirty years, the Friends of the LSU Museum of Art have sponsored annual soirees to nurture the growth of the collection, and many individuals have given their time and creativity to support new acquisitions through gifts of art and funds. The museum's collective donors comprise distinguished preservationists, philanthropists, and civic leaders, including Mr. and Mrs. William Tait Baynard, Mr. and Mrs. H.P. Breazeale Sr., Ione E. Burden, Steele Burden, Dr. A. Brooks Cronan Jr. and Diana Cronan, Dr. Theodore Gross, Mrs. Julia H.R. Hamilton, Dr. and Mrs. Jack Holden, Mr. D. Benjamin Kleinpeter, Mr. and Mrs. Emile N. Kuntz and family, Mrs. Katherine H. Long, the Manships, Mr. and Mrs. A. Hays Town Sr., Mr. and Mrs. Bert S. Turner, and many others. Through their steadfast contributions, the museum's collection has grown to reflect diverse styles and subjects in Louisiana painting, a significant collection of New Orleans silver, a rare sampling of early Louisiana furniture, a unique collection of pre-electric lighting devices, and pottery and crafts from all phases of the Newcomb enterprise.

The range of museum collecting activities since the 1970s has drawn private donors with substantial collections, many with early educational ties to LSU. Over the past decade, the museum has established international collections through generous gifts of artwork from Arnold Aubert Vernon, an enthusiast of Inuit art, Charles E. Craig Jr., who acquired vast holdings of international art, ancient to contemporary, J. Lucille Evans, an avid collector of Japanese art, and Dr. James R. and Ann A. Peltier, knowledgeable collectors of Chinese jade. Together, these private collectors helped form the museum's current philosophy to collect broadly and diversely.

When a donor gives a large private collection, the mystery of the collector's relationship to object ownership is heightened, and it becomes no simple task for the museum curator to conceptually distinguish between the collector and the collection. The desire and rationale compelling the collector's passion for certain objects seems to permeate the objects themselves, and even their exhibition. As cultural theorist Walter Benjamin observed, for a real collector "ownership is the most intimate relationship that one can have to objects. Not that they come alive in him; it is he who lives in them."[8] But what prompts a true collector to give an entire and

immeasurably valuable collection to a museum? How do collectors release their emotional bonds with their collections? Why do they wish to share them with strangers? Clearly, in this unique transaction the philanthropic gesture overcomes personal desire. Donors' collecting passions and altruistic spirit allow museums like ours to thrive and travel down roads never imagined. Every one of us benefits from this kind of generosity.

Regardless of when artworks were made or acquired, museum collections are always contemporary; even as objects reflect the past, seen through our eyes today they become bound up in our ideals, our aspirations. This melding of past and present offers museum workers, donors, and audiences a remarkable opportunity to explore art and culture through innovative dialogue. Museum collections have tremendous use value because as successive generations revisit them, they bring new perspectives to bear on their meanings and transform them in the process. More than simply remembered, the objects of the past resonate in the imaginations of audiences today, as they will in the future.

Collecting Passions offers a glimpse into the approaches to collecting and exhibiting that the museum is now positioned to take. The scholars who contributed to this project bring a wealth of knowledge to an outstanding collection that has yet to be seen in its breadth or studied in depth. The LSU Museum of Art welcomes these fresh perspectives and looks forward to enriching the use value of its collection through lively encounters with the audiences of today and audiences to come.

NOTES

1. Correspondence, Dr. Joseph W. Brouillette, Director Emeritus, General Extension Division, LSU, January 25, 1971. LSU Museum of Art archives.

2. Correspondence, Henry J. Hasselberg, Las Cruces, New Mexico, June 30, 1998. LSU Museum of Art archives.

3. Ibid.

4. Correspondence, Anonymous donor, June 12, 1968. LSU Museum of Art archives.

5. H. Parrott Bacot, "Foreword," in *Anglo-American Art Museum Catalogue: Paintings, Prints, Drawings*. (Baton Rouge: Louisiana State University, 1971): 3.

6. Ibid.

7. Correspondence, James Key Reeve, August 26, 1966. LSU Museum of Art archives.

8. Walter Benjamin, "Unpacking my Library," in *Walter Benjamin: Illuminations*, ed. Hannah Arendt, trans. Harry Zohn (New York: Schocken, 1968): 67.

The Anglo-American Art Museum: Particular Beginnings

PART | ONE

Part of the services which the museum maintains is to provide lectures on Anglo-American art and culture to University students of English, History and Art.... [T]he Museum has become a vital part of the cultural activities of this area, partly because of the active response we get from our citizens.... [W]e are now being offered gifts of first-class paintings and furniture which are needed for the collection.

Correspondence from James Key Reeve, Curator, to Dr. Joseph W. Brouillette, Baton Rouge, August 26, 1966 (LSU Museum of Art archives)

Anglo-American Portraits

BARBARA DAYER GALLATI

3. **William Hogarth** (English, 1697–1764)
The Analysis of Beauty, Plate II, 1753
Etching and engraving
Anonymous Donor's Purchase Fund, 62.8.100

page 21

2. **Attributed to Benjamin Trott** (American, c. 1770–1843)
Miniature Portrait of Captain Moses Hook, c. 1806–10
Mixed media on ivory
Gift of Mrs. George Gammon Jr.
(née Keith Shepherd) in memory of her mother, Emma Shepherd Bush, 88.21.3

The Louisiana State University Museum of Art's former name – the Anglo-American Art Museum – conveys the institution's original mandate to collect art that examines the aesthetic and social conditions linking portrait painting in Britain to art in the colonies that would become the United States. Indeed, the hyphenated term "Anglo-American" underscores how relatively unified that visual tradition was. Interruptions in the flow of influence from Europe resulted more from the distance imposed by the Atlantic Ocean than from any deliberate movement in the colonies to modify artistic production.[1] Although the museums's portrait collection is small, it constitutes a history in miniature of the close relations between the pictorial arts of Britain and its North American colonies from about 1720 to 1840.

John Smibert's companion portraits of the Scottish merchant David Miln and Eupham Miln, his wife (figs. 4, 5), exemplify the British influence and locate Smibert (1688–1751) squarely in the vernacular of contemporary British portraiture as he had learned it in the London academy of Godfrey Kneller (1646–1723). The portraits were painted in London in 1723, five years before the artist left England for the colonies as part of Bishop George Berkeley's Bermuda Project, an endeavor to establish a college on the island of Bermuda. When the Bermuda Project failed to reach fruition, Smibert stayed in the British colonies. He settled in Boston around 1729, where he remained active until failing eyesight forced his retirement in the 1740s.[2]

The trajectory of Smibert's career sets him apart from his contemporaries; he was the only artist of note to have left a flourishing business in England to establish a second one in the North American colonies. His art, including the Miln portraits, forms the nexus where the portrait tradition of the Old World intersected with the developing art market of the New. As a result of this hyphenated career, British and American art historians alike are eager to claim Smibert as their own. Briefly observing his dual English and American experiences illuminates the particular character of

the museum's collection, which reflects the artistic tradition Smibert left behind, and its translation into the idiom of provincial artmaking.

When he painted the Milns, Smibert had a studio on London's Strand, a space he took on returning from a nearly four-year stay in Italy, where he had immersed himself in antique and Renaissance art. Back in London and armed with the requisite credentials, he garnered a reasonably fashionable and well-to-do clientele, which he seems to have cultivated by exploiting his Scottish origins – a tactic borne out by the Miln portraits. Smibert then fully engaged a portrait formula derived from the example of Kneller and such treatises as Jonathan Richardson's *An Essay on the Theory of Painting* (London, 1715), which were essential sources for artists at the time because they codified the dominant rules of portraiture. The German-born, Amsterdam-trained Kneller had imported continental baroque portrait styles that were quickly grafted onto British modes already influenced by the effects of Van Dyck and earlier Flemish painters, such as the anonymous creator of the c. 1620 full-length portrait of Sir Thomas Conaway in the museum's collection.

4. **John Smibert** (American, 1688–1751)
Portrait of Mr. David Miln, Merchant from Leith, Scotland and London, England, 1723
Oil on canvas
Gift of the Heirs of Fairfax Foster Bailey, 92.4.1

5. **John Smibert** (American, 1688–1751)
Portrait of Mrs. David Miln, 1723
Oil on canvas
Gift of the Heirs of Fairfax Foster Bailey, 92.4.2

page 24

6. **William Hogarth**
(English, 1697–1764)
Portrait of a Lady, c. 1740
Oil on canvas
Anonymous Donor's Purchase Fund, 59.2.2

page 25

7. **Thomas Gainsborough**
(English, 1727–88)
Portrait of Ralph Leycester of Toft Hall, Knutsford, Cheshire, c. 1763
Oil on canvas
Anonymous Donor's Purchase Fund, 59.10.2

These conjoined influences of art and theory resulted in an aristocratic template for portraying sitters, whose likenesses were enhanced by expressions, gestures, costumes, and settings denoting elevated states of mind and manner. Smibert also popularized the Kit-Kat portrait format (a compositional invention credited to Kneller that depicted the head and shoulders of the sitter with one or both hands showing) and imported it to the colonies, where it surfaced from time to time.[3] In his portrait of David Miln, the merchant's dignified pose confirms Smibert's adherence to the portrait canon for depicting gentlemen of business. Miln's elegantly positioned left hand draws our attention to the ship in the distance, while his right hand anchors a letter. His posture affirms his identity as a man of balanced thought and action. Smibert presents Eupham Miln in an equally dignified fashion, as her expensive but modest attire and her poised, contained bearing all suggest a woman of refined taste. Both portraits conform to Richardson's prescriptions, including his dictate that "[the] figures must not only do what is proper, and in the most commodious manner, but [the] painter's people must be good actors; they must have learned to use a human body well; they must sit, walk, lie, salute, do every thing with grace."[4]

Smibert's departure from London in 1728 deprived him of what promised to have been a more celebrated place in the history of British art; the contemporary commentator George Vertue had ranked him as a painter of talent, on a par with such figures as William Hogarth (1697–1764) and Joseph Highmore (1692–1780). As it happened, Smibert became a luminary in the American colonies, inspiring the first generation of American-born artists as a model of professionalism and a conduit of the canonical language of European portraiture.

Had Smibert stayed in England, he would have found himself in even greater competition with Hogarth, whose painterly gifts were amplified by a canny flair for self-promotion through the print medium and his own complex theories about art, published as *The Analysis of Beauty* (1753). Plate II of Hogarth's volume (fig. 3) demonstrates the vitality of his linear, serpentine forms – the basis of his aesthetic theory.[5] Illustrating a particular aspect of his theory and expressing his typically satiric attitude, Hogarth's country-house dancers frolic beneath Grand Manner portraits referencing Tudor, Stuart, and contemporary styles. Paintings like these had been the sources of his and Smibert's training. While Smibert's art may be said to have stagnated after a time in the colonies, Hogarth's art flourished. His portrait of an unidentified woman in the museum collection (c. 1740) (fig. 6) exemplifies the type of work he produced that stimulated a new taste for portraiture among the middle classes.

As Hogarth was rising to prominence painting mercantile and civic worthies and aspiring ladies, the young Thomas Gainsborough (1727–88) was studying at London's St. Martin's Academy (from 1740 to 1748), embarking on a career painting England's fashionable aristocracy. Unlike Hogarth's solid, linear style,

Gainsborough's delicate brushwork brought a transitory rococo spirit to his canvases, however much their tonalities were muted and their presentation was restrained. Gainsborough's portrait of Ralph Leycester of Toft Hall, Knutsford, Cheshire (c. 1763) (fig. 7) provides a vivid contrast to Hogarth's pragmatic approach. Viewed against a nearly contemporaneous portrait by Sir Joshua Reynolds (1723–92) of Maria Walpole, Countess Waldegrave, later Duchess of Gloucester (c. 1760) (fig. 8), Gainsborough's portrait also reveals the differences often separating his art from that of his chief rival. While Gainsborough's light touch adds to the sense of witnessing a living personality, Reynolds' firmer brushstrokes demonstrate his concern for approximating the sitter's likeness (however idealized) and the varied textures of her orientalizing costume. Such differences customarily reflect the purposes of commissions, the sitters' desires, and the artists' subjective responses to their models. Little is known about the circumstances leading to Gainsborough's painting of the country gentleman Leycester, but Reynolds' painting of the young countess is well documented. It is one of three portraits of her that he painted within one to two years of her first marriage in 1759, and the timing suggests notable demand for paintings of this recent bride who enjoyed the reputation as one of England's most beautiful women.6 Years later, at the time of the countess' second marriage, her beauty was still much admired, although marred in the opinion of one of her social competitors, Lady Mary Coke, who deemed her "not of much sense."7 In this regard, it may be worth speculating that Reynolds posed the countess in near profile to accentuate her physical appearance and downplay the possibility that an expressive spark of personality was lacking in her face.

8. **Sir Joshua Reynolds**
(English, 1723–92)
Portrait of Maria Walpole, Countess Waldegrave, c. 1760
Oil on canvas
Anonymous Donor's Purchase Fund, 64.1

Whether Reynolds or Gainsborough was the superior portraitist is a source of lively and continuing debate. Yet with respect to the hyphenated tradition of Anglo-American portraiture, it is Reynolds who stands at another significant crossroads of English and American art. In contrast to Gainsborough, Reynolds was the ultimate insider, and his success relied on his social finesse and organizational prowess in the politicized arena of the London art world as surely as it did on his painterly skills. Elected the first president of the London Royal Academy (founded under the

patronage of King George III in 1768), Reynolds wielded unassailable power as head of the select group of forty academicians. Moreover, his art theories (delivered first in lectures to the academy's students and later published as *Discourses on Art*) augmented his position of international respect.[8] Despite the absence of his art from the North American colonies, Reynolds, by reputation alone, set the standard for a generation of young artists there who craved European training and pinned their hopes on achieving the social and professional esteem embodied in Reynolds' success.

Foremost among the American artists who benefited from Reynolds' model was the Pennsylvania-born Benjamin West (1738–1820).[9] Like most colonial painters, West was painfully aware of the cultural disadvantages of his native land. With no art academies, few paintings of note to study, and only occasional contact with European-trained artists, West acquired much of his early knowledge of art through the writings of Richardson and other theoreticians. Nonetheless, West managed to carve out a respectable beginning as a portrait painter in Philadelphia, demonstrating enough talent to gain a stipend from local patrons for a trip to Italy in 1760. His three-year Italian sojourn made him the first American-born artist to view first-hand the legendary glories of antique Rome and the works of the Italian Renaissance and Baroque masters.

West had planned to return to the colonies, but a hiatus in London – where he put to good use the social connections he had made among the English contingent resident in Rome – brought him lucrative patronage that he found difficult to relinquish, given the professional hardships promised at home. West found himself welcome in London. With his good looks and forthright manner, he also attracted attention for the sheer novelty of his "savage" colonial origins, which made his artistic achievements seem that much more remarkable. Within a short time he was assimilated into the rhythms and customs of English art culture. West was befriended by Reynolds (a portrait specialist to whom he posed no great threat because of his own concentration on historical and literary subjects), and was, like Reynolds, a founding member of the Royal Academy. He went on to become the king's Official History Painter (an exceptionally noteworthy appointment in those times of political strife) and gained the presidency of the Academy on Reynolds' death in 1792.

The spread of West's fame in America (and of Reynolds' fame, as well) owed much to the shared cultural heritage – language, social customs, religion, and government – and the relatively continuous communications between England and her rebellious colonies. His meteoric rise was proof of the opportunities available to Americans in Europe, if only they would take them. And take them they did, as witnessed by the number of young colonial artists – including Charles Willson Peale (1741–1827), Rembrandt Peale (1778–1860), Ralph Earl (1751–1801), Gilbert Stuart (1755–1828), and Samuel F.B. Morse (1791–1872) – who went to London to study at the studio of their illustrious compatriot.[10]

9. **Attributed to Benjamin West**
(American, 1738–1820)
Portrait of Miss Sarah Elizabeth Young, Subsequently Mrs. Richard Ottley,
c. 1775–80
Oil on canvas
Anonymous Donor's Purchase Fund, 62.4

West is represented in the museum's collection by an unsigned, undated painting identified as a portrait of Sarah Elizabeth Young, later Mrs. Richard Ottley (fig. 9).[11] The authorship of this portrait is currently not secure primarily because it is not listed in West literature.[12] An unfortunate cleaning campaign prior to the painting's purchase by the museum has also made assessment on the basis of connoisseurship difficult. However, it is reasonable to attribute it to West given the painting's provenance (there is a clear path of ownership from the Ottley family to the museum) and the fact that West painted portraits of Sarah Young Ottley's brothers. Regardless of the question of authorship, the museum's purchase of this painting in 1962 signals the recognition of West's centrality in building a collection of this type. Moreover, it was doubtless this painting presented a strong argument for the acquisition of the Reynolds portrait just two years later. Virtually the same size, similarly composed, and nearly contemporaneous, the paintings complement each other in typifying two mainstream British modes of portrait characterization – Reynolds portraying his sitter in high contemporary fashion, and West depicting his subject in the guise of a classical character, possibly Sappho or another poet, as suggested by the lyre and sheet of paper she holds. This iconographic tradition of linking women with music also informs the portrait of a woman with an accordion (c.1830–35) (fig. 10), a charming, plain-style, anonymous portrait of an unidentified woman that entered the museum's collection in 1965. The painting was likely purchased precisely to emphasize these thematic connections while providing an example of painting techniques lying at the opposite end of the academic spectrum.

The style of the portrait of a woman with an accordion and the anonymity of the artist who painted it signify a division in American colonial art that persisted well into the nineteenth century – a division between work by artists who were formally trained and work by artists who were largely self-taught, itinerant, and now anonymous. The portrait's flat, linear facture denies atmosphere and nuanced form. This style, once referred to as "primitive" but now called "plain," reminds us of the hundreds of artists who traveled from town to town in North America, catering to a portrait market too weak to sustain a single artist's permanent residence in any one locale. These men had little or no technical instruction, but often labored to perfect their skills by studying the readily available prints engraved after the works of European masters. As a result, they adhered to European compositional templates, but failed to realize the painterly surfaces achieved by artists who were academically trained.

Even the brilliantly talented Bostonian, John Singleton Copley (1738–1815), who had benefited from Smibert's legacy and achieved unprecedented success in the pre-Revolutionary portrait markets of Boston and New York, submitted to the advice of West and Reynolds and quit the colonies for London's more sophisticated art environment and the opportunity to improve his technique.[13] Ambitious painters

10. **Anonymous**, American
Portrait of a Lady with an Accordion,
c. 1830–35
Oil on canvas
Anonymous Donor's Purchase Fund, 65.3

11. **Ralph Earl**
 (American, 1751–1801)
 Portrait of Mrs. Bradley and Her Daughter, Sally, 1788
 Oil on canvas
 Anonymous Donor's Purchase Fund, 59.7.3

12. **Rembrandt Peale**
 (American, 1778–1860)
 Portrait of Governor John Hoskins Stone of Maryland, 1797–98
 Oil on canvas
 Anonymous Donor's Purchase Fund, 60.13

like Copley sailed for Europe if they were able. The majority gravitated to London, and inevitably to West's studio. Unlike West and Copley, however, these young men returned to their homeland, where they became the first generation of academically trained American-born artists, many of whom were instrumental in establishing the first art institutions in the New World.[14]

Ralph Earl's *Portrait of Mrs. Walter Bradley and Her Daughter, Sally* (1788) (fig. 11) and Rembrandt Peale's *Portrait of Governor John Hoskins Stone of Maryland* (1797–98) (fig. 12) are significant examples of the transmission of European influence largely attained through contact with West and his milieu. Despite this shared influence, there is otherwise very little to connect the artistic output of Earl to that of the much younger Peale. Earl was largely self-taught and modeled his portraits after Copley's American style before his own loyalist sentiments led him to leave the colonies in 1778, abandoning his wife and two children for England. Under the patronage of the man who orchestrated what was essentially Earl's political escape, the artist gained portrait commissions and was by 1783 within the circle of West, who no doubt vetted the inclusion of Earl's work in Royal Academy exhibitions. Earl returned to America in 1785 (with a second wife from a bigamous union) and quickly established himself in Boston, and then New York, as a popular portraitist whose work reflected the fluid elegance of the British manner. Prone to economic and alcoholic excess, Earl was sentenced to debtor's prison from 1786 to January 1788. He radically modified his life upon his release and retreated to his native rural Connecticut, where he catered to a less sophisticated but nonetheless eager clientele. Earl's portrait of Mrs. Bradley and her daughter was painted the year he returned to Connecticut. It displays the dualities of his later manner, as he rejected the aristocratic portrait formulas he had learned in England and adopted a simple delineation of forms and broad brushwork; changes in style that were better suited to the modest conservatism of the rural, though wealthy, patrons in Connecticut.[15]

In contrast to Earl, Rembrandt Peale was born to cultural privilege and formally trained in art. A son of the renowned inventor, naturalist, painter, and museum founder, Charles Willson Peale, Rembrandt was part of a large family of accomplished painters. His portrait of Governor Stone speaks to his early artistic prowess, acquired in the studio of his father, who had studied with Benjamin West for two

years in London. Having learned well, the elder Peale returned to the colonies in 1769 and became the leading portraitist after Copley's departure in 1774. Rembrandt's portrait demonstrates his second-hand reception of West's teachings as conveyed to him by his father. Indeed, the painting exhibits the modified formal baroque style (replete with drapery and landscape backdrop) often used for official military or state portraits. It also echoes the more famous image of George Washington in uniform painted by the elder Peale in 1776, which, in turn, had its origins in the same British portrait traditions that yielded such paintings as the *Portrait of Vice-Admiral Lord Shuldham* (c. 1777–80) (fig. 13) by Sir Nathaniel Dance (1734–1811). Even this early in his career, however, the twenty-year-old Peale's portrait showed a taste for a higher palette and promised a greater technical facility than that which his father had achieved. By the time he actually studied with West in 1802, Rembrandt's high opinion of himself and his skills interfered with his progress, which was reportedly cut short because of his outward lack of respect for the elder artist.[16] It was not until after his trips to Paris in 1808 and 1809, when he adopted a highly finished surface in emulation of the neoclassical style, that Rembrandt Peale reached his full potential as a portraitist.

The role that visits to Paris played for Peale raises several issues concerning the flow of artistic influence from Europe to North America. In the northern and mid-Atlantic states, notwithstanding the hostilities between Britain and her colonies, and France's political and military support of the revolutionary cause, the dominant influence in portraiture came from England, largely as a result of shared cultural heritage. France had less influence in part because of the political difficulties often involved in crossing the English Channel, the narrow but important barrier separating the two historic adversaries, England and France. (For example, even an artist as well connected as Benjamin West was forced to wait until 1802, during the brief Peace of Amiens, to make a much-desired trip to Paris.) In the American Deep South, however, the lines of artistic influence had a French flavor and followed a different route, connecting the South with French colonial power that officially ended with the Louisiana Purchase in 1803. In Louisiana, for example, few works by northern colonial artists, and even fewer by British painters, were known. Instead, artists born or trained in France flourished in an active New Orleans market.

An outstanding exception to this general rule is John Wesley Jarvis (1780–1840). Born in England and raised in Philadelphia, Jarvis was, by 1809, one of the most popular portrait specialists in New York City. Beginning in 1810, however, he made regular painting excursions to the South and spent significant periods of time in New Orleans; in 1820 to 1821, 1829 to 1830, and 1834. Jarvis' portraits of Richard Butler and Harriet Butler Hook, his sister (c. 1815–20 and c. 1818–22) (figs. 14, 15), represent a rare intersection of the Anglo-American pictorial tradition (as it had evolved in the northern states) with southern patronage.[17] Furthermore,

13. **Sir Nathaniel Dance**
(English, 1734–1811)
Portrait of Vice-Admiral Lord Shuldman,
c. 1777–80
Oil on canvas
Anonymous Donor's Purchase Fund, 62.10

Vice Admiral
J. Shuldham

14. **John Wesley Jarvis**
(American, 1780–1840)
Portrait of Richard Butler of New Orleans,
c. 1815–20
Oil on canvas
Gift of Mrs. George Gammon Jr.
(née Keith Shepherd) in memory of her
mother, Emma Shepherd Bush, 88.21.1

15. **John Wesley Jarvis**
(American, 1780–1840)
*Portrait of Mrs. Moses Hook
(née Harriet Butler)*, c. 1818–22
Oil on canvas
Gift of Mrs. George Gammon Jr.
(née Keith Shepherd) in memory of her
mother, Emma Shepherd Bush, 88.21.2

the vivid contrast between Jarvis' loosely brushed surfaces (testimony of his reported ability to produce six portraits per week) and the tightly controlled technique of the Paris-trained Jacques Guillaume Lucien Amans (1801–88; born in Belgium and active in New Orleans 1828–56), displayed in his *Portrait of a Gentlewoman* (c. 1840–45) (fig. 16), supplies an additional avenue for investigating hyphenated artistic traditions – here, Franco-American. With its strong collection of Anglo-American portraits and others originating in the rich regional history of French artistic influence, the LSU Museum of Art is ideally, even uniquely, positioned to expand its curatorial aims by integrating the histories of portraiture in northern and southern America that are usually treated as distinct.

NOTES

1. See especially Wayne Craven, *Colonial American Portraiture: The Economic, Religious, Social, Cultural, Philosophical, Scientific, and Aesthetic Foundations* (Cambridge, London, New York: Cambridge University Press, 1986) and Richard H. Saunders and Ellen G. Miles, *American Colonial Portraits, 1700–1760* (Washington, DC: Smithsonian Institution Press for the National Portrait Gallery, 1987).

2. For a detailed account of Smibert's career, including the failed Bermuda Project, see Richard H. Saunders, *John Smibert: Colonial America's First Portrait Painter* (New Haven and London: Yale University Press, 1995).

3. Kneller devised the Kit-Kat portrait formula in the course of executing portrait commissions for members of London's Kit-Kat Club. The prevalent reuse of standardized poses is borne out in the comparison of Kneller's *William Robinson, later Sir William Robinson, Knt.* (1693, The Huntington Library, Art Collections, and Botanical Gardens, San Marino, CA), Smibert's portrait of David Miln in the LSU Museum of Art's collection, and his portrait of Joseph Turner painted in Philadelphia in 1740 (Cliveden Trust, England).

4. Jonathan Richardson, *An Essay on the Theory of Painting* (London: W. Bowyer, for John Churchill, 1715), quoted in Craven, *Colonial American Portraiture*: 156.

5. A standard source on Hogarth is Ronald Paulson, *Hogarth: His Life, Art, and Times* (New Haven and London: Yale University Press, for The Paul Mellon Centre for Studies in British Art, 1971).

6. Reynolds' paintings of the Countess of Waldegrave are recorded in David Mannings, *Sir Joshua Reynolds: A Complete Catalogue of His Paintings: The Subject Pictures Catalogued by Martin Postle* (New Haven and London: Yale University Press, published for The Paul Mellon Centre for Studies in British Art, 2000), Text: 474–77, where the present painting is listed as n. 1896.

7. Mannings, *Sir Joshua Reynolds*: I: 475.

8. For an analysis of the *Discourses* and their part in solidifying Reynolds' authority, see Robert R. Wark, ed., *Sir Joshua Reynolds: Discourses on Art* (San Marino, CA: Huntington Library, 1959), xv-xxxv.

9. The standard authority on West is Helmut von Erffa and Allen Staley, *The Paintings of Benjamin West* (New Haven and London: Yale University Press, 1986).

10. For this aspect of West's influence see especially Dorinda Evans, *Benjamin West and His American Students* (Washington, DC: Smithsonian Institution Press for the National Portrait Gallery, 1980).

11. The LSU Museum of Art's date for the painting, c. 1775–80, was supplied by an unknown source. Further research is required to confirm or correct it.

12. The issue of determining the painting's authorship is complicated and demands further research. Although the painting is not included in von Erffa and Staley, its absence does not necessarily preclude its authenticity and may be accounted for by accidental omission in the course of gathering information for the project. Correspondence between the museum's staff and von Erffa, the scholar who spearheaded the West catalogue project (later handed over to Allen Staley) documents von Erffa's awareness of the painting and implies his acceptance of it as a West in 1962, when the painting was purchased from Agnew's, London. In the years between von Erffa's correspondence and the publication of the West catalogue in 1986, opinion about the painting may have changed. Now, nearly two decades later, the assessment must be reconstructed. Understandably, Professor Staley does not recall all of the details leading to the inclusion or exclusion of works in the massive volume (telephone conversation with the author, September 24, 2004). Answers may yet be found in the voluminous West catalogue files deposited by Professor Staley with the Pennsylvania Historical Society, Philadelphia.

13. Copley had sent his *Boy with a Squirrel* (1765, Museum of Fine Arts, Boston) to London for exhibition at the Society of Artists in 1766 and by letter sought advice from West. West replied, advising him to make the journey to Europe to study great works of art, "for this [was] a Source the want of which . . . cannot be had in America." (Quoted in Evans, *Benjamin West*: 36.)

14. Major examples are Charles Willson Peale, who founded his own museum of natural history and art in Philadelphia in 1786, and the short-lived American Academy of the Fine Arts, also called the Columbianum, in 1794; and John Trumbull, who was a driving force in the American Academy and later the National Academy of Design in New York. Both men were inspired by the example of the London Royal Academy of Art.

15. See Elizabeth Mankin Kornhauser, *Ralph Earl: The Face of the Young Republic* (New Haven and London: Yale University Press, 1991). Earl painted frequently for the Bradley family. In addition to the present work, Earl executed portraits of Walter Bradley and his parents, Samuel and Sarah, in 1788 (all private collection). In 1794, he returned to the town of Greenfield Hill, where he painted Walter Bradley's sisters, Lucy and Huldah. (Kornhauser: 198.)

16. Evans, *Benjamin West*: 142.

17. The Butlers were born in Pennsylvania, but the family figured prominently in the development of the Lower Mississippi River Valley. The question remains as to whether the portraits were painted in Jarvis' New Orleans studio during his first stay in 1820–21, or whether the Butlers commissioned them during an unrecorded trip to the northern states. The portraits are not listed in the standard source on Jarvis – Harold E. Dickson, *John Wesley Jarvis: American Painter, 1780–1840* (New York: The New-York Historical Society, 1949) – but even at its publication more than fifty years ago, Dickson noted the need for further study of Jarvis' New Orleans output (232).

Visual Records of Louisiana and its Cultural Progress

PART | TWO

[I] gave three of my grandchildren, who do not live in Baton Rouge, a guided tour of the University campus.... I ... was fascinated and intrigued with the changes I noted in the Anglo-American Art Museum. [T]he Museum is housed in the Memorial Tower, which serves as a beacon of welcome to all University visitors – the imposing tower serves as the front door to the University.

Correspondence, Dr. Joseph W. Brouillette, Director Emeritus, General Extension Division, LSU, January 26, 1971 (LSU Museum of Art archives)

Portraiture, Landscapes, and Marine Scenes in Nineteenth-Century Louisiana

JUDITH H. BONNER

16. **Jacques Guillaume Lucien Amans**
(Franco-American, 1801–88)
Portrait of a Gentlewoman, c. 1840–45
Oil on canvas
Gift of Mr. and Mrs. W.E. Groves, 60.2.1

page 39

17. **Anonymous**, American
Mourning Brooch Miniature Portrait of Emile Lecoul, c. 1860
Tin-type photograph, gold, enamel, and hair
Gift of the Friends of LSU MOA, 85.2.3

Excitement is always generated during a time of new beginnings, and as the Louisiana State University Museum of Art turns over a new leaf, the excitement is tangible. It is a time of taking inventory of the museum's holdings and forging new directions in collecting. The museum holds representations by most of the major painters of the nineteenth century. These artworks reflect the state's artistic development during that period and document the citizens, the land, and the historic events. New Orleans, like her sister cities Philadelphia, Boston, and Charleston, was an important art center in the early nineteenth century. Artists flocked to Louisiana from abroad, as well as from the eastern seaboard. Portraiture dominated the first half of the century in the city and in the plantation country. The preference for portraits continued until Reconstruction (1867–77), when it was edged out by the reduced circumstances of its citizens, the inexpensive daguerreotype, and a growing appreciation of the state's scenic views, especially the unique characteristics of its swamplands. Beginning in 1794, theaters were well patronized and a number of artists found work as scene painters. Depending on the theatrical production, these backdrops were usually European in flavor. As late as the 1870s, some landscapes reflected artists' experiences painting stage sets, while others were distinctively drawn from the natural locale.

Only one name emerges during the colony's earliest years, and not until the late eighteenth century when colonial Louisiana was governed by Spain. Surprisingly, the artist José Francisco Xavier de Salazar y Mendoza (mid-1700s–1802), came not from Europe, but from Mérida in the Yucatán. He portrayed the fledgling colony's prominent citizens, including its military and religious leaders, from his arrival in 1782 until his death in 1802. Louisiana's portrait tradition is undeniably rooted in the eighteenth-century work of this painter. No other artist found an equivalent monopoly on patronage during the nineteenth century. Indeed, no artist enjoyed sustained patronage until the 1830s, when French artists practiced the then prevailing neoclassical style of portraiture.

For the two decades following Salazar's death, painters of miniature portraits found commissions in the newly purchased American territory. The museum's collection includes a large number of these oil and watercolor gems by Louisiana artists, as well as by their European and Anglo-American counterparts, and they

comprise a study unto themselves. More intimate than large portraits, the format for these miniatures usually follows a predictable formula: oval bust-length views of the sitter turned in three-quarter view against a plain background. The ground is occasionally mottled, stippled, or marked by variations in the sky. Modeling is minimal overall, and clothing and accessories are simplified. Their small size made miniatures portable and easily accessible for close examination or admiration. The smallest miniature portraits were worn as mourning jewelry and were often combined with hair from the deceased. The anonymous circa-1860 *Mourning Brooch Miniature Portrait of Emile Lecoul* (fig. 17) exemplifies this custom. Lesser-trained artists and visiting artists also found commissions, sometimes painting pendant portraits, group portraits, or individual portraits of family members. William Coutant (dates unknown), who was active in New Orleans from 1830 to 1855, was fortunate in earning a double commission. His circa-1832 pendant portraits of West Feliciana Parish planter Albert Gallatin Howell and Sarah Anne Johnson Howell, his Mississippi-born wife, appear stiff in anatomy, yet Coutant achieves credible

18. **Alfred Boisseau**
 (American, 1823–1901)
 Portrait of Gracieuse Molière Atkinson, 1849
 Oil on canvas
 Gift of Mr. and Mrs. Jules F. Landry and family, 65.2.2

19. **Alfred Boisseau**
 (American, 1823–1901)
 Portrait of William Atkinson, 1859
 Oil on canvas
 Gift of Mr. and Mrs. Jules F. Landry and family, 65.2.1

likenesses and captures his sitters' personalities.

Born in England, John Wesley Jarvis (1780–1840) immigrated to America when he was a young boy. One of the first New England artists who traveled to Louisiana, Jarvis was already established professionally when he arrived in New Orleans in 1821, where he wintered through 1834. His national standing underscores the importance of his artistic contribution to the cultural milieu of Louisiana, which achieved statehood only nine years before his arrival. Over the years, Jarvis portrayed Battle of New Orleans hero Andrew Jackson and a number of notable Louisiana citizens. He moved freely among the accomplished artists of New England. Together with John Vanderlyn (1775–1852), Samuel Lovett Waldo (1783–1861), and Thomas Sully (1783–1872), in 1814 Jarvis was commissioned to paint portraits of military and naval heroes of the War of 1812 for New York's new City Hall. His romantic tonal compositions convey a sense of warmth, and his loosely brushed background provides a textural contrast to the more finished treatment of the sitters. His subjects appear calm, composed, and dignified, as in the *Portrait of Richard Butler of New Orleans* (fig. 14), and *Portrait of Mrs. Moses Hook, née Harriet Butler*, Richard's sister (fig. 15). Although the Butler family came from Pennsylvania, they were prominent in the development of the Lower Mississippi River Valley. Butler lived most of his life in Louisiana and Mississippi, and his sister was the mistress of Golden Grove Plantation in St. James Parish and Salisbury Plantation near Woodville, Mississippi.

From the period of colonization through the Louisiana Purchase and statehood, the majority of the citizenry was French. Consequently, French artists trained in the academies of their native country dominated the antebellum period. The most notable portraitist of the 1830s and 1840s was Jacques Guillaume Lucien Amans (1801–88). In 1836, he left France with compatriot and fellow painter Jean Joseph Vaudechamp (1790–1866); both established studios in the same block of Royal Street in the Vieux Carré. Amans, who married a Louisiana resident, bought Trinity Plantation on Bayou Lafourche as a summer residence and painted in New Orleans during the winter months. Although Vaudechamp is considered the foremost portraitist in the city during the 1830s, Amans' skill and local connections brought him numerous commissions statewide from the late 1830s until his departure in 1856, when he returned to France. *Portrait of a Gentlewoman* (fig. 16), painted in the early 1840s, is typical of Amans' neoclassical portraits that allude to social position through clothing, accessories, and household furnishings. His expertise is particularly evident in the rendering of the hands and the subtle modeling of the face. The three-quarter-length figure set against a plain background is characteristic of the elegant portraiture that was preferred for grand homes during the antebellum period.

The Parisian Alfred Boisseau (1823–1901) was considered less accomplished artistically, yet his work, focusing on ethnic Louisiana subjects, was exhibited in the 1848 Paris Salon. Boisseau portrayed *Gracieuse Molière Atkinson* in 1849 (fig. 18),

and in 1859 he made a companion portrait of her husband, *William Atkinson* (fig. 19). Both portraits are signed and dated and attest to Boisseau's artistic development over the decade. The Atkinsons owned a plantation with a large tract of land near Donaldsonville, Louisiana, and their portraits document the prosperity of the Louisiana plantation class.

Born in France, George David Coulon (1822–1904) came to New Orleans with his family in 1833, while a young boy. Resisting his father's efforts to make him become a jeweler, he studied with several local artists, including Amans. His earliest attempt at portraiture in 1842 differs considerably from his work of the late nineteenth century. His 1865 *Portrait of a Little Girl* retains some of the stiffness and charming naive quality of his earliest portrait. Like other artists who hand-colored photographs, Coulon improved his artistic skills dramatically, especially in depicting human anatomy. The setting, showing a balustrade behind the girl, resembles a photographer's backdrop, a device that appears in many Louisiana portraits. Painted on the eve of the Civil War, Coulon's small oval portrait of a woman wearing a bonnet, rendered in textural brushstrokes, retains a freshness that was lost in his portraits from the 1880s and 1890s. These he executed in the smoothly finished style preferred for portraiture during that period.

François Bernard (1812–80s), also born in France, portrayed numerous Louisianians and their families. His 1856 oval pastel portrait of *Miss Corinne Taylor at Age Sixteen* (later Mrs. Alfred Dufilho), displays the family's wealth through the lavish lace-trimmed gown, the rococo revival gilt commode with marble top, and the Vieux Paris vase. The furniture and porcelain give visual evidence of the family's ability to acquire fine European furnishings, and Bernard excelled in portraiture that demonstrates the sitters' pride in their possessions. Bernard, like many artists who left New Orleans during the Civil War, moved to Mandeville on the North Shore of Lake Pontchartrain, where he depicted the native tribes of the area, a rarity in Louisiana painting.

Louis Nicolas Adolphe Rinck (1802–95), another Frenchman and a friend of Vaudechamp, arrived in New Orleans in 1840 and later bought a farm in Algiers, across the Mississippi River from the French Quarter. Like Amans, Rinck's friendship with Vaudechamp served as an introduction to Louisiana's planter class. A highly competent artist, he was in demand by the planter and merchant class, as well as by political figures like Judah P. Benjamin. In 1844 Rinck painted a stately three-quarter-length *Portrait of Mrs. Richardson of New Orleans* (fig. 21), whose niece was the wife of the Honorable Howard McCaleb of the Louisiana Supreme Court. Mrs.

20. **George Peter Alexander Healy**
(Irish-American, 1813–94)
Portrait of a Lady in a Black Gown, 1845
Oil on canvas
Gift of Mr. and Mrs. W.E. Groves, 60.2.3

21. **Louis Nicolas Adolphe Rinck**
(American, 1802–95)
Portrait of Mrs. Richardson of New Orleans, 1844
Oil on canvas
Gift of Mrs. Joyce P. O'Connor, 96.29

Richardson stands near a balustrade, a barrier that focuses attention on the sitter and sets her apart from a meticulously landscaped garden, a reference to the family's land holdings.

Artists from other areas of the country were drawn to New Orleans and its Old World charm. During his visit to the city in 1860 to 1861, the Irish-American portrait and historical painter George Peter Alexander Healy (1813–94) portrayed many prominent Louisianians and visitors, including Jenny Lind. Although born in Boston, Healy worked in America and Europe from 1830 to 1855, and then established a studio in Chicago. His patrons included many American statesmen, as well as English and French royalty. His 1845 *Portrait of a Lady in a Black Gown* (fig. 20) is skillfully rendered: the subject's anatomy is credible, the hands are well formed, and the flesh is convincingly modeled. The painting, however, differs from most antebellum portraiture in the sitter's almost wistful expression, her sensuous posture, and the sense of an interrupted moment. She is shown in three-quarter view, her arms extended before her with her hands resting on an open book lying on a table, almost as though she were playing a piano.

While portraiture dominated Louisianians' preference, landscape painting experienced a slow start until interest accelerated after the Civil War. Visual focus on the Louisiana terrain began early in the century in the form of marine painting, as artists depicted the broad Mississippi River and the ships that navigated its waters. From 1812 on, steamships plied the river, making upriver return trips possible; because of the treacherous downriver currents, such voyages had formerly been made by overland travel. Commerce increased dramatically, contributing to the wealth of Southern planters, cotton brokers, shippers, and other mercantile concerns. Paintings portraying steamships have long been equated with the romance of the river. Other marine paintings document historical events, for example, sea battles during the War of 1812 and the Civil War.

French port painter François Joseph Frédéric Roux (1805–70) focused on a dramatic incident in Louisiana maritime history, when Americans rescued British sailors from their sinking ship in the English Channel. *Portrait of the Ship Bolivar of New Orleans Saving the Crew of the British Brig Friends Good Will on January 7, 1835* (fig. 22) represents a rare instance of a French port painter depicting a New Orleans vessel during the first half of the nineteenth century. One of Roux's first known paintings, it is signed "Frédéric Roux au Havre 1836." While this drama involving a Louisiana vessel took place at Le Havre in the English Channel, other paintings focus on maritime events closer to home waters. During the second quarter of the century, German-born Edward Everard Arnold (1816–66), who set up his French Quarter studio in the late 1840s, drew on his experience as a sign painter, engraver, and lithographer to produce many renderings of Louisiana ships. With New Orleans being one of the major port cities in the United States, commissions for paintings of

page 46

22. **François Joseph Frédéric Roux**
(French, 1805–70)
Portrait of the Ship Bolivar of New Orleans Saving the Crew of the British Brig Friends Goodwill on January 7, 1835, 1836
Watercolor on paper
Gift of Dr. A. Brooks Cronan Jr. and Diana Cronan, 81.4.1

page 47

23. **Edward E. Arnold**
(German-American, c. 1816–66)
Battle of Port Hudson on the Mississippi, 1864
Oil on canvas
Gift of the Friends of LSU MOA, 71.20

24. **Richard Clague**
(American, 1821–73)
Farm in St. Tammany, bet. 1851 and 1870
Oil on canvas
Gift of Mr. and Mrs. W.E. Groves, 60.2.2

ships were frequently sought, although they were not nearly as numerous as those for portraits.

Like Roux's rendering of the *Bolivar*, Arnold's ships can also be classified as portraits. Traditionally, ships' owners fondly bestow the feminine gender to their vessels, which metaphorically take on a life of their own. Shipbuilders and owners appreciate the faithful portrayal of their ships, and often specify that a commissioned painting be highly detailed. Accordingly, Arnold's ships are characterized by sharply delineated contours and rigging, as in his *Portrait of Schooner Allen Middleton* (1866); the linearity, coloring, and rendering are reminiscent of painted signs. Even his 1864 painting of the *Battle of Port Hudson on the Mississippi* (fig. 23) is more a portrait of Union ships than a battle scene. The event was significant, for the Union captured the extensive three-mile long batteries atop the bluffs, the strongest fortifications between New Orleans and Vicksburg. The victory strengthened the Union's blockade from the Chesapeake to the Mexican border and prevented the South from receiving supplies or exporting cotton to England.

A number of the museum's holdings focus on subjects that complement those of LSU's Civil War Center. Artworks focusing on the Civil War in Louisiana were generally created by visiting artists, specifically military artists and illustrator-correspondents, occupations that drew a number of illustrators to Louisiana. One such artist, Charles F. Allgower, Captain in the 77th U.S. Colored Troops (dates unknown), left a series of drawings documenting the Union occupation and the destruction of Baton Rouge's notable gothic revival architecture. These include the State House, which burned in 1862, and *The Deaf and Dumb Assylum* [sic] (1863), which served as a hospital. Allgower's pencil sketches are skillful; his keen powers of observation are underscored by his ability to capture elements of daily life among the troops. Francis H. Schell (1834–1909), an illustrator for *Harper's Weekly*, drew numerous New Orleans and Baton Rouge scenes and events. Like Allgower, Schell rendered a view of the *Burning of the State House, Baton Rouge, on Sunday, December 28, 1862*. In his painting the disaster is almost lost in the background, while the side-wheeler steamboat St. Maurice takes prominence in the foreground. Schell's sketch, *Advance upon Port Hudson* (1863), concentrates on wagons, infantry, mounted officers, and ground activity during a baggage train crossing of Bayou Montecino. The scene is a lively contrast to Arnold's marine scenes, for it documents the event without being a dry depiction. Arnold's seascapes in no way compare with the drama in those by Bror Anders Wikström (1854–1909) later in the century. Having gone to sea as a boy and worked his way up to captain, Wikström, a native of Sweden, knew well the undulating motion of a ship in rough waters. Although he skillfully delineated a ship navigating smooth waters in his 1905 *Louisiana Sailing Vessel on a Calm Sea*, his marine scenes are frequently dramatic, capturing the majesty and ferocity of the seas. Where Arnold paints a meticulous

25. **Joseph Rusling Meeker**
(American, 1827–87)
After a Storm, Lake Maurepas,
c. 1886
Oil on canvas
Gift of the Phi Gamma Chapter
of Chi Omega Sorority, 98.14

portrait of a ship, Wikström captures the life of a ship under sail. The museum owns several of these seascapes.

Although some landscapes and street scenes were painted prior to the Civil War, only afterwards did the landscape genre begin to assert itself in Louisiana. It can be said about the South in general that Southerners' appreciation of the land grew after their having fought for, and to a large extent, lost their land. The most obvious example of the opportunities offered by this increased interest in the land is the peripatetic South Carolinian William Aiken Walker (1838–1921), who traveled throughout the South, painting romantic formulaic cabin scenes, dock scenes, sharecroppers, and cotton pickers. There are, however, a number of exceptions to these stereotypical scenes in which he varies his subject and experiments with technique. His circa-1880 landscape *Carolina Home*, which falls into the latter category, appears

to have been painted as a study.

The name of Richard Clague (1821–73), a native son of Louisiana who is often referred to as the "Father of the Louisiana Landscape," is forever linked with his two students, William Henry Buck (1840–88) and Marshall Joseph Smith Jr. (1854–1923). Clague's landscapes, however, are immediately distinctive from those of his two protégés. His *Farm in St. Tammany* (bet. 1851 and 1870) (fig. 24) more closely resembles the landscapes of the Barbizon painters, with whom he worked in the late 1840s. Clague began his art studies early in life: in Switzerland, emphasizing the fine arts, in New Orleans, focusing on landscape studies with muralist Leon D. Pomarède (1807–92), and in Paris, studying at the École des Beaux-Arts.

26. **Marie Adrien Persac**
(Franco-American, 1823–73)
*Interior of the Main Cabin
of the Steamboat Princess/Imperial*, 1861
Gouache and collage on paper
Gift of Mrs. Mamie Persac Lusk, 75.8

Given his European studies and Pomarède's instruction, combined with his innate talents and artistic expression, Clague produced a body of work unlike any Louisiana landscapist who had preceded him. A native Virginian, Smith was reportedly Clague's favorite pupil. *Cows Feeding on Swamp Grass on the Shore of Lake Pontchartrain* (bet. 1870 and 1890) is typical of his scenes featuring moss-draped oaks near a body of water, usually rendered in thinly applied umber pigment and glazes. The compositional arrangement and generally sparse treatment of the foliage differ from Clague's dense landscapes. There are common elements, however, especially the inclusion of cows. The circa-1875 *Louisiana Bayou at Sunset* by American-born Harold Rudolph (1850–83/84) combines the dark, verdant, tangible earth of Clague's landscapes with the romantic, warmly lit bayou scenes of Joseph Rusling Meeker (1827–87).

Born in Newark, New Jersey, Meeker studied at the National Academy of Design, New York, in 1845. He was active in Louisville, Kentucky from 1852 to 1859 and in Louisiana from 1862 to 1865. While serving as paymaster on a Union gunboat, he made numerous sketches of the swamps in the Mississippi Delta, returning for intermittent sketching trips through the early 1870s. He produced many quiet, poetic, dramatically lit bayou scenes with moss-draped cypress trees, like his circa-1886 bayou scene, *After a Storm, Lake Maurepas* (fig. 25). Set either at dawn

REFERENCES

Anglo-American Art Museum Catalogue: Paintings, Prints, Drawings. Baton Rouge, LA: Louisiana State University, 1971.

The Historic New Orleans Collection, Artists' files.

Kelly, James C. *The South on Paper: Line, Color and Light.* Spartanburg, SC: Robert M. Hicklin Jr. Inc., 1985. Intro. by Estill Curtis Pennington.

Louisiana State University Museum of Art, Accession files.

Mahé, John A., and Rosanne McCaffrey. *Encyclopaedia of New Orleans Artists, 1714–1914.* New Orleans: The Historic New Orleans Collection, 1987.

Pennington, Estill Curtis. *Antiquarian Pursuits: Southern Art From The Holdings Of Robert M. Hicklin Jr. Inc.* Spartanburg, SC: Robert M. Hicklin Jr., Inc., 1992.

Pennington, Estill Curtis. *A Southern Collection.* Augusta, GA: Morris Communications, 1992.

Richardson, E.C. *A Short History of Painting in America: The Story of 450 Years.* New York: Thomas Y. Crowell, 1963.

27. **Marie Adrien Persac**
 (Franco-American, 1823–73)
 Louisiana Asylum for the Deaf, Dumb, and Blind, 1859
 Gouache and collage on paper
 Gift of the Friends of LSU MOA, 77.4

or at dusk, his swamps are warmly luminous, mysterious, and solitary. While Asher B. Durand (1796–1886) and the other Hudson River painters established a voice for the Northeast, Meeker achieved for the South a distinctively geographic portrayal of the bayou imbued with an overtly psychological mood.

One of the best visual recorders of Louisiana history and architecture, Marie Adrien Persac (1823–73) depicted plans and residences of innumerable properties, both private and public. Persac's plantation scenes parallel Arnold's portraits of ships in their meticulous attention to detail, which is evident in four plantation scenes and a steamboat interior in the museum's collection. *Hope Estate Plantation* (c. 1855) depicts property on the Mississippi River about four miles below the present campus of LSU. Persac painted three gouaches in 1861 at the height of his career. *Faye Plantation* shows a Greek revival home with numerous dependencies characteristic of Louisiana plantations: pigeonnier, garçonnière, cisterns, barns, sugar houses, slave quarters, and a plantation bell that signaled the mandatory call to work. Mounted riders and dogs are collaged in the foreground, a technique Persac employed in many plantation scenes. *St. John Plantation, St Martin Parish* similarly documents the plantation home and outbuildings. *Interior of the Main Cabin of the Steamboat Princess/Imperial* (fig. 26) records the furnishings and decorations found in elegant parlors of the period. Among Persac's portrayals of public buildings is his 1859 gouache of the *Louisiana Asylum for the Deaf, Dumb, and Blind* (fig. 27). One of the largest structures in the gothic revival style, the building was LSU's first home after it moved to Baton Rouge in 1869. The women in the foreground wear the same type of antebellum gowns that Persac showed in his artworks of the 1870s.

Despite their popularity, landscapes did not entirely replace portraiture, and artists like Coulon, John Genin (1830–95), and others continued making likenesses of the people and the land. Coulon, Smith, Walker, and Wikström, among others, painted into the next century as artistic trends developed into a more painterly style and a greater freedom of choice in subject. With its broad range of holdings, the museum's collection illustrates the breadth and depth of visual art and its development in nineteenth-century Louisiana.

Louisiana Art in the Early to Mid-Twentieth Century

CLAUDIA KHEEL

28. **Ellsworth Woodward**
(American, 1861–1939)
Newcomb Chapel, 1918
Oil on canvas
Gift of Mrs. Nina Nichols Pugh, 97.11.1

29. **Knute Heldner**
(Swedish-American, 1886–1952)
Heldner and Colette, date unknown
Oil on canvas
Transfer from Special Collections,
LSU Libraries, 2004.4.3

Painting in Louisiana during the first half of the twentieth century was defined by a distinctly Southern regional character and influenced by modern art movements prevailing in America and Europe. English Arts and Crafts and American Impressionism inspired the Woodward brothers, William (1859–1939) and Ellsworth (1861–1939), who brought those influences to the South. In 1886, Ellsworth established the Art Department at Newcomb College in New Orleans, laying the foundation for the enduring tradition of Newcomb pottery and crafts. In the 1930s and 1940s, Caroline Durieux (1896–1989) combined in her prints and paintings contemporary Social Realism and her own sense of social satire. Conrad Albrizio (1892–1973) engaged the mural tradition of the State Works Progress Administration and the influence of the famed Mexican artist Diego Rivera (1886–1957) to create monumental murals for the new Capitol Building in Baton Rouge and the New Orleans Union Passenger Terminal train station. Clarence Millet (1897–1959), Knute Heldner (1886–1952), and Ben Earl Looney (1904–81) adopted the tenets of the American Scene movement and used painting to chronicle everyday life in America. Self-taught artists Clementine Hunter (1886–1988), France Folse (1906–85), and Rhoda Brady Stokes (1901–88) brought individual vision and naive style to their work. As much as these and other artists engaged contemporary artistic trends, they were also strongly influenced by the South's own distinctive arts, and its culture, traditions, agriculture, industry, and geography. As a group, the artists were instrumental in establishing Louisiana's Southern Regional art movement.

In the late eighteenth century and through the nineteenth, portraiture dominated Louisiana art. Working in the French neoclassical style, Jean Joseph Vaudechamp (1790–1866) and Jacques Guillaume Lucien Amans (1801–88) (fig. 16) prevailed with their elegant and meticulously crafted portraits of the wealthy bourgeoisie. After the Civil War, a landscape tradition emerged as Richard Clague (1821–73) (fig. 24) and his students William H. Buck (1840–88) and Marshall J. Smith Jr. (1854–1923) focused on the dark, brooding bayous and marshes of southern Louisiana. Fisherman in their boats and rustic cabins scenes also became a unique source of inspiration for them. The prolific Alexander John Drysdale (1870–1934) carried the new tradition of Louisiana landscape painting into the

twentieth century. A native of Marietta, Georgia, Drysdale moved to New Orleans and studied with Paul Poincy (1833–1909), and later at the Art Students League of New York. Using his trademark technique of diluting oil paint with kerosene, Drysdale created impressionistic views of the bayous, waterways, and oak trees of the South.

The artists and teachers William and Ellsworth Woodward had trained at the Royal Academy in Munich and were among the first to study at the Rhode Island School of Design. They arrived in New Orleans in 1885 and had a remarkable influence on the local art community. William founded the School of Architecture at Tulane University, while Ellsworth established the Newcomb Pottery and Crafts enterprise in 1895. Ellsworth often painted the scenic vistas and buildings of the Newcomb campus, located at that time on the former James Robb estate in the Garden District. In his brilliantly rendered *Newcomb Chapel* (1918) (fig. 28), Ellsworth worked in the American Impressionist manner to depict one of his favorite and often-painted campus sights.

From the 1920s to the mid-1940s, a group of bohemian writers and artists populated the historic French Quarter. William Faulkner, Sherwood Anderson, and Lyle Saxon were among talented writers who found the lifestyle and ambiance of the Quarter inviting and inspirational. The New Orleans Art League, Art Association of New Orleans, and Arts and Crafts Club thrived and regularly exhibited work by local artists, and by national artists who frequented the city. The Art League and Art Association's annual members' exhibitions were regularly hosted by the Isaac Delgado Museum of Art (now the New Orleans Museum of Art). The members of the Art League tended to be conservative – they viewed the emerging modern movements with disdain and limited their membership to men, in order "to avoid a tea party atmosphere."[1] The Art Association was more broad-minded, as it exhibited both representational and modernist work. The Arts and Crafts Club was probably the most progressive of the three organizations. It maintained a permanent gallery and school at the corner of Pirate's Alley and Royal Street in the French Quarter, with the objective to promote local artists and support contemporary art in the city.

As the French Quarter art colony matured, several other avenues opened up for local artists to show and sell their work. During the Depression years, under the direction of Gideon T. Stanton (1885–1964) and later, Caroline Durieux, the State Works Progress Administration maintained on Toulouse Street an exhibition space known as the Louisiana Art Project Gallery. J.S.W. and Virginia Harmanson's gallery on Royal Street actively published and sold fine art prints, books, calendars, and postcards by prominent local writers and artists, including Morris Henry Hobbs (1892–1967) and Wiley Churchill (dates unknown). Dillard University's exhibition schedule featured an annual show of local artists, as well as the Harmon Foundation's traveling exhibition of nationally distinguished African-American

artists. The Southern States Art League toured exhibitions of work by regional artists throughout the South. Jackson Square provided a viable alternative to the art galleries and art associations; on the cast-iron fence that surrounded the Place D'Armes Park, artists displayed paintings for sale to tourists and locals alike.

Clarence Millet and Knute Heldner were active in the thriving French Quarter art colony. Born in Hahnville, Louisiana, Millet studied at the Art Students League and achieved recognition early in his career by exhibiting at the Pennsylvania Academy of Fine Arts, the New York World's Fair of 1939, and the Art Institute of Chicago. In his picturesque *Watermelon Schooner* (date unknown), Millet painted one of the many boats that traversed the Old Basin Canal near the French Quarter. The docked schooner here is laden with a cargo of fresh watermelons most likely destined for sale at the French Market. Boatmen often lived on the schooners with their families, and they traveled up and down the waterways between New Orleans and southern Louisiana, delivering fresh produce and goods. Other artists, including the midwesterners Louis Oscar Griffith (1875–1956) and Robert Grafton (1876–1936), were also intrigued by the activity along the canal and regularly captured it in paint.

30. **Ben Earl Looney**
(American, 1904–81)
Downtown Baton Rouge, 1920
Oil on canvas
Gift of the Artist,
Transfer from Special Collections,
LSU Libraries, 2004.4.4

The Swedish-born Knute Heldner had settled in Minnesota's Scandinavian community and studied at the Minneapolis School of Fine Art before attending the Art Students League. In 1923, he and Colette Pope Heldner (1902–90), his wife, visited New Orleans for the first time, and soon after they made the French Quarter their studio home. Heldner's *World War II* (c. 1940) is a dynamic port scene featuring battleships with airplanes flying overhead. During the war, New Orleans' Shushan airport on the lakefront was converted to a military airbase, and production of the famed Higgins boats employed hundreds of men and women. Undoubtedly, Heldner felt deeply the impact of the war on the city and the nation. His untitled painting known as *Heldner and Colette* (date unknown) (fig. 29) shows the influence of the French artist Henri Matisse (1869–1954), and the intimacy of the couple's pose reflects their close personal and professional relationship. In both of these paintings, Heldner moved away from his representational bayou cabin scenes and French Quarter vistas, and took a more modernist approach to his work.

Born in southern Indiana, Will Henry Stevens (1891–1949) trained at the Cincinnati Art Academy and worked as a tile designer for the Rookwood Pottery Company. While studying briefly at the Art Students League, he was exposed to the latest developments in international modern art and had a one-man show of his paintings at the New Gallery. In 1921, he joined the faculty at Newcomb College, where he taught for over twenty years. Throughout his career, he exhibited in New York City and at Flora Lauter's gallery, which was part of the Brown County Art Colony in Indiana. Stevens embraced Abstract Expressionism and the Oriental philosophy of Daoism. His pastel drawing *New Orleans Roman Catholic Church* (c. 1940) combines both representational and abstract elements.

In 1935, Louisiana State University in Baton Rouge established the Fine Art Department. Ben Earl Looney was one of the first instructors of the department, and some of the most talented artists of the day, including Conrad Albrizio, joined the faculty. Looney taught art for a time in Boston and New York, where he was elected to the Board of Control of the Art Students League, but he spent most of his life in Louisiana, painting plantation homes and urban scenes from 1940 to 1970. His softly detailed social realism has much in common with work by the American Regionalists active primarily in the Midwest, including Thomas Hart Benton (1889–1975), whose humble, anti-modernist style and depictions of everyday life gained prominence in the 1930s. Looney's *Downtown Baton Rouge* (1920) (fig. 30) takes a vantage point from the River Road running along the Mississippi, depicting the Old State Capitol building (from 1847) rising in the background and the Baton Rouge Waterworks Company standpipe (from 1875) towering above industrial warehouses on the left.[2]

Born in New York City, Conrad Albrizio initially studied architecture, then went on to study painting with George Luks (1866–1933) at the Art Students League. In

31. **Conrad Albrizio**
(American, 1892–1973)
And the Lord Commanded Me... Deuteronomy 4:14: Study for a Mural, State Capitol, Court of Appeals, 4th Floor, 1930
Pencil and watercolor on paper
Gift of the estate of Mrs. Ernestine H. Eastland Lowery, 93.7.1

1930, at Governor Huey Long's instigation, the new State Capitol building incorporated work by local artists, including the muralist Albrizio and the sculptor Angela Gregory (1903–90). For the Governor's Room, Albrizio created a series of murals with themes of Louisiana culture, agriculture, and industry, and for the Court of Appeals, he featured Biblical passages on the theme of judgment. Before painting his large-scale murals, Albrizio made preliminary watercolor sketches. In the sketch for *And the Lord Commanded Me . . . Deuteronomy 4:14* (1930) (fig. 31), he drew a graphite grid overtop the watercolor and a scale of dimensions in the lower right corner, to guide him in translating the smaller image to the large mural painted on the wall. Using a classical technique he also employed for the murals of the Union Passenger Terminal, he created large-scale cartoons with small holes outlining the design, placed the cartoons against the wall, and threw chalk dust into the holes to leave behind a silhouette of the design. Albrizio taught art at LSU for over twenty years and, as an advocate for public art in the South, earned several mural commissions in Louisiana and Alabama.

The talented printmaker and painter Caroline Durieux was an influential professor of art at both Newcomb College and LSU. Born and raised in the French Quarter, Durieux studied with Ellsworth Woodward at Newcomb College and at the Pennsylvania Academy of Fine Arts. In the 1920s, she moved with her husband to Cuba and then to Mexico, where she became friends with Diego Rivera. Durieux's work is humorous and often satirical in tone. The artist seemed to delight in chronicling human behavior and relationships, and her images often feature stylized depictions of people in different surroundings and social situations. In *Café Tupinamba* (1934) (fig. 32), Durieux hones in on four smartly dressed Mexican gentlemen in a local café, enjoying aperitifs and conversation while smoke from their cigarettes billows overhead. Comparing the preliminary drawing for this piece to the finished painting reveals how Durieux altered the poses of the figures and the location of the bar in the background. In the painting, the faces are more exaggerated and expressive, and each gentleman's individual personality emerges more fully.

The self-taught artist Clementine Hunter enjoyed a productive and enduring career in art. Hunter first worked as a laborer in the cotton fields, and later as a house servant for Cammie Henry at Melrose Plantation in Natchitoches. "Miss Cammie," as all knew her, attracted a literary and artistic coterie to her northwest Louisiana home. In the early 1940s, Hunter embarked on her artistic career after she discovered a set of oil paints left behind by one of Miss Cammie's frequent visitors, New Orleans artist Alberta Kinsey (1875–1968). Hunter painted pictures of the world she knew – life on Melrose Plantation – including *Funeral* (c. 1950) (fig. 33), a complex multifigure scene set outside the St. Augustine Catholic Church.

Throughout the twentieth century, distinct regional art movements developed in various parts of America in response to diverse ethnic populations, histories,

32. **Caroline Durieux**
(American, 1896–1989)
Café Tupinamba, 1934
Oil on canvas
Gift of Mr. Charles P. Manship Jr.,
91.25

traditions, culinary arts, industries, and cultures. For example, art movements in the southern city of Charleston were in some ways similar to, yet also distinct from, artistic trends in the midwestern city of Indianapolis. In the South, artists were talented, diverse, and well aware of the prevailing art movements in America and Europe alike. New Orleans was somewhat unique among southern art centers. Along with the influence of the city's distinct character, the many artists who visited there and interacted with the local art community also played a key role in fostering and furthering the Southern Regional art movement in Louisiana.

NOTES

1. Meigs O. Frost, "New Art Body Makes Bow with Fine Exhibit: Old Claiborne Mansion at 630 Toulouse, Becomes Center of Society of Clubs," *New Orleans States*, December 4, 1927.

2. The Old State Capital building (1847) and the Baton Rouge Waterworks Company standpipe (1875) are now recognized by the National Register of Historic Places, and the very location Looney depicts marks the new home of the LSU Museum of Art (and branches of the university's School of Art and Laboratory for Creative Arts and Technologies) at the new Shaw Center for the Arts.

33. **Clementine Hunter**
(American, 1886–1988)
Funeral, c. 1950
Oil on board
Gift of Mrs. H. Payne Breazeale,
74.3.6

Decorative Arts: A Collecting Focus

PART | THREE

I would like to donate to the Anglo-American [Art] Museum the following pieces of coin silver: I. Water Pitcher by Hyde & Goodrich of New Orleans; II. Four Matching Goblets; III. Six Matching Punch Cups (all by Hyde and Goodrich); IV. Beaker by Baldwin and Company, made by Taylor Baldwin.

I would like to thank you, Pat Bacot, and the University for allowing me to [be] part of the very exciting, educational, and worthy cause that is put forth by all.

Correspondence from Dr. A. Brooks Cronan, Sunshine, Louisiana, to Mr. Lloyd Moon, Director, LSU Foundation, April 9, 1985 (LSU Museum of Art archives)

Early Louisiana Furniture and Other American Furniture

H. PARROTT BACOT

35. Armoire in Louis XV style, c. 1770–90, Louisiana
Walnut, cypress, brass, and iron
Gift of the Friends of LSU MOA, 86.29.1

page 65

34. **Adolphe Himmel** (German-American, 1826–77) for Hyde and Goodrich, New Orleans
Covered cream jug, c. 1853–61
Coin silver
Gift of Dr. and Mrs. A. Brooks Cronan Jr. 81.4.2

page 67

36. Campeachy chair, c. 1810–25, probably New Orleans
Mahogany with white oak and satinwood inlay, leather, and nails
Gift of D. Benjamin Kleinpeter, 96.13.3

Most of Louisiana's surviving furniture from the Franco-Spanish colonial period (1699–1803) dates from Spain's governance of the entire Louisiana Territory. Spain never heavily colonized Louisiana, using it instead as a buffer zone between the British, and later the United States, and its more prized possessions in the American West and Mexico. As a consequence, Louisiana's French population, and its language and culture, remained dominant even during Spain's suzerainty. After the Louisiana Purchase in 1803, the culture of mixed French and Spanish Creoles and Creoles of color was thoroughly entrenched and remained popular.

As more Anglo-Americans arrived in Louisiana, French forms in architecture and furniture blended with Anglo-American elements, such as sash windows and pictorial and line inlay in the English tradition, to produce styles unique to Louisiana. For example, an acculturated armoire could blend Anglo-American inlay with French iron and brass *fisches* (exposed hinges) and English-made, Hepplewhite-style stamped brass escutcheons and drawer pulls.

The Louisiana State University Museum of Art's collection of early Louisiana-made furniture is not large, but it has great significance because of the number of forms included, the range of time represented, and the high quality of each piece. The collection consists of ten pieces – armoires, chairs, a table, and a bookcase – made between roughly 1770 and 1845. The woods employed in their construction include walnut, cherry, cypress, poplar, and red mulberry native to the region, plus several varieties of mahogany brought up from the West Indies.

Most early Louisiana furniture of the colonial and federal periods (1620–1780; 1788–1825) is not as heavily carved as the furniture made in French Canada or in France itself. While much of Quebec's furniture was made of softwoods such as white pine and birch, which are easily carved, Louisiana's furniture was more often made from the figured hardwoods, whether in its primary or exposed construction, and relied on good lines and proportion for its beauty.

It may come as no surprise that of all Louisiana-made furniture, except for slat-back chairs, the quintessentially French form – the armoire – is the type that survives in the greatest number. The earliest armoire in the museum's collection (fig. 35) could date to the early 1770s. Made of American walnut with cypress secondary wood, this armoire is typical of the eighteenth century as it follows French fashion

37. Armchair, c. 1780–1825, Louisiana
Red mulberry and pecan
Gift of Mrs. Paula Garvey
Manship, 96.13.2

38. Side table, late 18th century, Louisiana
Mahogany, cherry, and cypress
Gift of the Friends of LSU MOA and Mrs. Winifred Gill in memory of her husband James Monroe Gill, 94.16

slavishly. Its key elements – a carved cartouche panel in the upper register of each door, five-panel configuration on each side with one horizontal panel set between two pairs of vertical panels, the vertical stiles chamfered and terminating in a lamb's tongue, and the generally heavy, over-constructed nature of the piece – all relate directly to France. The cabriole legs are thick and rise from pyramidal feet, and have a bead carved on the inner edge that flows into the apron. The front stiles are rounded and paneled.

Pre-1800 armoire doors employ ninety-degree joinery, whereas nineteenth-century examples employ mitered door construction. Full-size Louisiana-made armoires typically have detachable cornices that simply rest on the top of the carcase. The *cavetto* shape was the preferred model for cornices, but the museum's armoire is unusual in that its front and side elements are joined on each end by a single, hand-carved dowel, as opposed to the usual blocked construction. Even in this relatively early armoire, something new was introduced: rather than having moveable shelves, as French armoires do, a fixed belt of two drawers was placed across the interior. Like several other colonial-Louisiana armoires and tables, these drawers had no hardware, so one had to reach under the apron to push the drawer open.

The museum has two very rare rush-bottom, slat-back armchairs (*fauteuils*) made of native red mulberry, including one from c. 1780–1825 (fig. 37), gifted to the museum by Mrs. Paula Garvey Manship in 1996. Both chairs are likely of eighteenth-century origin, but their vernacular style does not preclude an early-nineteenth-century date of manufacture. They are part of a select group of Louisiana-made chairs that relate to an equally small group of French-Canadian armchairs. The museum's chairs have handsome turnings on their stiles, and the rear stiles are crowned with acorn filials. Like much seating furniture in the French tradition, their seats tend to be lower than those made elsewhere in Europe, Britain, and America. There is also a good deal of open space between each chair's arms and seat rails, and one of the chairs has a horizontal bar between its arms and seat rails. The space was designed to accommodate the very thick down-filled squabs (cushions) so loved by the French and their colonials during the second half of the eighteenth century. The squabs would originally have been covered in a chequered linen (usually blue), or in a copper-plate-printed cotton. These chairs afford physical evidence of what early Louisianians generally used for comfort in lieu of expensive, fully upholstered pieces.

The collection also includes two slat-back side chairs (*chaises à la capucine*). One of them, with sophisticated turnings, scribed-line-decorated stiles, and graduated, arched back-slats, was probably made in either New Orleans or one of the nearby

39. Armoire, c. 1800–25, probably New Orleans
Santo Domingan mahogany, Spanish cedar, poplar, walnut, and brass
Gift of Mr. and Mrs. Emile N. Kuntz, 79.43

Mississippi River parishes. The other chair, with delightful sausage-turned stiles and elongated finials, reflects the *Acadien* tradition of southwestern Louisiana and was most likely made in St. Martinville.

The Spaniards made their mark on one aspect of furniture manufacturing in Louisiana. The *boutaca* (a Spanish term referring to an upholstered chair) was a type of lolling chair that had originated in Spain by the seventeenth century. With its sling-type seat raised on curule-shaped legs, the *boutaca* was very popular in the Yucatan Peninsula of Mexico. Numerous chairs of this type, with either tooled leather upholstery or a caned seat, were made in the district of Campeche, inspiring the name campeche chair, which Anglo-Americans corrupted to "campeachy." Local, East Coast, and West Indian inventories also call this type of chair a "Spanish Chair."

Campeche chairs were sent to New Orleans in considerable numbers, where local chair makers copied them. Thomas Jefferson received one from a friend in New Orleans in 1819, and it still remains at Monticello. From New Orleans, the style spread elsewhere in the United States, but it was most popular in the Deep South. The museum has one campeche chair (fig. 36), found in Natchez by a pioneer collector and made either there or in neighboring Louisiana. Crafted from mahogany, the chair has a graceful melon-shaped crest, whose center is inlaid in native white oak in a fan pattern. This fan-and-line inlay border on the crest reflects Anglo-American taste and helps date the chair to c. 1810–25.

The mid-eighteenth-century European taste for the light, curvilinear rococo style, inaugurated during the reign of Louis XV, continued to enjoy favor in Louisiana as late as 1830, although it became acculturated as it blended with the ideas brought by the Anglo-American settlers. Of the thirty-odd known Louisiana-made tables raised on cabriole legs, the museum's side or tea table (fig. 38) ranks in the top five percent for design and originality. The table has a thin, two-piece lap-jointed mahogany top and front rail, and the sides and legs are native cherry. It has its original cypress drawer runners, but as with many of these small tables, the drawer is a bench-made replacement. The four legs are slim and a little attenuated, which lends the piece a sassy elegance that it shares with other Louisiana-made rococo furniture from the first quarter of the nineteenth century. A convex moulding runs all around the top, and all four sides are finished, indicating that the table was intended to be seen in the round for the service of tea or coffee, and that it may have been used in gaming.

The museum owns two Creole armoires that seem to be unique survivors from the early nineteenth century. One of them, from c. 1800–25, has a classic Creole form, but is made from Caribbean mahogany and employs American tiger stripe and bird's eye maple as veneers. This use of maple in early Louisiana furniture is not unknown in the inventories, but the museum's armoire is the only known piece employing these dramatic maple veneers. The armoire has a fine set of French-made

40. Tea table, c. 1770, American
Cherry
Gift of Mr. and Mrs.
Michael Williams, 97.26

hinges in the Louis XV style, but the other hardware is English-made cast and stamped brass. The pair of shield-shaped, stamped door escutcheons crowned with eagle finials is especially appealing; the museum owns an engraved plate from a c. 1810–25 Birmingham brass founder's catalogue that illustrates these very escutcheons. In the center of the armoire's carcase, two oval brass Heppelwhite backplates stamped in a rosette pattern embellish the two terminal drawers of the belt of three. The belt of drawers, and two removable shelves – one above and one below – are another hallmark of the classic Creole armoire. It is typical in the acculturated style for the central drawer to be smaller and to open with a key. In addition to the various maple veneers, including the drawer fronts, the armoire is decorated with light and dark line inlay in the Anglo-American taste, and has a false central stile that is part of the left door.

The other rococo armoire in the museum collection (c. 1800–25) (fig. 39) is large and constructed of rich, dark, West Indian mahogany, Spanish cedar from the Islands, and poplar. It is raised on amazingly fragile-looking cabriole legs and pyramided feet. While this piece has no inlay, its door panels are made from beautifully figured wood known as "plum pudding" mahogany, and its front stiles are reeded. This is the only known armoire on cabriole legs to be fitted with side closets and wooden cloak pins. Like the other Creole armoire described above, the false central stile swings with the left principal door. Opened, its interior reveals other interesting features. In addition to the usual belt of three drawers, there are three sliding linen shelves – a feature seen on only one other cabriole leg armoire. Both the drawers and linen shelves have their original English-made oval brasses, each embossed with a mariner's star. The brass rim lock is the largest known on any Louisiana-made armoire. The secret, snap-action mahogany latches under each of the three drawers are unique in Louisiana-made furniture.

There were few significant collections of books in colonial or early republican Louisiana. Traditionally, books were stored in armoires, but by the 1820s, free-standing bookcases begin to appear in the inventories. The museum has one bookcase, c. 1835, designed in the early Grecian taste and first owned by the celebrated surgeon, author, planter, and philanthropist, William Newton Mercer, M.D. (1789–1874) of Adams County, Mississippi, and New Orleans. This massive, straightforward rectilinear, two-section piece consists of an upper and lower range of glazed cupboards. The lower register is deep, to accommodate oversized volumes, while the upper register is stepped back and fitted with a broad, flange-like cornice. The bookcase is built of walnut, with a single band of mahogany veneer bordering

the vertical edge of the top of the lower cupboards. All the cupboards lock with large, French-made, steel and brass rim locks that survive with their decorative steel and brass keys.

A group of furniture made elsewhere in America and ranging in date from about 1730 to 1906 complements the Louisiana-made furniture in the museum collection. Highlights from the colonial period include a superior walnut tilt-top candle stand whose single board top revolves on a birdcage action. This c. 1750–75 rococo-style piece was made in Chester County, Pennsylvania, and is distinguished by the flattened ball ornament on its turned pillar. Its tripod base is handsomely carved, and each leg terminates in a snake foot on a pad. Also from the same area and period is a slope-fall-front walnut desk (c. 1765) with blocked interior and a shell-carved prospect door. A mid-eighteenth-century Delaware River Valley slat-back side chair (c. 1730–65) (fig. 41) with bold bun front feet in its original Spanish brown paint invites comparison with the Louisiana-made slat-back chairs. Of the group of Windsor chairs owned by the museum, the fan-back side chair (1780) with its pierced volutes in the crest represents the very best of New England Windsor chairmaking in the late eighteenth century.

The museum has a fine collection of furniture from the federal period, and it is fitting that some of the most significant pieces were made in the South. Kentucky, in particular the city of Lexington, is represented in the museum's collection by two case pieces. The bowfront Hepplewhite chest of drawers is signed in ink twice by its maker, Elisha Warner (d. 1829), who was active in Lexington from 1810 to 1829. Especially noteworthy is how Warner banded each drawer with sap cherry and ingeniously employed a hot iron to brand the border with decorative ellipses. This is the only signed piece by this cabinetmaker discovered to date. It survives with its original stamped brass pulls embossed with the Scottish thistle.

Sugar chests or boxes, and cellarettes or bottle cases, are two more forms unique to the South. Sugar chests were made primarily in Kentucky and Tennessee. The museum's sugar chest (c. 1810–15) (fig. 42), in walnut with light and dark inlay, is a sophisticated example of the form. The interior of the chest is divided into two parts, with a small section for refined sugar and a larger one for raw sugar used in cooking. Some families would use the larger section of a sugar chest to store liquor bottles. The chest, with its line and spandrel inlay, is raised on a stand containing a

41. Slat-back side chair,
Delaware River Valley
c. 1730–65,
Pennsylvania
Painted maple
Gift of the Friends of
LSU MOA, 79.15

REFERENCE

Louisiana State University Museum of Art accession records.

42. Sugar chest, c. 1810–15,
 Kentucky
 Walnut
 Gift of Miss Ione Easter Burden,
 72.5

drawer for storing sugar tongs, teaspoons, and other objects associated with the service of food. Then, as now, cabinet makers worked by the hour, so the chest's front and rear legs are short several reeds where they would not have been seen during ordinary use.

The American classical period (c. 1825–45) is represented in the museum collection by two pier tables. The earlier one was made in New York City around 1820 to 1830. Constructed of mahogany with mahogany veneer and poplar secondary wood, the table features white alabaster columns and pilasters capped and footed with either English- or French-made gilt-brass mounts, and front feet carved like paws from poplar, then ebonized. The white marble top has reeded edges typical of the best New York tables of the period. Like other pier tables of this era, the museum table has a lower shelf with a mirrored back above to reflect light.

The museum's other table from the classical period was made in Philadelphia c. 1830–35. Half of a mariner's compass star – in rosewood veneer inlaid in its lower shelf – is completed by its reflection in the companion mirror. The façade supports are monopodic carved, stylized lion's legs terminating in powerful lion's paw feet. These legs are characteristic of the best work of the Philadelphia cabinetmaker Antoine Quervelle (1789–1856), who was born and trained in France, and his chief competitors, the brothers Charles Haight and John Ferris White (active 1828–52). The table, which has been in Mississippi and Louisiana since its manufacture, may have originally had gilt-stenciled decoration on its frieze, which was damaged by the climate and removed in the refinishing process. Its original mottled gray King of Prussia marble top does survive intact.

Rococo-revival-style furniture produced from 1840 to 1865 enjoyed a particular vogue in the Deep South's golden age, (c. 1830–61). By that time, New York City had arrived as America's fashion center, and well-to-do planters, merchants, and factors in the South ordered rococo revival furniture from the North by the shipload. The museum's music cabinet/*étagère* is a capital example of the style and was very likely made by the New York City firm of the brothers John (1801–75) and Joseph Meeks (1806–78) around 1855. This piece, in mahogany and mahogany veneer on poplar and maple, represents two of the leisure activities of middle-to-upper-class Victorians – musical performance and the collection of bric-a-brac. The single reticulated door, backed with green silk, opens to a blaze of curly and tiger-striped maple shelves and slots, used to store sheet music and bound volumes of music.

Keeping good company with the Yale University Art Galleries on the East Coast and the University of Utah in the West, the LSU Museum of Art is one of a select few art museums under the aegis of an institution of higher learning that has collections of historic furniture for students of art history, interior design, architecture, and human ecology, in particular, to study.

Pre-Electric Lighting Devices

H. PARROTT BACOT

43. Pair of candlesticks,
c. 1710, France
Brass
Gift of the Friends of
LSU MOA, 84.36 a-b

44. **Joseph Wood**
(English, active 1736–49)
Candlestick, mid-18th century
Brass
Gift of the Friends of
LSU MOA, 77.13

45. Detail: **Joseph Wood**
(English, active 1736–49)
Candlestick, mid-18th century
Brass
Gift of the Friends of
LSU MOA, 77.13

Few challenges have proved as daunting as the quest for adequate artificial lighting. Most of us living in twenty-first-century industrialized nations give little or no thought to the many types of electric lighting enjoyed today, yet the light bulb was invented by Thomas Alva Edison (1847–1931) only a little over a hundred years ago, in 1879.

In antiquity, fine lighting devices were status symbols, and surviving lamps from the Greek and Roman civilizations demonstrate that some of the finest sculptors and founders in bronze lavished their talents on creating elegant lamp standards for aristocratic patrons. High-end lighting devices would remain in the purview of the upper classes until technological advances in the twentieth century made sophisticated models more accessible to all.

The Louisiana State University Museum of Art's collection of pre-electric lighting devices focuses largely on pieces dating from the late Renaissance period (1580–1600) through the Arts and Crafts Movement (1860–1915). Most were made by hand for an upper-class clientele, and devices like these have survived in some number because their design, decoration, and materials have been appreciated for their beauty and valued as reflections of their times. They were considered so desirable that among the earliest lighting devices, many candle-burning lamps were adapted to use newer fuels such as kerosene and gas, and then later were electrified. While candle-powered devices dominate the museum's holdings, fixtures burning various oils and gas are also well represented.

The earliest device in the collection is a late Renaissance bronze capstan candlestick dating from the second half of the sixteenth century. The baroque era (c. 17th–18th century) is represented by several pieces, including the glass candlestick with a baluster shaft rising on a capstan base, made in Holland, France, or Germany around 1660. The pair of trumpet-footed candlesticks with broad mid-drip pans follows a design originating in England around 1640 and demonstrates how people would often try to update lighting devices: in the eighteenth century, a crude rectangular aperture was cut in the side of one of the candlesticks to accommodate a

pushup candle ejector.

Around 1680, metalsmiths in England and France discovered that much raw material could be saved if candlestick stems were cast not in whole, but in halves that were then soldered together. Throughout the eighteenth century, this casting technique was used for some of the most elegant candleholders designed in the baroque, rococo, and neoclassical styles. From the mid-seventeenth century on, candlesticks made in base metals such as brass, pewter, and bronze copied patterns originally executed in silver. The museum's pair of early-eighteenth-century Louis XIV brass candlesticks, with their low, octagonal bases and octagonal stems, are classic examples (fig. 43). What really sets this pair apart, though, is the skill demonstrated by the artist who engraved them in a jewel-like manner. In contrast, a single unengraved candlestick made in Birmingham, England (c. 1740–60) (figs. 44, 45) is less accomplished, but its beautifully finished underside bears the die-stamped mark of its maker, Joseph Wood (active c. 1736–49).

Paktong, an alloy of copper, zinc, and nickel, was developed by the ancient Chinese and introduced to Europe around 1730. This material was popular among the upper classes because it looked very much like silver, and usually required polishing only once a year. The museum owns three pairs of paktong candlesticks from c. 1745–75, all of them executed in the British rococo style. The pair with shell-shaped bases and companion detachable *bobeches* (drip pans) is a superlative example of understated yet refined British design. The same sensibility is reflected in another pair made from "red" or "pink" brass (brass with a high copper content). Each of the red brass pair is designed with a twisted plinth that spirals dramatically from a square gadrooned base.

In the early neoclassical period (1780s), a series of revolutionary discoveries and inventions energized the evolution of lighting. Spermaceti candles, made from the oil found in the head cavity of the sperm whale, were beautifully white, burned with a clear, steady flame, and did not require wick trimming every few minutes to keep them from guttering, as tallow candles did. The museum's handsome brass snuffer/wick trimmer on stand, from c. 1740–60, represents the kind of device required to extinguish a flame before spermaceti candles were introduced.

In the late eighteenth century, a new type of candlestick was invented – the telescopic model, which had a columnar shaft that could be raised to make it taller. Telescopic candlesticks were popular in late-eighteenth- and early-nineteenth-century Britain and her colonies, and in the United States. Made from brass, silver-plated copper, and silver, they were rarely marked by their manufacturers, except for those made in sterling. The museum has one candlestick from c. 1808–20, marked by its Birmingham brass founder, William Fiddian and Company, whose name appears in the Birmingham directories from 1807 through 1830 as a manufacturer of brass candlesticks and cocks.

The 1783 invention by the French-Swiss scientist Aimé Argand (1705–1803) of a new burner for oil lamps changed the course of lighting for the next sixty years. Argand created a double cylindrical tube fixed with a conforming wick, which allowed air admitted by decorative vents at the base of the tube to pass on both sides of the flame. This design increased the intensity of the flame and thus the brightness of the light. As early as the late 1780s to early 1790s, fine English-made silver-plated argand lamps were owned by such sophisticated Americans as George Washington and Thomas Jefferson.

Initially, argand lamps were imported to the United States from England and France, but by the 1830s, some American firms were producing ones that equaled the quality of those made in England. The museum's holdings include examples by two such firms; Henry N. Hooper in Boston, and Cornelius and Sons in Philadelphia. Although unsigned, the suite of three c. 1845 classical-Gothic revival style argand lamps, in their original bright and matte gilded lacquer finish, can be attributed to the Cornelius factory (fig. 46). Consisting of a double-burner central fixture flanked by a pair of single-burner lamps, this set survives with all of its brilliantly faceted prisms intact and has never been electrified. As with most argand lamps, the reservoirs that would have held either whale oil or colza oil (rapeseed) are

46. **Attributed to Cornelius and Sons**, Philadelphia
Three-piece argand mantel garniture, c. 1845
Gilt bronze with faceted prisms
Gift of Mr. and Mrs. Raymond J. St. Germain Jr, 81.33.2 a-c

47. Three-light girandole, c. 1840–55,
United States
Gilt ormolu, white marble, and glass
Gift of Mrs. Mamie Henry and Mr. and Mrs. Stephen G. Henry Jr. in memory of the late Stephen G. Henry Sr., 82.22. 1-2

located above the burners so that the fuel would flow smoothly down to them. Highly decorative, these lamps were used as mantel garniture or placed on pier tables and sideboards.

Another type of lamp using the argand burner is the astral or sinumbra lamp. The name sinumbra comes from the Latin word meaning "without shadow," and reflects how the annular oil font in this design, largely disguised as an element of the reservoir by the shade ring, does not create as much shadow as a font placed above and to the side of the burner. The museum collection includes several sinumbra lamps. The most typical example is a patinated and gilt bronze model crowned with an engraved mushroom-shaped shade, made in England around 1830–45. A more unusual example has a shaft featuring Atlas supporting the world; the globe is ebonized wood inscribed with longitude and meridian lines. Made in England, this lamp can be dated to 1830–38: it bears the brass plate of its New Orleans retailer, Valsin Vignaud, who ran a fancy goods store on Chartres Street during that period.

An even rarer astral lamp is one fashioned from pressed and cut glass, and brass and sheet metal. Made in c. 1825–50, it bears a brass plaque stamped with the factory's name, the New England Glass Company of Cambridge, Massachusetts, and is one of only three examples of this model known to survive.

The museum's pewter whale oil lamp with two wick holders, probably made in either New England or New York in c. 1825–70, is a type of fixture that would have been found in the best rooms of a lower-middle-class family's residence, or in the tertiary spaces of wealthier homes. The design of the lamp, with its wick supports rising straight up from the flange screwed into the reservoirs, indicates that this fixture probably burned whale oil.

During the first half of the nineteenth century in America, experiments were made in the search for inexpensive burning fluids or combinations of fluids. One significant trial involved camphene, a mixture of alcohol and turpentine that unfortunately proved to be highly explosive. Camphene was often used in glass peg lamps that could be inserted into candleholders. Peg lamps ranged in quality from inexpensive clear glass fixtures to more refined models made from colored and clear cased glass with gilding or enameling. The museum's pair of cranberry and clear glass peg lamps, from the mid-nineteenth century, represents the higher end of design for this type of device. The brass wick supports are flared to form a V that separates the two

flames and was supposed to deter explosions. The original chained brass snuffers or covering caps for each wick are among the few known to survive.

By the 1830s, America had truly become a pig economy, boasting more than one pig for each person in the population. While lard had been used as a burning element in iron wick-supported grease lamps since colonial times, it was not surprising that in 1843, America's largest lighting manufacturer, Cornelius and Company of Philadelphia, patented a lamp featuring a modified argand burner fueled by liquefied lard. Called solar lamps, they were manufactured in locales from Philadelphia to New England and, as with peg lamps, they ranged from inexpensive tin devices to high-end models. Burning a rather crude fuel, the lamps were somewhat odorous and messy, so most of the finer examples were adapted to burn kerosene after oil was discovered in Pennsylvania in the 1850s. The museum's solar lamp, probably manufactured by the Boston and Sandwich Glass Company in Sandwich, Massachusetts, c. 1845–55, is a sumptuous piece made from white marble and gilt brass with a blue, white, and gilded overlay glass column, and a diaper-patterned Turk's Cap shade. The long, coffin-shaped prisms, which are both frosted and copper-wheel engraved, were probably made in Bohemia for the American market.

The development of oil-powered devices and the advent of gas hardly dimmed the use of candles by the poor for practical lighting, and by the upper classes for romance. Among the most inventive of nineteenth-century candle-powered devices was the Palmer Patent Lamp, which was registered at the London Patent Office by William Palmer in 1830. Its columnar lamp standards were fitted with an internal brass sleeve to hold the candle, and a coil spring to force the candle to rise. Large candles with three wicks of woven wire and cotton were made specifically for these lamps. These triple-wick candles burned brighter, which probably accounts for why the Palmer Patent Lamp was the only candle-powered lamp shown at London's great Crystal Palace Exposition in 1850–51. The museum's Palmer Patent Lamp (c. 1840–55) is made from gilt and patinated bronze, with imitation damascene enameling that unfortunately has been largely rubbed away.

A group of girandoles, possibly invented by the Cornelius firm of Philadelphia around 1840, features shafts and branches cast so thin that they are almost two-dimensional. Raised on single or double marble plinths, the standards were available from the manufacturer in a variety of finishes ranging from bright and matte gilded lacquer, to bright silver, to dull gold. They were usually embellished with figures inspired by characters in European and American novels from the late eighteenth to the mid-nineteenth century; the heroes and heroines of Sir Walter Scott, James Fennimore Cooper, and Washington Irving were especially popular subjects.

The museum's collection boasts the largest known surviving set of girandoles. Featuring two sculptures in the round, they are distinct among other American-made designs. The George Washington/Benjamin Franklin model (fig. 47) was probably

REFERENCE

Bacot, H. Parrott. *Nineteenth-Century Lighting: Candle-powered Devices: 1783–1883.* West Chester, PA: Schiffer, 1987.

48. **Starr, Fellows and Co.**, New York
Four-branch gasolier, c. 1857–61
Gilt brass, bronze, copper, bronzed metal, and etched glass
Gift of the Baton Rouge Coca-Cola Bottling Co., Ltd., 82.13

made by the Cornelius firm in c. 1840–55 as a commission for the first president of the New York Central Railroad, Dean Robinson. The Washington figure holds in his right hand a scroll inscribed, "Declaration/of/Independence," while the Franklin figure clasps another scroll inscribed, "The Law/of/Pennsylvania."

Another set of girandoles in the collection is based on characters from Cooper's *The Last of the Mohicans* (1826), one of the earliest of the frontier novels. The elaborate, five-branch central candelabrum features the Mohicans Uncas and Chingachgook, and the frontiersman Hawkeye, and the flanking single socket fixture presents Major Duncan Heyward and Colonel Edmund Munro in full late-eighteenth-century military dress. A design depicting one of Munro's daughters was also available. The museum's set is clearly an assembled one, because the Munro and Heyward figures rest on single marble blocks, while the candelabrum rises from a double-step base. The candelabrum bears the mark "Cornelius & Co." /Patent/December 5, 1848," while the Heyward and Munro pieces bear the same marks, except the patent date is April 10, 1849. As the stamps indicate, all of these pieces may indeed have been made before 1851, when the firm changed its name to Cornelius and Baker. Since the firm was cavalier about marking its products, though, the pieces cannot be dated for certain.

While gas made from coal was lighting British factories and streets by 1815, gas was not commonly used in American homes until the 1840s and 1850s. In the United States, manufacturers of fine gasoliers quickly incorporated in their designs decorative motifs from history and literature. The Christopher Columbus gasolier first appeared in Starr and Fellows' 1857 catalogues, but the museum's gasolier (c. 1857–61) is the only known fixture based on this design (fig. 48). The Columbus figure dominates the lamp, but the swan-shaped bronzed spelter (zinc) branches and the gilt bronze serpents intertwined on the edge of the central bowl add great cachet. The underside of the gasolier's bowl is fitted with a gas nozzle and cock, where a rubber hose would be attached and run to a companion Columbus gas stand on a center table below. Although not original to this gasolier, the shades date from the same period and are rare examples featuring symbols of fraternal organizations – in this case, the Odd Fellows.

With its broad range of examples, the LSU Museum of Art's collection sheds considerable light on how technological developments and economic circumstances sparked innovation in both the design and function of pre-electric lighting devices.

New Orleans Silver

H. PARROTT BACOT

49. **Jean Baptiste Lamothe**
(Santo Domingan, 1800–79) or
Jean Marie Lamothe
(Santo Domingan, 1795–1880)
Beaker, c. 1815-25
Coin silver
Gift of the Friends of LSU MOA, 77.3.1

50. **Henry P. Buckley**
(English, 1822–1903)
Cann or mug, c. 1855
Coin silver
Gift of the Friends of LSU MOA and Dr. and Mrs. Steven Abramson in memory of Alex Watsky and Rae C. Abramson, 90.11

The Louisiana State University Museum of Art holds the largest public collection of New Orleans-made silverware. The pieces range in date from the 1770s to the end of the twentieth century and include several that were made at LSU. Louisiana has no silver mines, so in the past, the raw material for smithing was obtained by melting down damaged or out-of-fashion pieces and coinage. During Spain's governance of the Louisiana Territory, much of the material came from coins made in silver-rich Mexico.

Three silversmiths were known to be working in New Orleans in 1719, the year after the founding of the city, but for several reasons little New Orleans silverware from the eighteenth century survives. First, the town was small at that time, and half of its population was composed of slaves. Second, the difficulty in obtaining raw materials made silverware a great luxury in Louisiana. Third, the fires of 1788 and 1794 leveled large parts of New Orleans, including silver workshops. Finally, the custom of melting down old silverware to make new pieces meant that many of the older pieces disappeared into creating new objects.

New Orleans silver evolved from three different, overlapping traditions – the French, the Anglo-American, and the German. In the colonial and early republican periods, silversmiths came either directly from France or from the older and wealthier islands of the French Caribbean. On the islands, the slave insurrections of the late eighteenth and nineteenth centuries, especially in Saint Domingue, brought to New Orleans whole families of silversmiths, including the Delarues, Lamothes (fig. 49), and Couverties. The only piece of eighteenth-century New Orleans-made silver in the museum's collection is a soup spoon from c. 1768–79, made by the American Pierre Coudrain (1729–79) (fig. 51). Like all of the flatware made by smiths working in the French style, the spoon is fashioned from very heavy gauge metal in a plain fiddle-back pattern: that pattern continued to be made as late as the 1840s. Relatively little hollowware made by New Orleans silversmiths during this period survives, except for small French-style beakers.

After the Louisiana Purchase of 1803, Anglo-American silversmiths began to arrive in New Orleans, mostly from the eastern seaboard states. Some made pieces in

51. **Pierre Coudrain**
 (Franco-American, 1729–79)
 Soup spoon, c. 1768–79
 Coin silver
 Gift of the Friends of LSU MOA, Mrs. R. Elizabeth Williams, Mrs. Bert S. Turner, Mrs. Mathile Abramson, Mrs. Lewis A. Bannon, The Exxon Education Foundation, and Mr. Maurice R. Meslans, 97.3.1

52. **Adolphe Himmel**
 (German-American, 1826–77) for Hyde and Goodrich, New Orleans
 Hot water kettle on a stand, c. 1855–61
 Coin silver
 Gift of Mr. Milton J. Womack in memory of his wife, Barbara Sevier Womack, 85.22 a-c

the heavy gauge French style to suit Creole tastes. Others catered to Anglo-American preferences by using lighter gauge silver and employing new patterns, such as fiddle and shell, and sheaf of wheat. They also produced more neoclassical hollowware and presentation and commemorative pieces. A variety of cups, goblets, and urns were made by or for the Anglo-American silversmiths. Among their many uses, these pieces celebrated mechanical and fraternal societies and volunteer fire companies, and were offered as gifts to medical doctors for bravery during yellow fever epidemics. The most productive of the silversmiths were the British Henry Peat Buckley (1822–1903) (fig. 50), the American E.A. Tyler (1815–79), and the Bavarian Anthony Rasch (1778/80–1858), who is grouped with the Anglo-Americans because he worked in Philadelphia for many years before arriving in New Orleans.

After political unrest began in the German states in 1848, large numbers of talented craftsmen migrated to America. Initially, many of the German silversmiths in

53. **Adolphe Himmel**
(German-American, 1826–77) for Hyde and Goodrich, New Orleans
Water pitcher, c. 1853–61
Coin silver
Gift of Dr. A. Brooks Cronan Jr. and Diana Cronan, 83.6.1

54. **Adolphe Himmel**
(German-American, 1826–77) for Hyde and Goodrich, New Orleans
Presentation pitcher, c. 1853–61
Coin silver
Gift of Dr. A. Brooks Cronan Jr. and Diana Cronan, 80.2.3

55. **Adolphe Himmel**
(German-American, 1826–77)
for Hyde and Goodrich, New Orleans
Lidded soup tureen, c. 1861–77
Coin silver
Gift of Dr. A. Brooks Cronan Jr.
and Diana Cronan, 78.2.1-2

56. **Adolphe Himmel**
(German-American, 1826–77)
and **Christopf Christian Küchler**
(German-American, active in New Orleans
1852–70) for Hyde and Goodrich, New Orleans
Egg boiler, c. 1852–53
Coin silver
Gift of the Friends of LSU MOA, 84.31.1 a-d

New Orleans worked for well-established Anglo-American manufacturers and jewelers. The largest and most famous of these firms was the fancy goods store of Hyde and Goodrich, which, until the Germans arrived, primarily sold silverware that had been manufactured in New York and New England. The most prolific of all the silversmiths in New Orleans were the Bavarian Adolphe Himmel (1826–77) (figs. 52–55) and Christopf Christian Küchler (dates unknown) (fig. 56). They made large amounts of hollowware in the late classical style and especially in the rococo revival style. Himmel was the manager of the Hyde and Goodrich silverware manufactory from 1854 until 1861, when the firm dissolved. The Germans continued to dominate local silversmithing after the Civil War and adapted their designs to the Renaissance revival style that was in fashion at the time.

Although there were few African-American silversmiths in this period, they nevertheless played a role in the production of New Orleans silver. As early as 1763, Jacob Bunel (dates unknown), a slave of the silversmith Jean-Baptiste Domingue

59. John Chandler Moore
(dates unknown) for Tiffany,
Young & Ellis, New York
Seven-piece tea and coffee service,
c. 1850–52
Coin silver
Gift of Major General Junius
Wallace Jones, 76.23.1-7

57. William St. Leger Hamot
(American, 1800–51)
Set of three tablespoons,
c. 1827–44
Coin silver
Gift of Mrs. L. Heidel Brown
in memory of her husband,
97.3.3 a-c

58. William St. Leger Hamot
(American, 1800–51)
Detail: Tablespoon, c. 1827–44
Coin silver
Gift of Mrs. L. Heidel Brown
in memory of her husband,
97.3.3 a

Bunel, trained in the craft and, after being freed in the 1770s, continued to pursue it until 1782. The museum owns nine spoons made by another African-American, the free man of color William St. Leger Hamot (1800–51) (figs. 57, 58), who practiced the art of silversmithing from 1827 to 1844.

During Louisiana's golden age of 1830 to 1861, vast quantities of luxury goods were consumed. Following the Civil War, silver Mardi Gras pins became fashionable favors, and the museum's examples include a 1888 Krewe of Rex pin by the Bavarian Maurice Schooler (1827–1900). The heyday of silver manufacturing in New Orleans ended with the close of the nineteenth century.

In addition to silver made in New Orleans, the collection includes many pieces made elsewhere for patrons in Louisiana. Among them, the seven-piece coffee and tea service made in c. 1850–52 (fig. 59) by Tiffany, Young and Ellis of New York City (which became Tiffany & Co. in 1853) for Dr. and Mrs. William Jones Lyle of Smithfield Plantation in West Baton Rouge Parish, is regarded as one of the finest early Tiffany services ever made. It is but one gem in a key public collection that recognizes New Orleans as an important center for American silversmithing and silver patronage alike.

Newcomb Pottery and Crafts

JESSIE POESCH

60. **Mary Frances Baker**
(American, 1879–1943)
Newcomb Academic Calendar for 1902–3
Woodblock print
Gift of the Friends of LSU MOA, 88.5.1

61. **Mary Given Sheerer**
(American, 1865–1954)
Chamberstick, 1903
High glaze on buff clay body
Gift of the Friends of LSU MOA, 88.10.1

The woodcut cover of the 1902–03 *Newcomb College Calendar* (fig. 60) shows two young women shaking hands; one woman wears an academic robe and holds a book while the other wears an artist's smock and holds an artist's palette. The image illustrates the kind of institution that Josephine Louise Newcomb wished to create when she endowed a women's college as a coordinate unit of Tulane University, New Orleans, in 1886 to 1887. She wanted to provide young women with academic instruction and to have them study "practical and industrial subjects," as well.[1] The Newcomb College program should unite the educational ideals of "Vassar and Smith on one side and Pratt and Drexel on the other."[2]

It was within this context that Ellsworth Woodward (1861–1939) (fig. 28), who was made head of the art department of the new institution in 1886, conceived the quasi-commercial enterprise of Newcomb Pottery and Crafts in 1894/95. Initially he established an art curriculum that included mechanical or industrial drawing, as well as classical drawing, painting, and design. The small original faculty of twelve included two instructors in drawing and painting. Despite his concern for balanced instruction, by 1893 Woodward began to feel that the only professional opportunity open to the young women he was training would be teaching. If there were an art pottery, though, graduates might find creative employment. Woodward had been among the first group of students trained at the then new Rhode Island School of Design, and he was inspired by the ideas taught there. The school was founded on the principles of the art reform movements in England: to provide beautiful objects for everyday use in homes through the reassertion of handcraft (thus raising the level of design above that of the mechanical reproduction that came with the Industrial Revolution), and to provide workers with the opportunity to be engaged in the entire process of creating an object. "Fine arts" and "industrial arts" were seen as intimately related.

With these Arts and Crafts ideals in mind, Newcomb College supported the experiment of a "model industry" to create pottery. In 1894, Mary Given Sheerer (1865–1954) (fig. 61), who had trained at the Art Academy of Cincinnati (another

64. **Anonymous**, decorator, probably Louise Wood (American, 1874–1919) or Katherine Kopman (American, 1870–1950); **Anonymous**, potter
Plate, c. 1896–97
High glaze on buff clay body
Gift of the Friends of the LSU MOA, 93.8

62. **Joseph Fortune Meyer**
(Franco-American, 1848–1931)
Left: Experimental bowl, c. 1925, semi-matte glaze on buff clay body, 95.31.7
Center: Mug, c. 1895–1910, high glaze on white clay body, 95.31.2
Right: Experimental bowl, c. 1910–27, high and matte glaze on buff clay body, 95.31.3
Gifts of Dr. A. Brooks Cronan Jr. and Diana Cronan

63. **Joseph Fortune Meyer**
(Franco-American, 1848–1931)
Left: Ali Baba jar, c. 1900–20, matte glaze on buff clay body, 96.36.2
Center: Experimental vase, c. 1900, matte glaze on buff clay body, 95.31.9
Right: Experimental vase, Olla shape, c. 1915–27, matte glaze on buff clay body, 95.31.5
Gifts of Dr. A. Brooks Cronan Jr. and Diana Cronan

institution based on Arts and Crafts principles) and at the Art Students League of New York, joined the faculty to teach pottery design and china painting. The experimental program had begun. The students were responsible for the choice of shapes and for the decoration of their pottery. The heavy, dirty work – lifting sacks of clay, preparing clay, and turning forms on the wheel – was considered inappropriate for women, so a professional potter was employed for these tasks. Joseph Meyer (1848–1931) (figs. 62, 63), who had learned the trade from his father, helped to build the kilns for the new program. When the college launched the program, they employed a skilled French potter. After his death in 1897, Meyer became responsible for the dirty work, and also created and experimented with glazes. He worked at Newcomb Pottery and Crafts from 1897 to 1927, during its years of national acclaim.

The first exhibitions of Newcomb pottery were held in New Orleans in June and November 1896. Local newspapers gave them front-page attention, praising the quality of the work, the new opportunities for "art design and decorative work" suitable for "the gentler sex," and the "vigorous beginning of an industry."[3] In 1898, the students began to send collections to the newly founded Arts and Crafts Societies in Boston and Chicago. It was a going concern.

From the beginning of Newcomb Pottery and Crafts, certain principles were established. Shapes would be traditional. Decoration of each object would be

65. **Gertrude Roberts Smith**
(American, 1869–1962), decorator;
Joseph Fortune Meyer
(Franco-American, 1848–1931),
potter
Pitcher, 1904
High glaze on clay body
Gift of the Friends of LSU MOA,
82.26

66. **Irene Borden Keep**
(American, b. 1876), decorator;
Joseph Fortune Meyer
(Franco-American, 1848–1931),
potter
Vase, 1904
High glaze on buff clay body
Gift of the Friends of LSU MOA,
84.14

unique: no two pieces were to be alike. All decoration would be based on the familiar environment, mostly the flora and fauna of the region. After initial experiments, the students arrived at consistent procedures. Underglaze painting was covered with a glossy glaze, designs were repeated all around the vessel, and cobalt blue and sage green were the favored colors. An excellent example of work created in the early phase is an 1896 plate (fig. 64), attributed to Louise Wood (1874–1919) or Katherine Kopman (1870–1950).[4] It has a repeated border design of cicadas, fairly realistically rendered, against a blue background. The center of the plate is clearly distinguished, with lilies of the valley depicted against a sage green background.

Kopman, who graduated in 1895, was a member of the first pottery decorating class. She continued her career at Newcomb, first as a graduate student, then as an instructor in drawing, from 1898 to 1905, and 1907 to 1913. Another designer of note, Mary Frances Baker (1879–1943), creator of the aforementioned 1902–03 Newcomb College Calendar, was a special art student; such students were free to select their own programs but did not receive a degree. She was a pottery designer from 1905 to 1906, then went on to an active career in the arts in New Orleans, where she exhibited her work from time to time, designed Mardi Gras floats, and taught in the public schools. Kopman and Baker were examples of young women who began their careers as Newcomb designers, and then continued to work as practicing artists.

Newcomb had no plans to exhibit work at the 1900 Paris Exposition Universelle, but at the last minute the students were asked by colleagues in the National League of Mineral Painters, headed by Milwaukee art potter Susan Stuart Frackleton (1847–1932), to send a collection. To their surprise and pleasure, the young women won a bronze medal, and the news was trumpeted on the front page of a local newspaper. Increasing success and publicity followed. The students won medals at eight major expositions in the United States, and their pottery was sold through agents from California to Virginia, from New Hampshire to Texas.

Mary Sheerer and Gertrude Roberts Smith (1869–1962) were the two art instructors, teaching drawing and painting, in the first Newcomb faculty. Both women occasionally designed pottery, probably to test out suggestions for the designers. Smith was educated at the Massachusetts Normal School, an institution fostering new ideas in art education. An example of her work is a pitcher from c. 1904 (fig. 65) with a sinuous abstract design based on the cross-section of a plant. Along with a 1904 vase with a tall Louisiana iris motif (fig. 66) by Irene Borden Keep (b. 1876), who graduated from Newcomb in 1898, Smith's work demonstrates a popular trend at Newcomb during this period: creating designs based on the natural environment, as suggested by many of the English Arts and Crafts design books the students used to generate ideas. The resources the young women consulted are still held in the Tulane University Library.

In 1902, under Smith's direction, embroidery was introduced as another Newcomb craft. Rather than using embroidery stitches favored by craft workers elsewhere (such as satin stitch with couching, buttonhole and stem stitches, and French knots), the Newcomb pieces used darning or running stitches almost exclusively. Stitches ran parallel with the grain of the fabric, whether the warp or weft. Colored threads were juxtaposed in parallel lines, creating tonal variations and subtle, illusionistic designs. A rare collection of three items – a watercolor design of a grove of trees scene on onion skin (fig. 67), a template used to guide the embroiderer in placing the design on the fabric (fig. 68), and the finished table-runner (fig. 69) – all created by Pauline Wright Irby Nichols (1879–1983) around 1916, illustrates the steps taken in achieving an embroidered piece.

67. **Pauline Wright Irby Nichols**
(American, 1879–1983)
Watercolor design for table runner,
c. 1916,
Watercolor on onion skin
Gift of Mrs. Nina Nichols Pugh, 84.2.2 a

68. **Pauline Wright Irby Nichols**
(American, 1879–1983)
Template for table runner, c. 1916
Paper
Gift of Mrs. Nina Nichols Pugh, 84.2.2 b

69. **Pauline Wright Irby Nichols**
(American, 1879–1983)
Table runner, c. 1916
Beige linen and green, red, and purple embroidery floss
Gift of Mrs. Nina Nichols Pugh, 84.2.1

70. **Marie Levering Benson**
(American, active at Newcomb College 1904–1908), decorator; Joseph Fortune Meyer (Franco-American, 1848–1931), potter
Plate, 1907
High glaze on buff clay body
Gift of Mr. D. Benjamin Kleinpeter, 97.12.3

71. **Henrietta Davidson Bailey**
(American, 1874–1950), decorator; Joseph Fortune Meyer (Franco-American, 1848–1931), potter
Three-handled mug, c. 1907
High glaze on buff clay body
Gift of Dr. A. Brooks Cronan Jr. and Diana Cronan, 86.8

In most of the early pieces of Newcomb pottery, the designers suggested a shape, and the potter turned the pot on the wheel and fired it for the first time. The designer applied the colored underglaze painting to the bisque, and the final firing was done by the potter. Sometime around 1901, the designers began to incise lines of the design on the leather-hard clay before the first firing, thus becoming more fully involved in the creation of the pieces. A plate by Marie Levering Benson (dates unknown), featuring boldly incised outlines of crawfish (fig. 70), provides an excellent example of this process. Benson was a special art student and pottery worker at Newcomb from 1904 to 1908. In 1906 she attended the Ipswich Summer School of Art, Massachusetts, headed by Arthur Wesley Dow (1857–1922). There, students worked on design problems as defined in Dow's influential book, *Composition*.[5] They made bold line drawings, adjusted compositions to different spaces, studied color and tonal relationships, and experimented with various materials. Students from

across the country participated, often forming friendships and making contacts that they maintained throughout their careers. Benson was one of seven Newcomb students who attended the Ipswich Summer School on scholarships in the years 1900 to 1906. Several students attended two or three times.

The Newcomb designers were wonderfully imaginative in creating new designs while staying within the broad guidelines that made Newcomb recognizable. "Spanish Dagger" or yucca plant served as the point of departure for an intricately patterned design on a three-handled cup from c. 1907 (fig. 71), designed by Henrietta Davidson Bailey (1874–1950). In a color combination often favored in the period 1907 to 1910, yellows are used to complement the blues and greens throughout. The design's dense linear patterns are also typical of this era.

Along with Bailey (who graduated in 1903), Anna Frances Connor Simpson (1880–1930) and Sarah Agnes Estelle (Sadie) Irvine (1887–1970) (both of whom graduated in 1906) were three of the pioneer generation of designers who devoted virtually their entire artistic careers to Newcomb College; they were pottery designers, printmakers, and teachers in the art department. Simpson's 1918 bowl (fig. 73) and Irvine's 1922 vase (fig. 72), as well as a number of other excellent pieces in the museum collection, demonstrate how the characteristic appearance of Newcomb Pottery changed somewhat after a new matte glaze was introduced in 1910. Softer designs and colors, and motifs carved in low relief (rather than sharply incised lines) became popular. Variations of scenic designs, such as moss-laden trees with a moon peeping from behind, were increasingly favored.

The metalwork and jewelry program, begun in 1901, was modest at first but flourished after 1911. Flatware, hollowware, jewelry, and various objects such as mailboxes and doorbell surrounds were created, many of them modern in feeling. Metalwork designs adhered to natural motifs typical of the Newcomb pottery designs. An elegant pair of copper bookends from c. 1918–22 (fig. 74) depicts a stand of trees in a repeated screen pattern, illustrating the creative translation of the

72. **Sarah Agnes Estelle (Sadie) Irvine**
(American, 1887–1970), decorator; Joseph Fortune Meyer (Franco-American, 1848–1931), potter
Vase, 1922
Matte glaze on clay body
Gift of the Friends of LSU MOA, 83.28.1

73. **Anna Frances Connor Simpson**
(American, 1880–1930), decorator; Joseph Fortune Meyer (Franco-American, 1848–1931), potter
Bowl, 1918
Matte glaze on buff clay body
Gift of the Friends of LSU MOA, 88.34

REFERENCES

Ayres, Dianne, et al. *American Arts and Crafts Textiles*. New York: Harry N. Abrams, 2002.

Bragg, Jean Moore, and Susan Saward. *The Newcomb Style: Newcomb College Arts Crafts and Art Pottery, A Collector's Guide*. New Orleans: Jean Bragg Gallery, 2002.

Newcomb College. *Arts & Crafts Sales Exhibition*. New Orleans: Jean Bragg Gallery, 1998.

Ormond, Suzanne and Mary E. Irvine. *Louisiana's Art Nouveau: The Crafts of the Newcomb Style*. Gretna, LA: Pelican, 1978.

Poesch, Jessie, "Arthur Wesley Dow and Art Pottery: The Beauty of Simplicity," in Nancy Green and Jessie Poesch, *Arthur Wesley Dow and American Arts & Crafts*. New York: American Federation of the Arts, 1999: 108–68.

Poesch, Jessie, with Sally Main. *Newcomb Pottery & Crafts, An Educational Enterprise for Women, 1895–1940*. Atglen, PA: Schiffer, 2003.

Poesch, Jessie, with Sally Main and Walter Bob. *Newcomb Pottery, An Enterprise for Southern Women, 1895–1940*. Atglen, PA: Smithsonian Institution, 1984.

———. "The Art Program at Newcomb College and the Newcomb Pottery, 1886–1940," in *Southern Arts and Crafts 1890–1940*. Charlotte, NC: Mint Museum of Art, 1996: 63–71.

74. **Anonymous**
 Bookends, c. 1918–22
 Copper
 Gift of Mr. and Mrs James Flores and Mrs. Paula Garvey Manship, 98.18 a-b

Newcomb style into diverse media. Bookbinding was introduced to the program in 1913.

During the forty-five-year existence of the Newcomb Pottery and Craft program, new opportunities for careers in the arts opened to young women. One hundred or so women earned all or part of their income from the program, with two-thirds of them active before 1918. As a number of women began their careers at Newcomb, they provided a vision and an example of the role women could play in the arts.

The Arts and Crafts movement began to wane after 1915; several potteries, such as Grueby in New England, closed. The Newcomb Pottery and Crafts program weathered the Great Depression, but was finally terminated in 1940. Always under the umbrella of the college, it was never truly a "model industry." Still, as an enterprise, the Newcomb program successfully created many attractive objects of high artistic standard, and the Louisiana State University Museum of Art holds an excellent and representative collection.

NOTES

1. Anon. "President Dixon Talks of Newcomb," *New Orleans Picayune*, April 10, 1901.

2. Ibid.

3. Anon. "Practical Art Education for Woman," *New Orleans Picayune*, June 8, 1896.

4. The LSU Museum of Art purchased this plate, which has no visible decorator's mark, from an auction house that acquired it from the heirs of Newcomb artist Ada Wilt Lonnegan (1879–1963), and so attributed it to her. Since Newcomb artists frequently exchanged their works, the plate's provenance does not ensure its attribution to Lonnegan. In an article by Ellsworth Woodward in *Art Education* (May 1898): 166–8, this plate is illustrated and Katherine Kopman is identified as the decorator. On the same page, another plate, now owned by Newcomb College, is pictured; the decorator is identified as Louise Wood. The latter plate clearly has the "KK" cipher of Katherine Kopman on the back. Therefore, it seems probable that Woodward, or the publishers, made an error by mixing up the identities of each plate's designer. Louise Wood is probably the designer of the plate owned by the LSU Museum of Art. The LSU plate is illustrated in an article by Mary Sheerer in *Keramic Studio 1* (1899): 151–52, but the name of the designer is not noted.

5. Dow's ideas and theories were published in his 1899 book, *Composition: A Series of Exercises in Art Structure for the Use of Students and Teachers*, which was reissued in 1913 and reprinted several times over the next forty years. Through it, Dow influenced generations of American art teachers and students in the twentieth century.

Passionate Collectors, Generous Donors: A Global Scope

PART | FOUR

It was with great joy that I learned of your decision to broaden the scope of the museum to include, not just Anglo-American art, but world art as well....
This is what J. Lucille Evans hoped would come to pass....
[In her will, Lucille's] description of the new museum and her desire that her donation be used for that facility is clearly indicated. (There was no place for her collection in the Anglo-American Art museum.)

Correspondence from Henry J. Hasselberg, Las Cruces, New Mexico, to LSU Museum of Art, June 30, 1998 (LSU Museum of Art archives)

The Dr. James R. and Ann A. Peltier Collection of Chinese Jade

HELEN DELACRETAZ

Jade has played a significant role in China's artistic and cultural heritage. Venerated since pre-historic times, it has been carved into sacred objects, offered as celebrated gifts, and worn as coveted decorations. Valued by emperors more highly than gold or silver,[1] collected by scholars for its moral connotations, and cherished by rich and poor alike, this precious stone claims a devoted and unwavering audience.[2]

Excavations of ancient tomb sites have revealed the Chinese elite's early preference for jade. Fashioned into specific shapes, jade burial objects carry complex associations with spirit-gods, and the proximity of jade objects to the deceased's body within the tomb attests to their use in Neolithic ceremonial and religious customs. Thought to yield protective powers for the deceased's journey to and participation in the afterlife, the jades were placed at precise locations around the body. One such object, the *bi* (disc) was commonly laid on the chest.[3] At a few excavation sites, spectacular full-length jade burial suits have been found.[4]

Ceremonial burials had largely ceased by the second century CE, but jade ritual objects continued to be carved and assumed more decorative and intellectual functions. In the Louisiana State University Museum of Art collection, the Peltier *bi*, dating from the Early Ming dynasty (14th–15th c.) (fig. 76), exemplifies this ongoing tradition. The surface decoration of the *bi* – three dynamic dragons – follows the style of the much earlier Han dynasty (202 BCE–220 CE). Reference to earlier periods through archaism (the replication of ancient forms) is common in later Chinese art; it allowed artists and patrons to pay reverence to earlier traditions and display their knowledge of the arts.

In China, arts play many roles, and many key features of an art form such as jade can be discussed – the dynastic origin of a given piece, the type of jade stone used, the method of carving, the subject matter represented, and the object's function. The Peltier jades represent three major functions of Chinese art – religious, decorative, and intellectual – and many of them serve more than one at once. As such, they lend themselves to observations specifically on this theme.

In China, three religions have coexisted for centuries – Confucianism and Daoism since the sixth century BCE, and Buddhism since the third century CE – and they are woven deeply into the country's cultural fabric. Just as a person may practice all three religions at once, so may one jade exhibit traits that relate to two

page 105

75. **Maudie Rachel Okittuq** (b. 1944)
Taloyoak, Nunavut
Spirit, 1990
Black/gray stone
Gift of Arnold Aubert Vernon, 98.17.2

page 107

76. Archaistic (*fanguu*) *bi* disc
Early Ming, 14th–15th century
Nephrite with wood stand
Gift of Dr. James R. and Ann A. Peltier, 2002.17.9

77. Vase with grouping of three boys
Late Qing dynasty to early Republic,
c. 1875–1925
Jadeite
Gift of Dr. James R. and Ann A. Peltier,
2002.17.6

78. Imperial dragon-headed
rhyton with nine *qilong*
(immature dragons)
Qing dynasty, Qianlong reign, 1735–95
Nephrite
Gift of Dr. James R. and Ann A. Peltier,
2003.9.4

or even all three faiths.

Most of the jades in Peltier collection date from the Qing dynasty (1644–1911), a period of prolific and high quality carving.[5] Five of these can be understood within the context of Buddhism. An exemplary piece depicts Shakyamuni (Qing dynasty, late 18th–early 19th c.), the historical Buddha.[6] The depiction of the Buddha with distinctly non-Chinese features points to awareness of the Buddha's Southeast Asian origins. He is represented here as a wandering holy man who has renounced his princely past to search for divine truth. In his pose of deep contemplation, the Buddha may be experiencing the moment of enlightenment, when he fully understands universal truths. The skillful carving of the jade not only brings physical likeness to the subject, but also draws a sense of peace and compassion from the hard, unyielding stone.[7]

With its delicate openwork passages and complex poses, the carving of Pusa Wenshu in command of his lion[8] (Late Qing dynasty, c. 1875–1910) stands as another fine example of masterful work in jade. While the lion gazes at his rider, Pusa Wenshu holds his elegant, attenuated hands in *dharmachakra mudra*, the position that designates teaching and setting the Wheel of the Law in motion. The stylization in this piece is similar to that in the carving known as the *Buddha's Hand (citron)* (Qing dynasty, late 18th–early 19th c.), which takes its name from the organic tendrils characteristic of this fruit, and was likely used as a paperweight on a scholar's desk. Associations with Buddhism can also be seen in the covered box carved in the form of a honking goose seated on an openwork lotus flower (Qing dynasty, second half of the 18th c.). The lotus is one of the eight auspicious symbols of the Buddha, for like the Buddha, it rises out of the muck and mire of everyday existence, yet unfolds pure and unsullied.

The impressive double-tiered incense burner (Qing dynasty, Qianlong reign, late 19th c.) also bears Buddhist symbolism in the *baoxianghua* motif, or Buddha's rose, an openwork leaf-and-flower design. It carries Daoist associations, as well. The somewhat conical form of the incense burner, combined with the plumes of smoke it would emit, evokes ideas of the mist-shrouded mountains characteristic of China's landscape. In China, mountains are considered to be highly spiritual places, especially by followers of Daoism, one of the world's oldest philosophical traditions. Seekers of the Dao – the universal principle that transcends all things – see the mountains as microcosms of the universe and key receptacles of cosmic energy, or *qi*. The

mountains are where one can commune with nature, explore grottos believed to be gateways to paradise, contemplate the mysteries of the universe, and search for herbs and minerals, such as the lingzhi fungus used to make the elixir of immortality. Daoist symbolism may be seen in several Peltier jades, including the mountain (Qing dynasty, 18th c.), which depicts an evocative rocky landscape, the *bitong* (brush holder) (Qing dynasty, Qianlong reign, 1750–1800), whose equally idyllic scene is complete with viewing pavilions for recluses and scholars to use, and the *rhyton* (vessel) (Qing dynasty, Qianlong reign, 1735–95) (fig. 78), decorated with nine auspicious *qilong*, or immature dragons. The *rhyton* is associated with Daoism in its ritual function as the vessel from which the elixir of immortality is consumed. The Peltier *rhyton* is of excellent quality and in pristine condition, and its provenance can be traced from Emperor Qianlong (1736–95) to the Palace Collection (1912–19). Inscribed on the *ryhton* is a saying related to the veneration of sons: "Equal to the times dragons penetrate the depths of Heaven and Earth, may generations of sons and grandsons use and cherish this cup for myriads of ages."

Sentiments surrounding male offspring are expressed symbolically in several other jades from the Peltier collection. China has a historical preference for male children that stems from its ancient filial tradition, and symbols and themes expressing wishes for sons are popular in Chinese art. These can be seen in the openwork jade carving of two boys climbing rocks that support two vases and flowering plants (Late Qing dynasty–early Republic, c. 1875–1925) (fig. 77), and in the hundred boys motif carved on the rhinoceros horn libation cup (Late Qing dynasty, last quarter of the 19th c.). A male child is also used as a metaphor in the jade pillow (Qing dynasty, Qianlong reign, 1736–1795). The form of a crouching boy symbolizes fertility and the birth of sons; the pillow would have made an appropriate gift for a newly wed couple. Because of its ability to reproduce prolifically, the grasshopper is also connected to ideas of fertility.[9] The *Cabbage (baicai) with Grasshopper* (Late Qing dynasty, mid-19th c.) (fig. 79) is a composition similar to a famed jade carving in Taiwan's National Palace Museum. The insect is combined with a vegetable that represents both solidity and simplicity.

Wishes for longevity, good fortune, and wealth are also conveyed symbolically in jade. The carvings in the Peltier collection are rich with auspicious imagery, and they would likely have been offered as gifts bestowing good wishes upon the recipient. The aesthetic qualities of these jades are as important as their symbolic function; their decorative aspects are emphasized because they were usually intended for prominent display. Wishes for longevity are expressed through references to immortality, especially the lingzhi fungus, which figures in many of the Peltier jades, including the wedding bowl (Qing dynasty, Qianlong reign, c. 1750–1800) (fig. 80), the *ruyi* (scepter) (Late Qing dynasty, 19th c.) (fig. 81), the *gu* beaker vessel (Ming dynasty, late 16th–early 17th c.), and *meiren* (court beauty) (Late Qing dynasty, late

79. Cabbage (*baicai*) with grasshopper
Late Qing dynasty, mid-19th century
Nephrite
Gift of Dr. James R. and Ann A. Peltier, 2003.9.3

19th c.–early 20th c.). Phoenixes (dates unknown) (figs. 82, 83) are yet another symbol of immortality and, as emblems of feminine qualities, are associated specifically with the empress.

Themes of wealth and abundance are conveyed in several Peltier jades through the symbolism of the toad (Qing dynasty, 18th c.),[10] the stag (Qing dynasty, c. 1750–1800) (fig. 84),[11] and the boar (Han dynasty, 206 BCE–220 CE). The latter carving may have functioned as a burial piece; its presence in the tomb would have conveyed the wish for the deceased's financial security in the afterlife.[12]

Several pieces in the collection feature dragons, a perennially favorite subject in Chinese art. The dragon is associated with the emperor and his position as Son of Heaven, and functions as a symbol of male power and fertility. Its innate vigor and strength is conveyed in the Peltier jades by depictions of great dynamism and energy. This imperial symbol appears in several pieces, including the *bi* and the *rhyton* (figs. 76, 78), and two other archaistic ritual vessels: the *yong* (bowl) (Ming dynasty, 16th–17th c.) and the *gu* beaker vessel. The *yong* features five charged dragons encircling the bowl in pursuit of the flaming pearl of knowledge. The beaker vessel shows a single dragon rising from crashing waves, lingzhi fungus, and stylized rocks to coil itself around the vessel, creating a sense of energy swirling up the form and exploding at its flared rim.

Other animal-themed pieces in the collection also function symbolically. The water buffalo (Ming dynasty, 1368–1644) is associated with agricultural rites and the coming of spring. The elephant (Qing dynasty, c. 1750–1800) is prized for its strength, astuteness, and high moral standards. The horse (Qing dynasty, c. late 19th–early 20th c.) is admired for its strength and speed.

Observing the many symbolic references in the Peltier jades reveals how complex and widespread symbolism is in Chinese art. The recipient of a jade gift would recognize its expression of goodwill and admire its aesthetic and metaphorical qualities alike. The spectacular wedding bowl (fig. 80) is an excellent example of how a gift could convey wishes for prosperity, wealth, and long life. The quality of carving in the delicate details and the use of the stone's coloration within the design are fitting to this jade's association with Emperor Qianlong. The stylized lingzhi fungus forming the feet of the bowl, the bats symbolizing good fortune and happiness, and the calligraphic character for longevity create an excellent wedding gift.

The *ruyi* (fig. 81), a ceremonial scepter presented by the emperor or other high-ranking nobles as a sign of imperial favor, also bears multiple layers of meaning. While the lingzhi fungus, bats, and peach express wishes for longevity, happiness, and wealth respectively, the bamboo, used as a Confucian metaphor, symbolizes the recipient's upright character and high moral principles; bamboo is admired for its ability to move and sway in the breeze, yet never bend or yield.

Confucianism emphasizes the importance of propriety, virtuous behavior, filial

80. Wedding bowl on *rui*-shaped feet
Qing dynasty, Qianlong reign,
c. 1750–1800
Nephrite
Gift of Dr. James R. and Ann A. Peltier,
2002.17.5

81. *Ruyi* (scepter) as emblem of rank
Late Qing dynasty, 19th century
Nephrite, modern silk tassel and cord
Gift of Dr. James R. and Ann A. Peltier,
2002.17.7

piety, diligence, and the unwavering loyalty of the scholar official. The highest achievement for a Confucian was to secure an official post at court, which reflected not only on oneself but also on one's entire family. Men who passed the rigorous tests required to gain the coveted placements were known as scholar officials or literati, and they spent the majority of their lives at court, immersed in the bustle of large cities and acting as loyal servants to the emperor.

Despite the literati's ties to life in the urban court, most Confucian scholars also yearned to commune with nature and follow the Dao. Their combined faith was reflected in the many jade implements they kept on their desks – tools for calligraphy (holders, handles, and washers for brushes, ink stones, scroll weights, water cups, and wrist rests), and paperweights, seals, and miniature screens. The Peltier *bitong* and mountain represent natural scenery, a typical subject for the scholar's jades, reflecting Confucian principles of social order and the hierarchy of emperors, noblemen, and court officials,[13] as well as the Daoist belief that nature holds powerful concentrations of cosmic energy. By bringing the universe in microcosm to their court-bound lives, the literati allowed themselves to mentally celebrate and explore nature, and thus practice Daoism, without compromising their moral duties to the emperor. Like other jades, the phoenix paperweights (figs. 82, 83) that would have been used on a scholar's desk carry multiple meanings. In addition to symbolizing longevity, phoenixes also represent the Confucian values known as the Five Human Qualities: Virtue, Duty, Correct Behavior, Humanity, and Reliability.[14] Celebrating these values embodied in the jade stone itself, the Han dynasty scholar Xu Shen wrote in his dictionary, the *Shuowen Jieze*, that:

Jade is the fairest of stones. It is endowed with five virtues. Charity is typified by its lustre, bright yet warm; rectitude by its translucency, revealing the color and markings within; wisdom by the purity and penetrating quality of its note when the stone is struck; courage, in that it may be broken but cannot be bent; equity, in that it has sharp angles, which yet injure none.[15]

The Peltier collection includes many Qing jades, especially from Qianlong's reign. Jade's virtue held much appeal for Emperor Qianlong, who made a significant contribution to the development of jade carving and remains the greatest patron and collector of jade in Chinese history. Under his rule, the art form reached its pinnacle of technical perfection. Qianlong exercised his imperial power to take control of all aspects of jade carving, from the collection of raw material to the design and realization of the final product. He alone had the sole right to collect jade, and those who risked illicit trading faced the penalty of death. As well as being a great patron of the arts, Qianlong was also a respected calligrapher and poet. He expressed his reverence for jade in nearly 800 poems he composed to glorify the stone, and his writings were

often inscribed on the jade pieces that inspired him. In the Peltier collection, the superiority of jade carving under Qianlong is clearly seen in the Shakyamuni Buddha, *bitong*, *rhyton* (fig. 78), and jade pillow.

Today, jade continues to be celebrated for its beauty and respected for its virtue. Dr. and Mrs. Peltier have given the museum an exquisite collection, sharing their own passion for jade and expressing the goodwill inherent in any jade gift. As Qianlong wrote in 1769:

A jade bred from a block of stone,
As if polished by superb craftsmanship;
Inside it may store up the dew of a thousand years
With pungent fragrance of early spring;
And with such unpredictable veining
Like clouds to be believed as carrying divine spirits.[16]

82. Group of two birds
 Qing dynasty, 18th century
 Nephrite
 Gift of Dr. James R. and Ann A. Peltier,
 2002.17.1

83. Group of two phoenixes
 Qing dynasty, 18th century
 Nephrite
 Gift of Dr. James R. and Ann A. Peltier,
 2002.17.2

84. Recumbent stag
 Qing dynasty, c.1750–1800
 Nephrite
 Gift of Dr. James R. and Ann A. Peltier,
 2002.17.11

NOTES

1. As described by Barry Till and Paula Swart, "The Chinese Love of Jade," in *Jade, The Ultimate Treasure of Ancient China* (Toronto: Canadian Foundation for the Preservation of Chinese Cultural and Historical Treasures, 2000): 23.

2. As an indicator of the importance of jade to Chinese culture, the character "jade" is used as the radical in over 200 Chinese words, especially those describing beauty and goodness (for example, precious, brilliant, lucky, extraordinary, excellent, and king). A "jade rainbow" is a curved bridge. "Jade food" is delicious cuisine. "Jade essence" is fine wine. A "jade face" is a handsome face. A "jade expression" is beautiful looks and the highest praise. Fan Shimin, "Foreword," in *Jade, The Ultimate Treasure of Ancient China*: xix; and Till and Swart: 23.

3. The *bi*, which Jade scholars associate with the round dome of heaven, was paired at burial with the *cong* (square tube), which was associated with concepts surrounding earth and placed beneath the body of the deceased.

4. Until the first well-preserved jade suits were discovered in Hebei province in 1968, they were known only through writings from the Han dynasty. The jade suits of Prince Liu Sheng of Zhongshan (d. 113 BCE) and his consort Dou Wan (dates unknown) are made of thousands of jade plaques sewn together with gold, silver, and bronze wire. Since their discovery, more than twelve other suits have been found.

5. By the rise of the Qing dynasty, ownership of jades was more widespread and no longer solely within the domain of the elite. As a result, workshop production increased dramatically. Strong imperial patronage also led to the development of larger, better supported workshops, which in turn instilled innovation and new vigor in the art form.

6. As Buddhism developed and spread across Asia, different interpretations of the religion arose. One, Mahayana or "Greater Vehicle," incorporated a pantheon of Buddhas and other associated enlightened beings, one of which is Shakyamuni, the historical Buddha. Shakyamuni is an honorific title meaning "wise man of the Shakya clan," in deference to the historical Buddha's origins as Siddhartha Guatama, an Aryan prince born to the Shakya clan in Nepal near the Indian border.

7. Jade is not so much carved as it is ground away with abrasives. In ancient China, abrasives were mixed with water (and later, oils), then used with wood, bone, bamboo, and stone tools (and later, bronze and iron) to cut, saw, carve, incise, and drill jade. In the twentieth century, artificial carborundum and power tools came into use. Jade is harder than steel, so steel tools cannot be used to cut it. Till and Swart: 24.

8. Located within the Mahayana tradition, Pusa Wenshu is also known as the Bodhisattva Manjusri, the Bodhisattva of Wisdom. Bodhisattvas are enlightened beings who delay their liberation to remain on earth and give aid to others who seek their own enlightenment.

9. Sue's Gemstone World. Jade, The Symbol of Nobility and Honor: <http://www.suevematsu.com/jade.htm>; and Xing-Bao Jin. Chinese Cricket Culture. Insects.org: <http://www.insects.org/ced3/chinese_crcul.hrml> (October 30, 2004).

10. The toad was also known to neutralize evil.

11. The Chinese character for "deer" is a homonym for a Chinese official's salary.

12. The placement of a jade pig in the deceased's hands symbolized the deceased taking wealth accumulated in life to the afterlife. Yun Xizheng, "Jade: Ever Exquisite, Ever Sublime," in *Jade, The Ultimate Treasure of Ancient China* (Toronto: Canadian Foundation for the Preservation of Chinese Cultural and Historical Treasures, 2000): 7.

13. In *The Lofty Message of Forests and Streams*, the Song dynasty court artist Guo Xi declared, "A great mountain is dominating as chief over the assembled hills, thereby ranking in an ordered arrangement the ridges and peaks, forests and valleys as suzerains [feudal lords] of varying degrees and distances. The general appearance is of a great lord glorious on his thrones and a hundred princes hastening to pay him court, without any effect of arrogance or withdrawal [on either part]. A tall pine stands erect as the mark of all other trees, thereby ranking in an ordered arrangement the subsidiary trees and plants as numerous admiring assistants. The general effect is of a nobleman dazzling in his prime with all lesser mortals in his service, without insolent or oppressed attitudes." Susan Bush and Hsio-yen Shih, eds., *Early Chinese Texts on Painting* (Cambridge, MA and London: Harvard University Press, 1985): 153.

14. Asian Art Mall. Symbolism. <http://www.asianartmall.com/refsymbols.htm> (October 22, 2004).

15. Cited by Till and Swart: 23.

16. A Qianlong poem inscribed on a jade water trough. Artworld. Object Catalogue. Jade Water Trough with Two Dragons. <http://www.artworld.uea.ac.uk/objects /352/images/2391/details.htm> (October 22, 2004).

The Arnold Aubert Vernon Collection of Inuit Art

INGO HESSEL

What we show in our carvings is the life we have lived in the past right up to now. We show the truth.[1]

PAULOSIE KASADLUAK, 1977

Some 5,000 years ago an intrepid band of Siberians island-hopped across the Bering Strait in small boats, settling along the northern coast of Alaska.[2] From there, successive waves of their descendants quickly spread eastward across the Canadian Arctic to Greenland.[3] The last group to colonize Arctic Canada were the Thule (c. 1000–1700 CE), an organized and prosperous whaling people. Based on Alaskan traditions, Thule art consisted primarily of the graphic embellishment of tools and hunting implements, rather than the creation of sculpture. The Little Ice Age of 1600–1850 caused the early or permanent freezing of previously open waters, triggering the development of a smaller-scale, seminomadic hunting economy. As a result, Thule society rapidly disintegrated into a fractured group of regionally distinct tribal cultures. These were the peoples European explorers called "Eskimos." Canadians now use the term Inuit, which means "the people" in the Inuit language, Inuktitut.

Faced with the harsh Arctic environment and chronic shortages of game, Inuit were obliged to live in small family groups or bands. In spring and summer they traveled to various fishing and caribou hunting grounds, living in animal skin tents. In autumn they caught fish in stone weirs and cached meat and fish for the long winter to come. In winter they built snowhouses on the sea ice and hunted marine mammals. Almost all aspects of Inuit material and technological culture – clothing, transportation, shelter, and tools – were derived from animals. Stone, driftwood, and even ice and snow were supplements.

To foster the community cohesiveness crucial to survival, Inuit developed social practices such as arranged marriages, spouse sharing, adoption, ritual partnerships,

85. **Luke Anowtalik** (b. 1932)
Arviat, Nunavut
Bird Sitting on an Igloo, c. 1970s
Black stone
Gift of Arnold Aubert Vernon, 2002.18.14

86. **Lucy Elijassiapik** (dates unknown)
Puvirnituq, Nunavik
Mother and Child, late 1950s or early 1960s
Black stone
Gift of Arnold Aubert Vernon, 2002.18.3

87. **Tukai** (1888–1979)
Inukjuak, Nunavik
Man with Seal, early 1950s
Black stone
Gift of Arnold Aubert Vernon,
2002.18.19

and dispute resolution mechanisms. To deal with seemingly uncontrollable natural forces, they practiced a form of nature worship in which powerful deities and good and evil spirits required constant appeasement. Taboos were strictly enforced, and powerful shamans (medicine men and women) acted as intermediaries, seers, and healers. Each person also counted on animal helping spirits and amulets for protection.[4]

Sporadic European contact began around 1000 CE with the short-lived Norse settlements, and resumed in the late sixteenth century with European exploration in the Arctic. Sustained contact began two centuries later; by the early nineteenth century, Inuit groups in several parts of the Canadian Arctic were experiencing regular contact with explorers, whalers, fur traders, and Christian missionaries. The influx of trade goods created a growing dependence on non-traditional technology, foods, and commercial activities such as trapping and whaling. It also promoted the creation of trade objects – small models of Inuit lifestyle and technology, human and animal figurines, and European-inspired pieces such as decorated cribbage boards

and miniature rifles. These items, almost always fashioned from ivory, were bartered until the middle of the twentieth century.[5]

Beginning in the early 1950s, the Canadian government further disrupted traditional Inuit lifestyle and social structure by settling Inuit in permanent villages with schools, nursing stations, trading posts, and churches. Arts and crafts production was proposed as one of the few alternatives to living on welfare in the new northern cash economy. Inuit were encouraged to produce carvings, mittens and other clothing, wall hangings, baskets and other items, and later, drawings and prints.[6] Despite its humble, almost dubious beginnings, contemporary Inuit art quickly blossomed into a significant art form, and it has been hailed as one of Canada's chief contributions to the art world.[7]

Working in a time of rapid cultural assimilation, Inuit carvers (even younger artists whose connection to the past is increasingly tenuous) have consciously looked back to an earlier time for subject matter and inspiration. Some artists simply illustrate traditional camp and hunting scenes, the family, or Arctic animals, but others clearly express their personal experiences, sense of identity, values, traditional beliefs, and deep appreciation of the land and its gifts.

Given their ongoing dependence on and respect for animals, it is not surprising that Inuit have chosen wildlife as their favorite subject in art. Birds, bears, muskoxen, whales, walrus, and seals predominate, but fish, dogs, wolves, smaller mammals, and even insects have also inspired carvings. Animals are usually portrayed singly (fig. 85), but they may also appear as prey in hunting scenes, as hunters themselves, or in more enigmatic works that refer to shamanism, legends, or the artist's own imagination (figs. 75, 88). Inuit wildlife art can be highly naturalistic in detail, but rather than focus on anatomical correctness, artists often stylize form to express the personality, strength, or spirit of the animal instead.

Scenes of traditional hunting, camping, and community life are also prevalent, depicting men in their roles as providers of food (fig. 87) and women in their roles as caregivers (fig. 86) and preparers of food and clothing. Highly descriptive in their content, these genre works tend to be somewhat prosaic, providing cultural information rather than artistic insight.

Works that deal with the supernatural aspects of Inuit life, on the other hand, present considerably more ambiguity and mystery. Animal-human transformations are favorite themes, often involving shamans receiving powers from their spirit helpers (fig. 88). The relatively straightforward representation of these events sometimes belies their surreal content. Carvers also give full rein to their imaginations in depicting spirit beings (figs. 75, 89, 90). Benign and malevolent beings alike inhabit

88. **Anilnik Peelaktoak** (b. 1950)
Iqaluit, Nunavut
Shaman/Caribou Transformation,
c. late 1990s–2000
Black stone, caribou antler
Gift of Arnold Aubert Vernon, 2002.15.4

89. **Aqjangajuk Shaa** (b. 1937)
Cape Dorset, Nunavut
Winged Spirit with Two Faces,
c. 1980s
White stone
Gift of Arnold Aubert Vernon, 2003.2.6

90. **Eli Sallualu Qinuajua** (b. 1937)
Puvirnituq, Nunavik
Transforming Spirit, 1978
Black stone
Gift of Arnold Aubert Vernon, 2003.2.2

the spiritual landscape, and they have provided artists with a seemingly limitless variety of visual forms. Creation myths and epic legends derived from generations of oral history are another rich source of imagery.

For obvious reasons of climatic conditions, in Inuit art the human figure is usually shown bundled in heavy clothing (fig. 86). In scenes depicting mothers and young children, the child may be barely noticeable in the mother's voluminous parka hood. Even so, a number of works pay close attention to psychological meanings of the human face and hands, which may be exaggerated in size to that end (figs. 86, 91).

Since the 1950s, Inuit carvers have worked chiefly in stone, although whalebone, ivory, and caribou antler are carved in every region and even predominate in a few communities.[8] Now that ivory is no longer the primary carving material, the scale of work is larger, though still relatively modest. Inuit art is attractive because of this unpretentious human scale (many carvings are made to be caressed in the hand), its use of natural materials, and its direct, spontaneous look. Until recently, most carvers worked almost exclusively with simple hand tools. Today, the majority rough out their sculptures with electric grinders, then use files, rasps, and sandpaper for more detailed shaping and polishing.

Until recently, Inuit artists, scattered in villages along Canada's Arctic coastline, were isolated not only from the south,[9] but also from each other.[10] Not surprisingly, this isolation resulted in the development of regional and even local artistic styles and preferences for certain materials and subject matter. Particularly original or successful artists have often exerted great influence on the work of their fellow villagers. Even with increasing exposure to other communities' arts (including the art of the south) through travel, television, books, magazines, and exhibitions, the best Inuit sculptors tend to create works characterized by originality and diversity, not homogeneity.

Carvings made by artists from Inukjuak and Puvurnituq in Arctic Quebec were the first to be marketed in southern Canada in the early 1950s. The earliest works in stone often reflect the artists' hesitancy in working with an unfamiliar material and a somewhat larger format. *Man with Seal* by Tukai (1888–1979) (fig. 87) may look somewhat awkward and stiff to our eyes, but it was probably one of this artist's first

91. **Evaluardjuk** (dates unknown)
Repulse Bay, Nunavut
Couple, 1973
Stone
Gift of Arnold Aubert Vernon, 98.17.6

92. **Oqutaq Mikkigak** (b. 1936)
Cape Dorset, Nunavut
Falcon, c. 1980s
Green veined stone
Gift of Arnold Aubert Vernon, 98.17.12

daring experiments in "large-scale" carving and the opening up of negative space in stone. This type of genre carving, which depicts traditional hunting and camping scenes, while displaying an increasing degree of realism over the years, would remain the most popular style in Arctic Quebec for decades. Carved some ten years later, like many Inukjuak sculptures, the blocky forms of *Mother and Child* (late 1950s–early 1960s) (fig. 86) by Lucy Elijassiapik (dates unknown), follow the shape of the original stone. Carefully described details – such as hair, parka trim, and the fur mat on which the mother kneels – contrast with the flatter, simplified volumes of the clothing and head. In works like *Transforming Spirit* (1978) (fig. 90), Puvirnituq artist Eli Sallualu Qinuajua (b. 1937) creates a unique bestiary of fantastical supernatural beings that seem to have more in common with the surreal creations of Hieronymus Bosch and Salvador Dali than with art by his fellow Inuit.[11]

Cape Dorset is the Canadian Arctic's preeminent arts community. It boasts a famous printmaking program, and sculptors from Cape Dorset and the other communities on southern Baffin Island have been blessed with access to several types of excellent carving stone. They pride themselves on mastering the stone; their carvings tend to be relatively large, flamboyant, and technically impressive. Sometimes sculptures suggest the influence of drawings and prints. In his dramatic *Winged Spirit with Two Faces* (c. 1980s) (fig. 89), Agjangajuk Shaa (b. 1937) uses the bold outlines and strong two-dimensionality seen in works on paper to emphasize the dual nature of a Janus-faced head. In *Falcon* (c. 1980s) (fig. 92), Oqutaq Mikkigak (b. 1936) conveys the raptor's strength, but in true Cape Dorset fashion, its massive weight and almost ungainly pose also give it an anthropomorphic and vaguely humorous quality.

Two artists from Iqaluit on Baffin Island have evoked the spirit of the caribou in quite different ways. Inuit hunters sometimes tell stories of having stalked a caribou only to find that after it disappeared momentarily behind a low hill, it re-emerged as a man, revealing itself to be a shaman. These tales are recalled in *Shaman/Caribou Transformation* (c. late 1990s–2000) (fig. 88), by Anilnik Peelaktoak (b. 1950). In *Spirits Taking Flight* (c. 1990s) (fig. 93), Yassee Kakee (1947–2004) uses a branching section of caribou antler to create a work verging on relief carving because the shape of the material is so restrictive. The totemic quality of this piece brings to mind prehistoric Dorset-era works carved a thousand years before.

93. **Yasee Kakee** (1947–2004)
Iqaluit, Nunavut
Spirits Taking Flight, detail, c. 1990s
Caribou antler
Gift of Arnold Aubert Vernon, 2003.2.4

Sculptors from the Keewatin region tend to work their gray and black stones with less detail and polish than other Inuit carvers. The resulting forms are generally quite rugged and often have truncated features. The radically simplified *Bird Sitting on an Igloo* (c. 1970s) (fig. 85) by Arviat artist Luke Anowtalik (b. 1932) is an excellent example of whimsical Inuit folk art made to be held in the hand. Its incongruous scale turns the igloo into something more like a little nest or pile of stones.

In *Couple* (1973) (fig. 91), Evaluardjuk (dates unknown) makes a striking departure from Repulse Bay's strong tradition of miniature ivory carving. The large heads sharing one torso with barely discernible arms are riveting. The sculpture's strong, simple forms might result from magnifying the necessarily minimal features carved on miniatures, but they also bear an interesting resemblance to carvings from southern Keewatin communities such as Arviat.

Spirit (1990) (fig. 75), by Taloyoak artist Maudie Rachel Okittuq (b. 1944), has even greater psychological impact. Artists from Taloyoak and other Kitikmeot region communities, even when not depicting the spirit world directly, bring an expressionistic quality, even a sense of angst, to their works. Okittuq's spirit creature is simultaneously loveable and unsettling, and seems strangely like an infant.

After more than fifty years of production by three generations of artists, contemporary Inuit sculpture stands as a remarkable testament to the resilience of a small-scale culture struggling to explain and preserve itself in the face of rapid acculturation. Paradoxically, Inuit art itself is a product of that acculturation: almost entirely, it is stimulated by outside influences and destined for foreign consumption. It has recorded and celebrated a culture that had been transmitted through oral tradition for countless generations, but has yet to be communicated to any great degree through the written word. Inuit art is far more than a mere record of events, beliefs, and images, though. In the words of Gjoa Haven sculptor Uriash Puqiqnak:

We have to keep our language, our stories, and our identity alive....
The world has to learn about the Inuit and their culture and traditions,
so that they will not be forgotten.[12]

NOTES

1. Paulosie Kasadluak, "Nothing Marvelous," in *Port Harrison/Inoucdjouac*. (Winnipeg: Winnipeg Art Gallery, 1977): 21–23.

2. The Eskimoan peoples, living in Alaska, Canada, and Greenland, are therefore remotely related to the Aleuts and to Siberian groups such as the Chukchi. However, they are culturally and linguistically quite distinct from the Indian cultures of the Americas, the descendants of Asian peoples who had crossed the Bering land bridge several thousand years earlier.

3. Among the Siberians' descendants, the Dorsets (c. 800 BCE–1200 CE) developed what may be considered the most interesting sculpture of the prehistoric period in Arctic Canada. It seems to have been centered on shamanic rituals.

4. Small carved amulets, often shaped like animals, tools, or weapons and worn around the neck or sewn into clothing, and simple dolls and other toys, were often the only artistic objects made by a seminomadic people who could not afford the burden of carrying unnecessary items with them.

5. The period from the 1770s to the 1940s is known as the Historic Period of Inuit art.

6. In 1949, the Canadian Guild of Crafts and the Hudson's Bay Company, with active assistance from the government of Canada, began purchasing Arctic Quebec carvings and crafts for sale in the south. The first pieces resembled late Historic Period objects, but by the 1960s, Inuit-run cooperatives and private companies were marketing a wide variety of arts from many communities.

7. What we refer to as "Inuit art" is a relatively recent phenomenon. Although Canada's Inuit and their ancestors have inhabited North America for 5,000 years, during that time their artmaking was episodic rather than evolutionary. Contemporary Inuit art is largely the result of fairly recent (post-1940s) trading activities and government assistance projects in the Canadian north. Sculpture comprises about eighty percent of Inuit art production.

8. The term "soapstone" has been used generically to describe all Inuit carving stone, probably because the earliest carvers from Arctic Quebec usually used soapstone. However, soapstone is the common name for steatite, a specific type of soft stone abundant in Quebec and parts of the Keewatin, but rarely used in the Baffin or Kitikmeot regions. The beautiful green stone from Baffin is usually serpentine or serpentinite. Other stone types, including pyroxene, marble, basalt, and limestone, are used where available. Several communities suffer from chronic shortages of good carving stone. Inuit also use animal materials for carving, but they never hunt animals specifically for that purpose. Ivory is a by-product of traditional food harvesting activities, old whalebone is scavenged from beaches, and caribou antlers are shed naturally each year.

9. Among Inuit, the "south" refers to any place south of the Arctic.

10. Baker Lake, located at the geographic center of Canada, is the only inland Inuit community. The vast majority of Inuit live in the Arctic, and the population of most Inuit communities is at least ninety percent native. No roads connect Inuit villages. People and goods travel by air, and for neighboring communities, by small boat or snowmobile, weather permitting. An annual sealift brings in heavy supplies to each community.

11. In 1967 the anthropologist Nelson Graburn prompted a group of Puvirnituq carvers to create images never seen before. There is no evidence that the artists had ever seen pictures of European Surrealist paintings, although the similarities are striking.

12. Uriash Puqiqnak, in *Keeping Our Stories Alive: The Sculpture of Canada's Inuit*. Videotape. (Ottawa: Indian and Northern Affairs Canada, 1993).

The Charles E. Craig Jr. Collection of Global Art

MAIA JALENAK

94. Indian
 Deity figure, c. 11th century
 Stone
 Gift of Charles E. Craig Jr., 98.9

95. Indian, Jaipur
 Shiva and Matangi with Yantra,
 early 19th century
 Ink, graphite, and gouache on paper
 Gift of Charles E. Craig Jr., 99.8.3

When Charles Craig graduated from Louisiana State University in 1959, the LSU Museum of Art had not yet opened its doors to the public. Thirty-five years later, Craig's donations of artworks significantly expanded the scope of the museum's holdings. Made in Pre-Columbian Latin America and Asia, Africa, Oceania, and other regions, dating from ancient times to the present day, and representing all media, Craig's gifts constitute a truly global collection.

Asian cultures are represented in the collection by artworks from India, Thailand, Burma, Nepal, Cambodia, Tibet, China, and Japan. Among the Indian works, in one fascinating gray stone carving dating to the eleventh century, a deity figure holds an attribute in one hand and a fly whisk in the other (fig. 94). Figures like this one appeared often in Indian temples.

A number of Indian miniature paintings from the eighteenth century through the twentieth figure prominently in the collection. Many portray Hindu deities, including Vishnu, the protector of the universe, and Shiva, the destroyer of evil. *Hanuman Carrying Rama and Lakshmana* (c. 1780–1810) (fig. 97) tells a story about the monkey god Hanuman, a devotee of Rama (an incarnation of Vishnu), and Rama's younger brother, Lakshmana. Ravana, a devil, has stolen Sita, Rama's wife, and carried her off to the island of Ceylon (Sri Lanka). The monkey god offers to take Rama and Lakshmana across the strait between India and Ceylon so that they can rescue Sita from the devil.

Shiva and Matangi with Yantra (early 19th c.) (fig. 95) is a sensitively rendered image showing the god Shiva being entertained by Matangi, who plays a yantra, a stringed instrument. Shiva's wife, Durga, is the subject of another miniature from the same period, depicting *The Supreme Goddess Durga Seated on a Lotus Pad* (fig. 96).

The Pre-Columbian works in the Craig collection represent the three culturally distinct regions of Latin America – Mesoamerica (Mexico, Guatemala, Honduras, Belize, and El Salvador), Central America, and South America. A painted ceramic tripod vessel (fig. 98), originating from the Nicoya culture of Costa Rica and dating between 500 and 1200, is a significant treasure.

Contemporary art is another major field of interest for Craig. He befriended many artists, including Larry Rivers (1923–2002). In 1972, Rivers created a portrait showing the collector framed by personal checks that allude to his vocation as a

श्रीनारंगी

REFERENCES

Charles E. Craig Jr. Multicultural Art Collection, Baton Rouge, LA: LSU Museum of Art, 1995.

Diverse Directions, A Collector's Choice: Selections from the Charles Craig Collection, Santa Barbara, CA: Santa Barbara Museum of Art, 1987.

page 130

96. Indian, Rajput
 Supreme Goddess Durga Seated on a Lotus Pad, c. 19th century
 Gouache on paper
 Gift of Charles E. Craig Jr., 99.8.5

page 131

97. Indian, Jaipur
 Hanuman carrying Rama and Lakshmana,
 c. 1780–1810
 Gouache on paper
 Gift of Charles E. Craig Jr., 99.8.6

page 132

98. Mexican, Remojadas
 Vera Cruz warrior figure, early Classic period,
 c. 250–450 CE
 Ceramic with applied *chapapote* black pigment
 Gift of Charles E. Craig Jr., 97.17.1

page 133

99. Pre-Columbian, Costa Rica, Nicoya Culture
 Tripod vessel: human figure with
 rattle feet, 500–1200 CE
 Ceramic with applied pigment
 Gift of Charles E. Craig Jr., 96.41

banker. The glass sculpture *Open Diamond Step Diagonal* (1982) by DeWain Valentine (b. 1936), attests to the range of media represented in the collection's contemporary art component.

Charles Craig has been very generous to his alma mater. In addition to regularly donating artwork to the museum, in 1995 he established an annual scholarship that affords LSU students the opportunity to travel to Europe. It is Craig's hope that his gifts will allow American audiences to learn about and enjoy art from all times and cultures.

The J. Lucille Evans Collection of Japanese Prints

MAIA JALENAK

100. **Attributed to Yoshitoshi**
(Japanese, 1839–92)
Courtesan Seated with Screen,
c. 1868–1912
Woodblock
Gift of J. Lucille Evans, 90.16.34

page 136

101. **Attributed to Hiroshige**
(Japanese, 1797–1858),
Kiyomizu Hall and Shinobazu Pond,
from *100 Views of Edo*, April, 1856
Woodblock
Gift of J. Lucille Evans, 90.16.14

page 137

102. **Attributed to Hiroshige II**
(Japanese, 1826–69)
Nihonbashi Bridge, c. 1860
Woodblock
Gift of J. Lucille Evans, 90.16.16

As a student at Louisiana State University in the late 1930s, J. Lucille Evans was fortunate to be taught by the Pulitzer Prize winning author, Robert Penn Warren. Evans began a career that took her to the Far East for sixteen years. She was assigned as an aide to General Douglas MacArthur, reporting on reconstruction efforts in post-World War II Japan. Her work evolved into covering the events leading to the Korean conflict, and she rode on the last train out of Seoul before war broke out in Korea. Back in the United States, she and her husband, artist Henry Hasselberg, settled in Las Cruces, New Mexico, not far from the testing grounds for the first atomic bomb, where she continued her work in journalism covering military topics.

While living in Japan, Evans began to collect art, focusing on Japanese prints. For centuries, many collectors have been passionate about this art form, fascinated by the insights the images provide into the country's history and culture. Japanese prints are collaborative works, created by artists, woodblock carvers, printers, and publishers, and they were intended for the enjoyment of the working class. Although the images depict ordinary life, the prints themselves are far from ordinary; they are advanced in their composition and technical conception, striking in their cropped and angular views, and captivating in their bold use of color offset by contour drawing.

Appreciation of the prints spread to the west as Japanese fine and decorative arts began rapidly flowing out of the country following the opening of its ports in the 1850s. Their popularity is reflected in the late-nineteenth-century development of *Japonisme* – western enthusiasm for all things Japanese – and they have been an important source of inspiration for Western artists. Impressionists and post-impressionists like Claude Monet (1840–1926) and Vincent van Gogh (1853–90) were influenced by their unusual spatial compositions, use of color, and depictions of ordinary people's lives. The prints also intrigued twentieth-century modernists, among them the painters Pablo Picasso (1881–1973) and Amedeo Modigliani (1884–1920), and the architect Frank Lloyd Wright (1867–1959).

It is not uncommon for collectors of Japanese prints to be drawn to particular themes, such as historical events, military subjects, or scenes of kabuki theater. Surveying the hundred or so images Evans collected reveals her preference for

話當日院命延

REFERENCES

Munsterberg, Hugo, *The Japanese Print, a Historical Guide*, New York: John Weatherhill, 1982.

The Los Angeles County Museum of Art. Japanese Color Woodblock Prints. <http://www.lacma.org/art/perm_col/japanese/prints/woodblk.htm> (January 15, 2005).

103. **Attributed to Kuniyoshi**
(Japanese, 1791–1861)
Standing Bijin Carrying Bowl,
c. 1842
Woodblock
Gift of J. Lucille Evans, 90.16.33

page 140

104. **Attributed to Kuniyoshi**
(Japanese, 1797–1861)
Female Warrior and Two Attendants,
c. 1849–50
Woodblock
Gift of J. Lucille Evans, 90.16.28

page 141

105. **Attributed to Kawase Hasui**
(Japanese, 1883–1957)
Snow Scene at Temple, c. 1940
Woodblock
Gift of J. Lucille Evans, 90.16.4

landscapes and *bijin-ga* – images of beautiful women – a very popular subject with Japanese printmakers.

The collection includes Ukiyo-e prints created during the Edo period (1615–1865) and in the twentieth century. Ukiyo – the floating world – is a Buddhist term describing the transitory nature of the world. Ukiyo-e prints focus on landscapes, urban views, and intimate scenes of daily life. Among landscapes Evans collected are prints by the renowned and prolific Utagawa Hiroshige (1797–1858), who is said to have created more than 5,000 prints during his lifetime. Hiroshige is known for his many series of landscapes, which have been described as romantic and sentimental. Examples from one of his best-known and most ambitious series, *100 Views of Edo*, such as *Kiyomizu Hall and Shinobazu Pond* (1856) (fig. 101), are a highlight of the collection. The work of Kawase Hasui (1883–1957), one of the major twentieth-century landscape artists, is noted for its tranquility and compositional excellence. His *Snow Scene at Temple* (c. 1940) (fig. 105) reflects the Japanese fascination with the change of seasons and Japanese artists' sensitivity in rendering it.

During the Edo period, brothels were a common feature of city life. Women depicted in Japanese prints are typically high-ranking courtesans dressed in sweeping kimonos and engaged in domestic tasks or personal grooming, as in *Standing Bijin Carrying Bowl* (c. 1842) (fig. 103) by Utagawa Kuniyoshi (1797–1861), and *Courtesan Seated with Screen* (c. 1868–1912) (fig. 100) by Tsukioka Yoshitoshsi (1839–92), Kuniyoshi's chief pupil. Another work by the elder artist depicts a female warrior with two attendants (fig. 104); in ancient Japan, women of the samurai class were expected to raise their children with a proper education and protect their homes in times of war.

J. Lucille Evans' generosity to the museum included a monetary bequest upon her death in 1993. In the early 1990s, she was pleased to know that the scope of the Anglo-American Art Museum would soon expand and that her collection would become available to students, researchers, and everyone who is passionate about Japanese art. Thus, along with her collection, Evans donated funds to help the museum achieve its vision for the future – a new building to house a global art collection.

Exhibition Checklist

Dimensions are in inches; height x width x depth. Works are listed according to their thematic locations in the *Collecting Passions* exhibition.

Connecting to Collecting and Reflecting on Collecting

Walter Anderson (American, 1903–65) for Shearwater Pottery, Ocean Springs, Mississippi
Figure of a seated cat, c. 1947–48
High glaze ceramic, 11 5/8 x 12 1/2 x 5 1/4
Gift of Mrs. Nina Nichols Pugh, 97.4

Armchair, c. 1620, England
Oak with stained inlay, 49 x 18 x 24
Anonymous Donor's Purchase Fund, 60.5.1

Battle of Lookout Mountain souvenir demitasse spoon, United States, c. 1905
Sterling silver, 4 1/16 x 13/16 x 1/2
Gift of Mrs. H. Payne Breazeale, 80.19

Frederick Carder (American, 1863–1963)
Steuben Aurene vase, c. 1920
Hand-blown glass, 4 1/2 x 6
Gift of the Friends of LSU MOA and Mrs. John F. P. Farrar, 93.14

Dinky Manufacturers, England
Model cars, c. 1950
Varying dimensions
Gift of Professor Frank de Caro, 93.26.7, 10, 11

Harvey Dinnerstein (American, b. 1928)
Prospect Park, Brooklyn, 1973
Oil on paper, mounted on academy board, 9 x 18 1/8
Gift of the American Academy of Arts and Letters, 75.1

A.J. Drysdale (American, 1870–1934)
Untitled, date unknown
Oil on board, 20 x 30
Gift of Mr. Joe Armstrong, Transfer from Special Collections, LSU Libraries, 2004.4.6

Paul Arthur Dufour (American, b. 1922)
Scylla and Charibdis, 1988
Sumi-e/collage, 34 x 45 3/4
Gift of the Artist, 91.6

Caroline Durieux (American, 1896–1989)
Bal Masque, 1946
Lithograph, 15 1/2 x 7 5/8
Gift of the Artist, 68.9.33

Gorham Manufacturing Company, est. 1831, Rhode Island
New Orleans souvenir sugar shell, c. 1900
Sterling silver, 5 1/8 x 1 3/8 x 1/4
Gift of Mr. and Mrs. John T. Anderson, 79.22

Alvin Hill (American, active 1874–1909)
New Orleans souvenir demitasse spoon, c. 1891–1909
Sterling silver, 4 3/16 x 13/16 x 1/2
Gift of Mrs. H. Payne Breazeale, 80.17

Clementine Hunter (American, 1887–1988)
Funeral, c. 1950
Oil on board, 12 1/4 x 18
Gift of Mrs. H. Payne Breazeale, 74.3.6
Illustrated: fig. 33, p. 63

Marbles, c. 1930–35, United States and Mexico
Varying media and dimensions
Gift of Mr. and Mrs. Stephen G. Henry Jr., 91.27.1

Komoatuk Mathewsie (Cape Dorset, Nunavut, b. 1941)
Owl, 1981
Green stone, 13 1/2 x 8 x 5
Gift of Arnold Aubert Vernon, 98.17.9

Robin McGee (American, b. 1953)
Creamer, c. 1982
Sterling silver and ebony, 3 3/4 x 3 1/8 x 3 1/2
Gift of Mr. and Mrs. Bert S. Turner, 84.5

Cecile Owen (American, b. 1898)
Horse-Nettle, c. 1920–21
Pencil and watercolor on paper, 13 1/2 x 9 1/2
Gift of Dr. A. Brooks Cronan Jr. and Diana Cronan, 96.9.8

Pocket watch, date unknown, England
Eighteen-karat gold, 2 7/8 x 2 1/16
Gift of Dr. A. Brooks Cronan Jr. and Diana Cronan, 91.7.5

Diego Rivera (Mexican, 1886–1957)
Portrait of Caroline Wogan Durieux, 1929
Oil on canvas, 25 1/4 x 20 15/16
Gift of Mrs. Paula Garvey Manship, 2000.2

Probably Shepard Mfg. Co, active c. 1890–1922, Massachusetts
Battle of Lookout Mountain souvenir pickle fork
Sterling silver, 5 1/2 x 5/8 x 3/4
Gift of Mrs. H. Payne Breazeale, 80.20

Toy soldiers, c. 1933–34, China
Brass, varying dimensions
Gift of Mr. and Mrs. Stephen G. Henry Jr., 91.27.10 a-w

Watson Company, active 1879–1955, Massachusetts
Hibernia Bank, Louisiana souvenir spoon, c. 1905
Sterling silver, 4 3/16 x 7/16 x 5/8, 80.18

Souvenir spoon of Lexington, Mississippi, c. 1894–1909
Sterling silver, 5 13/16 x 1 1/4 x 1/2, 80.16

Gifts of Mrs. H. Payne Breazeale

The Anglo-American Art Museum: Particular Beginnings

Jacques Guillaume Lucien Amans (Franco-American, 1801–88)
Portrait of a Gentlewoman, c. 1840–45
Oil on canvas, 38 x 30
Gift of Mr. and Mrs. W. E. Groves, 60.2.1
Illustrated: fig. 16, pp. 8, 40

American Watch Company, Massachusetts
Woman's hunting case key-wound watch, 1869
Fourteen-karat yellow gold-filled, 1 3/4 x 1/2
Gift of Marion Edwards, Collection of the LSU Textile & Costume Museum, 1995.0027.0021

Anonymous, American
Brooch Miniature Portrait of Catherine Cordes Dawson, c. 1845
Daguerreotype, fifteen-karat gold, and pearls,
1 3/8 x 1 1/2
Gift of Rev. Dr. Mark Cordes Gasquet, 97.18.10

Anonymous, American
Mourning Brooch Miniature Portrait of Emile Lecoul,
c. 1860
Tin-type photograph, gold, enamel, and hair,
2 1/16 x 1 3/8
Gift of the Friends of LSU MOA, 85.2.3
Illustrated: fig. 17, p. 39

Anonymous, American
Portrait of a Lady with an Accordion, c. 1830–35
Oil on canvas,
29 1/2 x 24 1/4
Anonymous Donor's Purchase Fund, 65.3
Illustrated: fig. 10, p. 31

Anonymous, British
Portrait of Sir Thomas Conaway, c. 1620
Oil on canvas,
79 3/4 x 44 3/4
Anonymous Donor's Purchase Fund, 59.2.1

Anonymous, British School
(c. 1825–30)
Portrait of a Gentleman
(Probably Charles Stirling, 4th Son of William Stirling),
c. 1820
Oil on canvas, 30 x 25
Gift of Mr. and Mrs. W.E. Groves, 61.8.2

Armchair,
c. 1780–90, England
Satinwood,
31 1/2 x 21 x 20 1/2
Anonymous Donor's Purchase Fund, 64.5

Backstool,
c. 1765–75, England
Mahogany and wool,
39 3/4 x 23 1/4 x 24 1/4
Gift of Alma Campbell, 97.7

Thomas Badger
(American, 1792–1868)
Portrait of Captain Cleeves Symmes, 1820
Oil on canvas, 27 x 23
Anonymous Donor's Purchase Fund, 59.7.2
Illustrated: fig. 1, p. 14

Edward Bechtoldt
(origin unkown)
Hunting case watch, 1888
Fourteen-karat gold, 2 x 5/8
Gift of Marion Edwards, Collection of the LSU Textile & Costume Museum, 1995.0027.0022

Sir William Beechey
(English, 1753–1839)
Portrait of Captain Henry W. Bayntun, 1805
Oil on canvas, 50 1/4 x 40 1/2
Anonymous Donor's Purchase Fund, 59.8

Bonnet, c. 1840,
United States
Embroidered white linen with lace insertion and lace trim, 10 x 9 x 10; ties: 14
Gift of Lisa Perron Heifner and Suzanne Marie Perron, Collection of the LSU Textile & Costume Museum, 1996.057.0053

Bonnet, c. 1840,
United States
Natural straw with purple, green, and gold silk ribbon, 12 x 6 x 13; ties: 13
Gift of the LSU Rural Life Museum, Collection of the LSU Textile & Costume Museum, 1995.018.0001

M. Campbell,
New York and Chicago
Hair weaving kit, 1883
Comb: 1 3/4 x 5 1/16 x 3/4
Clamp and wheel:
7 1/8 x 6 1/4 x 1
Clamp and wooden handle: 11 x 2 3/4 x 1
Clamp and spools of thread: 11 x 2 3/4 x 3 1/2
Human hair: 9 x 6 1/2 x 2 3/4
Gift of Mrs. Audrey Bernard, Collection of the LSU Rural Life Museum

Candle snuffer and stand, early 18th century, England
Brass, 8 x 3 x 3
Gift of the Friends of LSU MOA, 70.8.2 a-b

John Carr
(English, 1723–1807)
Doorway in the Neoclassical style from Basildon Park, 1766
Carved mahogany, painted and gilded pine,
103 x 64 x 7
Anonymous Donor's Purchase Fund, 59.3

Chandelier, c. 1750, England
Brass and iron,
26 3/4 x 35 x 35
Gift of the Friends of LSU MOA, 75.21 a-i

Sir Nathaniel Dance
(English, 1734–1811)
Portrait of Vice-Admiral Lord Shuldman,
c. 1777–80
Oil on canvas, 50 x 40
Anonymous Donor's Purchase Fund, 62.10
Illustrated: fig. 13, p. 35

Desk, c. 1765,
Philadelphia
Walnut,
41 x 39 1/8 x 22 1/4
Anonymous Donor's Purchase Fund, 68.1

John Wood Dodge
(American, 1807–93)
Miniature Portrait of Jn H. B. Morton, Esq., 1848
Oil and watercolor on ivory,
2 7/8 x 2 1/4
Gift of the Friends of LSU MOA, 87.1

Dress with high neckline, bet. 1815 and 1820, probably Louisiana
Cotton, 50 x 30
Gift of Frances Murrell, Collection of the LSU Textile & Costume Museum, 1980.008.0020

Ambrose Duval
(Franco-American,
b. 1760–80)

Miniature Portrait of Jean-Baptiste Emanuel Prud'homme, c.1810–20
Oil and watercolor on ivory, 2 1/2 x 2 1/8, 92.8.1

Miniature Portrait of Mrs. Jean-Baptiste Emanuel Prud'homme, Marie Theresa Oilhaud St. Anne Prud'homme, c. 1810–20
Oil and watercolor on ivory, 2 1/2 x 2 1/8, 92.8.2

Gifts of Miss Elizabeth Williams in memory of her mother, Bessie Shepherd McInnis

Ralph Earl
(American, 1751–1801)
Portrait of Mrs. Bradley and Her Daughter, Sally, 1788
Oil on canvas, 37 x 30
Anonymous Donor's Purchase Fund, 59.7.3
Illustrated: fig. 11, p. 32

Earrings and matching brooch, date unknown, United States
Human hair and gold
Earrings: 7/8 x 7/8;
brooch: 1 5/8 x 5/8
Gift of Steele Burden, Collection of the LSU Rural Life Museum

Earrings and matching brooch, date unknown, United States
Human hair, gold, and pearls
Earrings: 2 1/4 x 1/4 x 1/4;
brooch: 1 1/4 x 1 3/8 x 1/4
Gift of Steele Burden, Collection of the LSU Rural Life Museum

Thomas Gainsborough
(English, 1727–88)
Portrait of Ralph Leycester of Toft Hall, Knutsford, Cheshire, c. 1763
Oil on canvas, 30 x 25
Anonymous Donor's Purchase Fund, 59.10.2
Illustrated: fig. 7, p. 25

Harp-shaped brooch, date unknown,
United States
Human hair and gold,
1 1/8 x 5/8 x 1/8
Gift of Steele Burden, Collection of the LSU Rural Life Museum

William Hogarth
(English, 1697–1764)

The Analysis of Beauty, Plate II, 1753
Etching and engraving,
16 x 20 13/16, 62.8.100
Illustrated: fig. 3, p. 22

The Bruiser, 1763
Etching and engraving,
14 15/16 x 11 1/4, 62.8.123

The Five Orders of Periwigs, 1761
Etching and engraving,
10 3/4 x 8 1/4, 62.8.114

Gulielmus Hogarth,
1748/49
Etching and engraving,
13 3/8 x 10 1/4, 62.8.2

Portrait of a Lady,
c. 1740
Oil on canvas,
30 x 25, 59.2.2
Illustrated: fig. 6, p. 24

Anonymous Donor's Purchase Fund

John Hoppner
(English, 1758–1810)
Portrait of Master Harvey Moore, c. 1798
Oil on canvas, 30 x 25
Gift of the Friends of LSU MOA, 62.9.1

Thomas Hudson
(English, 1707–79) or School of Hudson
Portrait of a Lady with a Basket of Flowers, c. 1745
Oil on canvas, 36 x 28
Anonymous Donor's Purchase Fund, 59.10.1

Inkstand, c. 1740,
Continental
Brass and walnut,
9 1/4 x 5 x 5
Gift of the Friends of LSU MOA, 78.4 a-b

John Wesley Jarvis
(American, 1780–1840)

Portrait of Mrs. Moses Hook (née Harriet Butler),
c. 1818–22
Oil on canvas,
36 x 24, 88.21.2
Illustrated: fig. 15, p. 36

Portrait of Richard Butler of New Orleans,
c. 1815–20
Oil on canvas,
35 1/2 x 34 1/2, 88.21.1
Illustrated: fig. 14, p. 36

Gifts of Mrs. George Gammon Jr. (née Keith Shepherd) in memory of her mother, Emma Shepherd Bush

Jean Baptiste Lamothe (Santo Domingan, 1800–79) or Jean Marie Lamothe (Santo Domingan, 1795–1880)
Beaker, c. 1815–25
Coin silver,
3 1/8 x 2 5/8 x 2 1/4
Gift of the Friends of LSU MOA, 77.3.1
Illustrated: fig. 49, p. 84

Looking glass,
c. 1730–40, England
Mahogany, gessoed moldings, and glass,
61 x 28 x 2 1/8
Gift of the Friends of LSU MOA, 78.23

Rudolph T. Lux (German-American, 1815–68)
Portrait of Dr. Frederick H. Knapp (1815–83) and his son, Dr. Frederick J. Knapp,
c. 1861–65
Oil on porcelain, 7 7/8 x 9 3/8
Gift of Friends of LSU MOA, 93.6

Frederick Marryat (English, 1792–1848)
A "Dignity" Ball, c. 1812–14
Oil on canvas, 8 5/8 x 6 7/8
Gift of Mrs. Julia H.R. Hamilton, 96.19

Attributed to John and Joseph Meeks (American, active 1836–69), New York City
Étagère music cabinet,
c. 1850
Rosewood and maple,
72 x 31 x 18
Gift of Mrs. Robert B. Smythe, 96.8

Peter Monamy (English, 1681–1748/49)
Man O'War and Other Vessels in a Calm Sea,
c. 1730
Oil on canvas, 18 1/2 x 38
Gift of the Friends of LSU MOA, 71.8

John Chandler Moore (dates unknown) for Tiffany, Young & Ellis, New York
Seven-piece tea and coffee service, c. 1850–52
Coin silver
Kettle: 13 x 10 1/2 x 6
Coffee pot: 9 1/4 x 9 x 3 3/8
Tea pot: 6 x 10 1/4 x 4 1/2
Sugar bowl: 5 1/4 x 7 3/4 x 3 3/4
Creamer: 6 5/8 x 5 3/8 x 3 7/8
Waste bowl: 4 1/4 x 6 1/16 x 6 1/16
Sugar basket: 6 5/8 x 5 1/2 x 4 7/8
Gift of Major General Junius Wallace Jones, 76.23.1-7
Illustrated: fig. 59, p. 91

Attributed to Samuel F.B. Morse (American, 1791–1872)
Portrait of Dr. Stephen Duncan, c. 1820
Oil on canvas,
30 1/8 x 25 1/8
Gift of the family of William Bull Pringle, 2004.5.1

Mourning handkerchief,
c. 19th century, Pennsylvania
Black cotton with white scalloped button-holed stitch trim, 12 1/4 x 12 1/2
Gift of Lisa Perron Heifner and Suzanne Marie Perron, Collection of the LSU Textile & Costume Museum, 1996.057.0084

Mourning handkerchief,
c. 19th century, Pennsylvania
White linen, pulled thread, and black border,
14 x 13 1/4
Gift of Lisa Perron Heifner and Suzanne Marie Perron, Collection of the LSU Textile & Costume Museum, 1996.0057.0081

Pair of candlesticks,
c. 1750–70, England
Paktong,
10 1/4 x 4 1/2 x 4 1/2
Gift of Mr. and Mrs. John W. Barton Sr., 79.6.1-2 a-b

Rembrandt Peale (American, 1778–1860)
Portrait of Governor John Hoskins Stone of Maryland, 1797–98
Oil on canvas, 36 x 27
Anonymous Donor's Purchase Fund, 60.13
Illustrated: fig. 12, p. 33

Queen Anne desk and bookcase,
c. 1710–25, England
Walnut, yew, and oak,
98 3/4 x 42 x 25 1/2
Anonymous Donor's Purchase Fund, 66.3

Queen Anne wing chair,
c. 1710, England
Walnut, needlepoint, and gold damask,
47 x 32 x 31
Anonymous Donor's Purchase Fund, 66.2

Attributed to Anthony Gabriel Quervelle (Franco-American, 1789–1856), Philadelphia
Pier table, c. 1830–35
Mahogany, rosewood, and marble,
37 11/16 x 48 x 21 7/8
Gift of Mr. and Mrs. Raymond St. Germain, 80.33

Sir Henry Raeburn (Scottish, 1756–1823)
Portrait of Dr. George Cameron of Edinburgh,
c. 1800
Oil on canvas, 30 x 25
Gift of Mr. and Mrs. A. Hays Town Sr., 64.21

Sir Joshua Reynolds (English, 1723–92)
Portrait of Maria Walpole, Countess Waldegrave,
c. 1760
Oil on canvas, 29 1/2 x 24
Anonymous Donor's Purchase Fund, 64.1
Illustrated: fig. 8, p. 27

Slab table,
c. 1755, England
Mahogany and marble,
30 9/16 x 38 x 25
Gift of the Friends of LSU MOA, 76.5 a-b

Slat-back side chair,
c. 1730–65, Delaware River Valley, Pennsylvania
Painted maple,
43 7/8 x 17 3/4 x 17 1/2
Gift of the Friends of LSU MOA, 79.15
Illustrated: fig. 41, p. 73

John Smibert (American, 1688–1751)

Portrait of Mr. David Miln, Merchant from Leith, Scotland and London, England, 1723
Oil on canvas,
49 7/8 x 39 7/8, 92.4.1
Illustrated: fig. 4, p. 23

Portrait of Mrs. David Miln, 1723
Oil on canvas,
49 7/8 x 40, 92.4.2
Illustrated: fig. 5, p. 23

Gifts of the Heirs of Fairfax Foster Bailey

Starr, Fellows & Co., New York
Four-branch gasolier,
c. 1857–61
Gilt brass, bronze, copper, bronzed metal, and etched glass, 43 x 20 1/4 x 29 1/4
Gift of the Baton Rouge Coca-Cola Bottling Co., Ltd., 82.13
Illustrated: fig. 48, p. 83

Sugar chest,
c. 1810–15, Kentucky
Walnut, 36 1/4 x 26 x 14
Gift of Miss Ione Easter Burden, 72.5
Illustrated: fig. 42, p. 75

Tea table,
c. 1770, American Cherry,
28 1/4 x 33 x 32 1/2
Gift of Mr. and Mrs. Michael Williams, 97.26
Illustrated: fig. 40, p. 72

Tilt-top tea table,
c. 1765, England
Mahogany,
28 1/4 x 20 1/2 x 20 1/2
Gift of the Friends of LSU MOA, 70.8.1

Attributed to Benjamin Trott (American, c. 1770–1843)
Miniature Portrait of Captain Moses Hook,
c. 1806–10
Mixed media on ivory,
2 5/8 x 2 1/16
Gift of Mrs. George Gammon Jr. (née Keith Shepherd) in memory of her mother, Emma Shepherd Bush, 88.21.3
Illustrated: fig. 2, p. 21

Wall sconces, early 18th century, possibly the Netherlands
Cast brass,
31 1/8 x 9 3/4 x 6 1/2
Gift of Milton J. Womack in memory of his wife, Barbara Sevier Womack, 84.4.1-2 a-b

Waistcoat, c. 19th century, probably Louisiana
White cotton embroidered four-buttoned waistcoat with shawl collar, 19 x 15 1/2
Gift of David, Richard, and Ormonde Plater, Collection of the LSU Textile & Costume Museum, 2004.0001.0043

Elisha Warner (American, active early 19th century)
Chest of drawers in the Hepplewhite style, Kentucky, c. 1810–29
Cherry, 39 1/2 x 41 x 23
Anonymous Donor's Purchase Fund, 68.5

Wax jack, late 18th century, England
Brass and steel,
5 x 4 3/4 x 3 3/4
Gift of the Friends of LSU MOA, 95.1

Attributed to Benjamin West (American, 1738–1820)
Portrait of Miss Sarah Elizabeth Young, Subsequently Mrs. Richard Ottley, c. 1775–80
Oil on canvas, 29 1/2 x 24 1/2
Anonymous Donor's Purchase Fund, 62.4
Illustrated: fig. 9, p. 28

Windsor armchair,
c. 1780, New England
Painted wood,
43 5/16 x 26 x 16
Gift of Mrs. Emile N. Kuntz and daughters, Mrs. Paul T. Westervelt, and Mrs. Carlo L. Capomazza, 84.28.1

Woman's watch chain,
c. 1850, United States
Human hair with gold metal, length: 46
Gift of Mr. and Mrs. Thomas Bennett Jr., Collection of the LSU Textile & Costume Museum, 2003.0037.0004

John (Johannes) Michael Wright (English, 1617–1700)
Portrait of Robert Bruce, 2nd Earl of Elgin, First Earl of Aylesbury, c.1685
Oil on canvas, 49 1/2 x 40 1/2
Anonymous Donor's Purchase Fund, 59.2.3

Visual Records of Louisiana and its Cultural Progress

Conrad Albrizio
(American, 1892–1973)

And the Lord Commanded Me... Deuteronomy 4:14: Study for a Mural, State Capitol, Court of Appeals, 4th Floor, 1930
Pencil and watercolor on paper, 21 7/16 x 26 7/8
93.7.1
Illustrated: fig. 31, p. 58

But the Judgement Shall Return unto... Psalms 94:15, Study for a Mural, State Capitol, Supreme Court, 1930
Pencil and watercolor on paper, 20 x 25, 93.7.2

Gifts of the estate of Mrs. Ernestine H. Eastland Lowery

Charles F. Allgower
(American, c. 19th century)

Destruction of State House of LA by Fire, Baton Rouge, 1862, 1862
Pen and ink on paper, 13 x 15 7/16, 76.7.1

Headquarters of Col. Wm. Wilson, Baton Rouge, 1863, 1863
Pen and ink on paper, 4 1/16 x 7 9/16, 76.7.2

Gifts of Mrs. Rawlston D. Phillips in memory of her late husband

Armchair,
c. 1780–1825, Louisiana
Red mulberry and pecan, 35 x 21 1/2 x 17 1/2
Gift of Mrs. Paula Garvey Manship, 96.13.2
Illustrated: fig. 37, p. 68

Armoire,
c. 1800–25, Louisiana
West Indian mahogany, Spanish cedar, tiger, curly, and bird's eye maple, 86 1/2 x 53 x 20
Gift of the Friends of LSU MOA, 95.8

Armoire, c. 1800–25, probably New Orleans
Santo Domingan mahogany, Spanish cedar, poplar, walnut, and brass, 89 3/4 x 65 1/4 x 21 7/8
Gift of Mr. and Mrs. Emile N. Kuntz, 79.43
Illustrated: fig. 39, p. 71

Armoire in Louis XV style, c. 1770–90, Louisiana
Walnut, cypress, brass, and iron, 89 1/2 x 47 1/2 x 23 3/4
Gift of the Friends of LSU MOA, 86.29.1
Illustrated: fig. 35, p. 66

Edward E. Arnold
(German-American,
c. 1816–66)

Battle of Port Hudson on the Mississippi, 1864
Oil on canvas,
30 x 40, 71.20
Illustrated: fig. 23, p. 47

Portrait of Schooner Allen Middleton, 1866
Oil on canvas, 22 x 30
93.10.1

Gifts of the Friends of LSU MOA

François Bernard
(Franco-American,
c. 1812–80s)
Portrait of Miss Corinne Taylor at Age Sixteen, 1856
Pastel on animal hide,
39 x 31 1/2
Gift of Dr. A. Brooks Cronan Jr. and Diana Cronan, 82.18.1

Alfred Boisseau
(American, 1823–1901)

Portrait of Gracieuse Molière Atkinson, 1849
Oil on canvas,
39 x 31 1/2, 65.2.2
Illustrated: fig. 18, p. 41

Portrait of William Atkinson, 1859
Oil on canvas,
39 x 31 1/2, 65.2.1
Illustrated: fig. 19, p. 41

Gifts of Mr. and Mrs. Jules F. Landry and family

Campeachy chair,
c. 1810–25, probably New Orleans
Mahogany with white oak and satinwood inlay, leather, and nails,
37 x 26 3/8 x 27 1/2
Gift of D. Benjamin Kleinpeter, 96.13.3
Illustrated: fig. 36, p. 67

Richard Clague
(American, 1821–73)
Farm in St. Tammany, bet. 1851 and 1870
Oil on canvas, 15 x 24 1/2
Gift of Mr. and Mrs. W.E. Groves, 60.2.2
Illustrated: fig. 24, p. 49

George David Coulon
(Franco-American,
1822–1904)

Hunting Dogs, 1898
Oil on canvas,
20 1/8 x 17 1/8

Rabbit, 1885
Oil on canvas, 30 x 16 1/4

The E.A. McIlhenny Natural History Collection, Special Collections, LSU Libraries

William Coutant
(American, active New Orleans 1830–55)

Portrait of Albert Gallatin Howell (1813–52),
c. 1832
Oil on canvas,
35 1/2 x 28, 96.16.1

Portrait of Mrs. Albert Gallatin Howell, née Sarah Anne Johnson (1818–42), c. 1832
Oil on canvas, 33 x 26
96.16.2

Gifts of Dr. O.M. Thompson Jr. in memory of Mr. and Mrs. Johnson Hereford Percy and Mr. and Mrs. Oscar Menees Thompson

Caroline Durieux
(American, 1896–1989)

Café Tupinamba, 1934
Oil on canvas, 32 1/2 x 40
Gift of Mr. Charles P. Manship Jr., 91.25
Illustrated: fig. 32, p. 61

Drawing for Café Tupinamba, c. 1934
Pencil on paper,
11 7/8 x 14 3/8
Gift of the Friends of LSU MOA, 91.26

Josephine Favrot
(American, 1785–1836)
View of Baton Rouge,
c. 1834–35
Pencil and watercolor on paper, 5 1/4 x 7 3/4
Collection of Mrs. Michelle Favrot Heidelberg

France Folse
(American, 1906–85)
The Sabine Passing a Cotton Field, c. 1942–47
Oil on canvas,
19 1/4 x 30 1/8
Gift of Mr. and Mrs. Stephen G. Henry Jr., 97.2

John Genin
(Franco-American,
1830–95)
Portrait of Mr. Gaude of New Orleans and Biloxi, 1875
Oil on canvas,
46 x 34 1/4
Gift of Dr. Brooks A. Cronan Jr. and Diana Cronan, 79.27

George Peter Alexander Healy (Irish-American, 1813–94)
Portrait of a Lady in a Black Gown, 1845
Oil on canvas, 32 x 25 5/8
Gift of Mr. and Mrs. W.E. Groves, 60.2.3
Illustrated: fig. 20, p. 43

Knute Heldner
(Swedish-American,
1886–1952)

Heldner and Colette,
date unknown
Oil on canvas, 30 x 24
2004.4.3
Illustrated: fig. 29, p. 55

World War II, c. 1940
Oil on burlap,
18 1/4 x 25, 2004.4.2

Transfers from Special Collections, LSU Libraries

William Henry Howe
(American, 1846–1929)
Louisiana Bayou Scene, 1877
Oil on canvas, 12 x 15 15/16
Gift of the Friends of LSU MOA, 91.17

Clementine Hunter
(American, 1886–1988)
Baptism, c. 1950
Oil on canvas, 30 5/8 x 53 1/4
Gift of Mr. Joe Henry and family, Transfer from Special Collections, LSU Libraries, 2004.4.1

Ben Earl Looney
(American, 1904–81)
Downtown Baton Rouge, 1920
Oil on canvas, 26 x 36
Gift of the Artist, Transfer from Special Collections, LSU Libraries, 2004.4.4
Illustrated: fig. 30, pp. 11, 57

William Samuel Lyon Jewett
(American, 1834–76)
Western View of Baton Rouge, c. 1857–61
Ink on paper, 4 3/4 x 6
Gift of John and Mary Boston, Robert and Richlyn Boston, and Roy and Lynne Boston Sheldon in honor of Mr. and Mrs. Joseph T. Boston, 83.14

Attributed to
Rudolph T. Lux (German-American, 1815–68)
Shaving mug with view of Baton Rouge, c. 1858–61
Porcelain, possibly made by Christian Fischer Porcelain Works of Pirkenhammer, Bohemia, 3 3/4 x 4 7/8 x 4
Gift of the Friends of LSU MOA, 76.1

Joseph Rusling Meeker
(American, 1827–87)
After a Storm, Lake Maurepas, c. 1886
Oil on canvas, 21 x 33
Gift of the Phi Gamma Chapter of Chi Omega Sorority, 98.14
Illustrated: fig. 25, p. 50

Clarence Millet
(American, 1897–1959)
Watermelon Schooner, date unknown
Oil on canvas, 19 1/4 x 24
Transfer from Special Collections, LSU Libraries, 2004.4.5

Achille Perelli
(Italian, 1822–91)

Amberjack, date unknown
Watercolor on paper,
27 3/8 x 17 5/8

Robin and Bluebird,
date unknown
Watercolor on paper,
27 3/4 x 17 5/8

Woodcock,
date unknown
Watercolor on paper,
27 1/2 x 18

The E.A. McIlhenny
Natural History Collection,
Special Collections,
LSU Libraries

Marie Adrien Persac
(Franco-American, 1823–73)

Faye Plantation, 1861
Gouache and collage on paper, 18 1/16 x 23 1/2
Gift of the Friends of LSU MOA, Mrs. Stuart Johnson, Dr. A. Brooks Cronan Jr., Diana Cronan, Mrs. Julia H.R. Hamilton, Mr. and Mrs. L.J. Persac Jr., Ms. May Baynard, and Dr. and Mrs. Richard Boyer, 94.5

Hope Estate Plantation,
probably 1855
Gouache and collage on paper, 15 7/8 x 25 1/2
Gift of the Friends of LSU MOA, 75.9

Interior of the Main Cabin of the Steamboat Princess/Imperial, 1861
Gouache and collage on paper, 17 x 22 15/16
Gift of Mrs. Mamie Persac Lusk, 75.8
Illustrated: fig. 26, p. 51

Louisiana Asylum for the Deaf, Dumb, and Blind, 1859
Gouache and collage on paper, 18 x 23 1/2
Gift of the Friends of LSU MOA, 77.4
Illustrated: fig. 27, p. 53

St. John Plantation, St. Martin Parish, 1861
Gouache and collage on paper, 18 1/2 x 22 1/2
Gift of the Friends of LSU MOA and Mrs. Ben Hamilton in memory of her mother, Mrs. Tela Meier, 87.23

Frederick Piercy
(English, 1830–91)
View of Baton Rouge, 1853
Sepia wash on tinted paper heightened with opaque white, 6 1/4 x 10 1/4
Gift of the Friends of LSU MOA, Dr. Edward M. Boagni III, Mr. and Mrs. Paul H. Due, Esq., Dr. Jack D. Holden, and Dr. David Miller, 81.26

Louis Nicolas Adolphe Rinck (American, 1802–95)
Portrait of Mrs. Richardson of New Orleans, 1844
Oil on canvas, 43 x 33
Gift of Mrs. Joyce P. O'Connor, 96.29

François Joseph Frédéric Roux (French, 1805–70)
Portrait of the Ship Bolivar of New Orleans Saving the Crew of the British Brig Friends Goodwill on January 7, 1835, 1836
Watercolor on paper, 17 7/16 x 23 1/4
Gift of Dr. A. Brooks Cronan Jr. and Diana Cronan, 81.4.1
Illustrated: fig. 22, p. 46

Harold Rudolph
(American, 1850–83/84)
Louisiana Bayou at Sunset, c. 1875
Oil on canvas,
13 11/16 x 18 15/16
Gift of the Friends of LSU MOA, 86.10

Francis H. Schell
(American 1834–1909)

Advance upon Port Hudson, 1863
Pen and ink on paper,
12 15/16 x 18 1/2
Gift of the Friends of LSU MOA and a special donation by Dr. Edward Boagni, 73.8.2

Burning of the State House, Baton Rouge, on Sunday, December 28, 1862, 1862
Ink on paper,
11 1/4 x 16 1/4
Gift of the Friends of LSU MOA, 75.6.1

Side table, late
18th century, Louisiana
Mahogany, cherry, and cypress,
27 x 31 1/4 x 22 1/2
Gift of the Friends of LSU MOA and Mrs. Winifred Gill in memory of her husband James Monroe Gill, 94.16
Illustrated: fig. 38, p. 69

Marshall Joseph Smith Jr.
(American, 1854–1923)
Cows Feeding on Swamp Grass on the Shore of Lake Pontchartrain, bet. 1870 and 1890
Oil on canvas, 12 x 17
Gift of the Friends of LSU MOA, 72.8

New Orleans Silver

Horace E. Baldwin
& Co., American
Bone holder, c. 1842–53
Coin silver, 6 3/4 x 2 1/4 x 1 9/16
Gift of Dr. and Mrs.
C.C. Coles, 81.32.1

Henry P. Buckley
(English, 1822–1903)

Cann or mug, c. 1855
Coin silver,
4 5/8 x 4 1/4 x 2 15/16
Gift of the Friends of LSU MOA and Dr. and Mrs. Steven Abramson in memory of Alex Watsky and Rae C. Abramson, 90.11
Illustrated: fig. 50, p. 85

Water pitcher, c. 1853–61
Coin silver,
10 7/16 x 9 x 6 1/2
Gift of the Friends of LSU MOA, 81.3

Armand Chassagne
(American, b. 1786)

Beaker, c. 1822
Coin silver,
3 1/16 x 3 5/32 x 3 5/32
84.12

Snuffer tray, c. 1820
Coin silver,
3/8 x 3 7/8 x 9 3/16
83.16

Gifts of Dr. and Mrs.
Redfield Bryan

Pierre Coudrain
(Franco-American, 1729–79)
Soup spoon, c. 1768–79
Coin silver, 7 3/4 x 1 3/4 x 1 1/8
Gift of the Friends of LSU MOA, Mrs. R. Elizabeth Williams, Mrs. Bert S. Turner, Mrs. Mathile Abramson, Mrs. Lewis A. Bannon, The Exxon Education Foundation, and Mr. Maurice R. Meslans, 97.3.2
Illustrated: fig. 51, p. 86

Louis Gabriel Couvertie
(Santo Domingan,
1779–1844)

Salt shovel, c. 1814–30
Coin silver, 4 15/16 x 1 x 3/8
80.36.4

Sugar shell, c. 1814–30
Coin silver, 4 1/8 x 3/4 x 3/8
80.36.3

Gifts of the Friends
of LSU MOA

William St. Leger Hamot
(American, 1800–51)
Set of three tablespoons,
c. 1827–44
Coin silver, 8 x 1 5/8 x 1 1/4
Gift of Mrs. L. Heidel Brown in memory of her husband, 97.3.3 a-c
Illustrated: figs. 57, 58 (detail), p. 90

Adolphe Himmel
(German-American,
1826–77) for Hyde and Goodrich, New Orleans

Coffee pot, c. 1853–56
Coin silver
11 3/4 x 10 1/4 x 5 3/4
Gift of the Friends of LSU MOA, 89.4

Covered cream jug,
c. 1853–61
Coin silver,
7 5/8 x 5 5/8 x 4
Gift of Dr. and Mrs. A. Brooks Cronan Jr., 81.4.2
Illustrated: fig. 34, p. 65

Five-piece tea and
coffee service, c. 1855–61
Coin silver
Teapot:
11 3/8 x 4 11/16 x 4 11/16
Sugar bowl:
9 3/4 x 9 1/8 x 4 1/16
Creamer:
8 3/4 x 5 5/16 x 4 7/16
Bowl: 5 1/2 x 5 7/8 x 4
Gift of Dr. A. Brooks Cronan Jr. and Diana Cronan, 83.6.2–6

Goblet, 1855
Coin silver,
6 3/8 x 3 1/2 x 3
Gift of the Friends of LSU MOA, 72.1

Hot water kettle on a stand, c. 1855–61
Coin silver,
17 1/4 x 9 1/4 x 7
Gift of Mr. Milton J. Womack in memory of his wife, Barbara Sevier Womack, 85.22 a-c
Illustrated: fig. 52, p. 86

Lidded soup tureen
and ladle, c. 1861–77
Coin silver,
11 3/4 x 15 1/2 x 10
78.2.1-2
Illustrated: fig. 55, p. 88

Presentation pitcher,
c. 1853–61
Coin silver,
8 1/4 x 9 3/4 x 5 3/8, 80.2.3
Illustrated: fig. 54, p. 87

Water pitcher, c. 1853–61
Coin silver,
9 3/4 x 9 1/2 x 6 1/8, 83.6.1
Illustrated: fig. 53, p. 87

Gifts of Dr. A. Brooks
Cronan Jr. and Diana
Cronan

Adolphe Himmel (German-American, 1826–77) and Christopf Christian Küchler (German-American, active in New Orleans 1852–70) for Hyde and Goodrich, New Orleans

Drip coffee pot,
c. 1852–53
Coin silver,
14 1/8 x 9 x 4 1/2
Gift of Mrs. L. Heidel Brown in memory of her husband, 96.1 a-b

Egg boiler, c. 1852–53
Coin silver, 16 x 8 1/4 x 4 5/8
84.31.1 a-d
Illustrated: fig. 56, p. 89

Four-piece tea and
coffee service,
c. 1852–53
Coin silver
Coffee pot:
9⁵/₈ x 9¹/₂ x 6³/₈
Teapot:
9³/₈ x 9¹/₂ x 6¹/₄
Sugar bowl:
7⁵/₈ x 8 x 5
Cream pitcher:
7 x 6¹/₂ x ³/₄, 86.12.1-4

Gifts of the Friends
of LSU MOA

Hot milk pitcher,
c. 1852–53
Coin silver,
8³/₈ x 8¹/₂ x 4³/₄
Gift of the Baton Rouge
Coca-Cola Bottling
Co., Ltd., 79.16.15

Presentation cup,
c. 1852–53
Coin silver,
9¹/₂ x 4¹/₄ x 4
Gift of the Friends of
LSU MOA and Mr. D.
Benjamin Kleinpeter, 90.1

Serving tray, c. 1850–53
Coin silver,
1¹/₁₆ x 12 x 8⁹/₁₆
Gift of the Friends of
LSU MOA, 84.31.2

Hyde and Goodrich,
New Orleans

Crumber, c. 1855
Coin silver,
13¹/₈ x 2¹/₈ x 1³/₄
Gift of Mrs. Katherine
H. Long, 79.16.6

Fish knife, c. 1845–61
Coin silver,
11¹/₈ x 2³/₄ x 2³/₈
Gift of the Friends of
LSU MOA, 79.16.4

Pair of serving tongs,
c. 1850
Coin silver,
9³/₄ x 4 x 1³/₄
Gift of Mr. and Mrs. Bert
S. Turner, 79.16.3

Robert Keyworth
(American, dates unknown)
Christening cup,
c. 1830–33
Coin silver,
3⁵/₁₆ x 4⁵/₈ x 3³/₈
Gift of the Friends of
LSU MOA, Dr. A. Brooks
Cronan Jr. and Diana
Cronan, 82.18.3

Christopf Christian Küchler
(German-American, active
in New Orleans 1852–70)
for Hyde and Goodrich,
New Orleans

Five-piece child's tea
service, c. 1855–61
Coin silver
Teapot: 5⁵/₁₆ x 6¹/₄ x 3¹/₂
Sugar bowl:
4¹/₈ x 4³/₄ x 3¹/₂
Cream jug: 4 x 4 x 3
Tea/coffee cup:
1⁷/₈ x 3³/₁₆ x 2³/₈
Tea/coffee cup:
2¹/₁₆ x 3¹/₄ x 2³/₈
Gift of the Friends of
LSU MOA, 89.19.1-5

Presentation goblet,
c. 1852–61
Coin silver, 6 x 3¹/₄ x 3¹/₄
Gift of Dr. and Mrs.
C.C. Coles, 89.22

Jean Baptiste Lamothe
(Santo Domingan, 1800–79)
or Jean Marie Lamothe
(Santo Domingan, 1795–1880)

Dinner forks, c. 1822–35
Coin silver, 8¹/₈ x 1¹/₈ x 1¹/₄
77.10.3 a-b

Dinner spoons, c. 1822–35
Coin silver, 8¹/₈ x 1⁵/₈ x 1³/₈
77.10.4 a-b

Rice spoon, c. 1822–35
Coin silver, 10³/₄ x 2¹/₄ x 1¹/₈
77.10.2

Gifts of Dr. A Brooks
Cronan Jr. and Diana
Cronan

Pierre Lamothe
(Santo Domingan, b. 1836)
Sugar tongs, c. 1809–23
Coin silver, 7 x 2¹/₂ x 1¹/₄
Gift of Dr. A. Brooks
Cronan Jr. and Diana
Cronan, 79.16.1

Jacques Leduf
(American, dates unknown)
Dressing spoon, c. 1816
Coin silver, 12 x 2¹/₄ x 1¹/₂
Gift of Mrs. Katherine
H. Long, 97.3.1

Joseph Rafel
(German, b. 1810)

Goblet, c. 1853–61
Coin silver, 6¹/₄ x 3³/₈ x 3³/₈
Gift of the Friends of
LSU MOA, 77.3.2

Handled cup, c. 1853–61
Coin silver, 3¹/₂ x 4³/₈ x 3¹/₈
Gift of Mrs. Rawlston
D. Phillips Sr., 79.16.2

Anthony Rasch (German-
American, 1778/80–1858)
Presentation pitcher, 1856
Coin silver, 10⁷/₁₆ x 9 x 6¹/₂
Gift of the Friends of
LSU MOA, 78.16

Bernard Terfloth (German,
b. 1829, active in New
Orleans 1858–70) and
Christopf Christian Küchler
(German-American, active
in New Orleans 1852–70)
Dressing spoon, c. 1858–66
Coin silver,
11³/₃₂ x 2³/₈ x 1¹¹/₁₆
Gift of the Friends of
LSU MOA, 86.17

E.A. Tyler
(American, 1815–79)

Christening cups,
c. 1846–52
Coin silver, 3³/₈ x 4¹/₄ x 2⁷/₈
Gift of the Friends of
LSU MOA, 79.39.1-2

Lidded regatta cup,
c. 1855
Coin silver,
10³/₄ x 8³/₄ x 4¹³/₁₆
Gift of Mr. D. Benjamin
Kleinpeter, 91.1

Charles H. Zimmerman
(American, dates unknown)
Butter cooler, c. 1870
Coin silver, 4³/₈ x 5⁷/₈ x 5
Gift of the Friends of
LSU MOA, 77.15.1

**Newcomb
Pottery and Crafts**

Anonymous
Bookends, c. 1918–22
Copper, 6 x 5³/₄ x 4¹/₂
Gift of Mr. and Mrs. James
Flores and Mrs. Paula
Garvey Manship, 98.18 a-b
Illustrated: fig. 74, p. 103

Anonymous, decorator;
Joseph Fortune Meyer
(Franco-American,
1848–1931), potter
Plate, 1906
High glaze on white clay
body, 1¹/₁₆ x 9¹/₂ x 9¹/₂
Gift of the Friends of
LSU MOA, 84.25

Anonymous, decorator;
Anonymous, potter
Experimental vase,
c. 1895–1910
High glaze on reddish
brown clay body,
2¹/₈ x 3¹/₈ x 3⁷/₈
Gift of Dr. A. Brooks
Cronan Jr. and Diana
Cronan, 95.31.33

Anonymous, decorator,
probably Louise Wood
(American, 1874–1919)
or Katherine Kopman
(American, 1870–1950);
Anonymous, potter
Plate, c. 1896–97
High glaze on buff clay
body, 1¹/₄ x 8³/₈ x 8³/₈
Gift of the Friends of
LSU MOA, 93.8
Illustrated: fig. 64, p. 95

Henrietta Davidson Bailey
(American, 1874–1950),
decorator; Anonymous, potter
Bowl, 1915
Matte glaze on clay body,
6¹/₈ x 8³/₈ x 8³/₈
Gift of Mr. and Mrs.
Charles B. Kahao in memory
of Mrs. Ethel Barkdull
Kahao, Charles B. Kahao's
mother, 82.15

Henrietta Davidson Bailey
(American, 1874–1950),
decorator; Jonathan
Browne Hunt (American,
1876–1943), potter
Bowl, 1929
Matte glaze on buff clay
body, 6 x 7¹/₂ x 7¹/₂
Gift of Millicent and Wilson
Hennigan in memory of
May E. Olson, 86.4

Henrietta Davidson Bailey
(American, 1874–1950),
decorator; Joseph Fortune
Meyer (Franco-American,
1848–1931), potter

Three-handled mug,
c. 1907
High glaze on buff clay
body, 8¹/₂ x 9¹/₂ x 8⁵/₈
Gift of Dr. A. Brooks
Cronan Jr. and Diana
Cronan, 86.8
Illustrated: fig. 71, p. 99

Vase, 1907
High glaze on white clay
body, 10³/₄ x 5 x 5
86.28.2

Vase, 1924
Matte glaze on clay body,
10³/₄ x 3¹/₄ x 3¹/₄
83.28.3

Gifts of the Friends of
LSU MOA

Mary Frances Baker
(American, 1879–1943)
*Newcomb Academic
Calendar for 1902–3*
Woodblock prints,
10¹/₄ x 7¹/₄
Gift of the Friends of
LSU MOA, 88.5.1-12
Illustrated: fig. 60, p. 92

Mary Frances Baker
(American, d. 1943),
decorator; Joseph Fortune
Meyer (Franco-American,
1848–1931), potter
Vase, 1901
High glaze on white clay
body, 4³/₄ x 5 x 5
Gift of the Friends of
LSU MOA and Mrs. H. Payne
Breazeale by exchange, 90.6

Claire Bancroft
(American, d. 1969)
*Bookplate for
Kathleen Black*
Engraving, 3¹/₈ x 2³/₈
Gift of Mr. Cary Long,
95.16.4

Marie Levering Benson
(American, active at
Newcomb College
1907–08), decorator;
Joseph Fortune Meyer
(Franco-American,
1848–1931), potter

Plate, 1905
High glaze on buff clay
body, 1¹/₁₆ x 8³/₈ x 8³/₈
Gift of the Friends of
LSU MOA, 89.5.1

Plate, 1907
High glaze on buff clay
body, 1 x 7¹/₂ x 7¹/₂
Gift of Mr. D. Benjamin
Kleinpeter, 97.12.3
Illustrated: fig. 70, p. 98

Selina Elizabeth Bres
(American, 1870–1953),
decorator; Joseph Fortune
Meyer (Franco-American,
1848–1931), potter
Bowl, 1897
High glaze on white clay
body, 5 x 5¹/₂ x 5¹/₂
Gift of the Friends of
LSU MOA, 89.13

Mary Williams Butler
(American, 1863–1937),
decorator; Anonymous,
potter
Candlestick, c. 1906
High glaze on white clay
body, 5¹/₂ x 4¹/₂ x 4¹/₂
Gift of the Friends of LSU
MOA, 86.28.1

Corinne Marie Chalaron
(American, d. 1977),
decorator; Joseph Fortune
Meyer (Franco-American,
1848–1931), potter
Bowl, 1923
Matte glaze on buff clay
body, 3³/₄ x 8¹/₈ x 8¹/₈
Gift of the Friends of
LSU MOA, 79.34

Mary Pearl Davis
(American, 1882–1956),
decorator; Joseph Fortune
Meyer (Franco-American,
1848–1931), potter

Mug, c. 1903
High glaze on buff clay
body, 6¹/₈ x 5¹⁵/₁₆ x 3³/₄
88.20.1

Vase, 1901
High glaze on buff clay
body, 5⁷/₈ x 4³/₄ x 4³/₄
91.7.24

Gifts of Dr. A. Brooks
Cronan Jr. and Diana
Cronan

Frances Dymond
(American, active at
Newcomb College
1923–27)
Table scarf, c. 1920
Belgian linen with silk
embroidery thread,
33¹/₄ x 11³/₄
Gift of Dr. A. Brooks
Cronan Jr. and Diana
Cronan, 91.7.15

*The Garden of Our College
Days*, Newcomb College,
Tulane University, New
Orleans, 1906
Book, 8¹/₂ x 6¹/₄ x 2
Gift of Mrs. Jean Moore
Bragg, 2004.1.28

Sarah Agnes Estelle
(Sadie) Irvine (American,
1887–1970). decorator;
Anonymous potter

Trivet, 1928
Matte glaze on buff clay
body, ¹/₂ x 5³/₄ x 5³/₄
Gift of Jean Vidos,
Auction Galleries, Inc.,
94.11

Wall pocket, c. 1907–20
Matte glaze on buff clay
body, 7⁷/₈ x 3¹⁵/₁₆ x 3¹/₂
Gift of Mrs. Jane K.
Anderson in memory of
her mother, Mrs. Elva
Gordon Kean, 93.19

Sarah Agnes Estelle
(Sadie) Irvine (American,
1887–1970), decorator;
Joseph Fortune Meyer
(Franco-American,
1848–1931), potter
Vase, 1922
Matte glaze on clay body,
11 x 6¹/₂ x 6¹/₂
Gift of the Friends of
LSU MOA, 83.28.1
Illustrated: fig. 72, p. 100

Vase, 1928
Matte glaze on buff
clay body,
14 ¹³/₁₆ x 9¹/₂ x 9¹/₂
Gift of Dr. A. Brooks
Cronan Jr. and Diana
Cronan, 91.7.17

Probably Sarah Agnes
Estelle (Sadie) Irvine
(American, 1887–1970),
decorator; Joseph Fortune
Meyer (Franco-American,
1848–1931), potter
Low bowl, 1916
Matte glaze on clay body,
4¹/₄ x 8³/₄ x 16¹⁵/₁₆
Gift of the Friends of
LSU MOA, 83.28.2

Sarah Agnes Estelle
(Sadie) Irvine (American,
1887–1970), decorator;
Kenneth Eugene Smith
(American, b. 1907), potter
Vase, 1933
Matte glaze on tan clay
body, 9¹/₄ x 5³/₄ x 5³/₄
Gift of Mr. and Mrs.
William Tait Baynard in
memory of Merritt Shilg,
78.15

Jambalaya, Tulane
University yearbooks, New
Orleans, 1901 and 1902
10¹/₄ x 8¹/₄ x 1
and 10 x 8 x ³/₄
Gift of Mrs. Jean Moore
Bragg, 2004.1.1-2

Harriet Coulter Joor
(American, d. 1965),
decorator; Joseph Fortune
Meyer (Franco-American,
1848–1931), potter
Pitcher, 1903
High glaze on buff clay
body, 9³/₈ x 6¹/₄ x 5
Gift of the Friends of
LSU MOA, 87.10

Irene Borden Keep
(American, b. 1876),
decorator; Joseph Fortune
Meyer (Franco-American,
1848–1931), potter

Sugar bowl,
c. 1897–1900
High glaze on buff clay
body, 4¹/₄ x 5 x 5
84.26 a-b

Vase, 1904
High glaze on buff clay
body, 13 x 8 x 4¹/₂, 84.14
Illustrated: fig. 66, p. 96

Gifts of the Friends of
LSU MOA

Roberta Beverly Kennon
(American, d. 1931),
decorator; Joseph Fortune
Meyer (Franco-American,
1848–1931), potter
Pitcher, 1902
High glaze on buff clay
body, 7³/₄ x 6¹/₈ x 4⁷/₈
Gift of the Friends of
LSU MOA, 93.15

Katherine Kopman
(American, 1870–1950),
decorator; Anonymous,
potter
Plant stand, c. 1894–99
High glaze on buff clay
body, 2 x 6³/₄ x 6³/₄
Gift of the Friends of
LSU MOA, 85.31

Margaret Sterling Lea
(American, 1838–1941),
decorator; Joseph Fortune
Meyer (Franco-American,
1848–1931), potter
Vase, 1907
High glaze on buff clay
body, 5³/₁₆ x 5 x 5
Gift of the Friends of
LSU MOA, 86.18.2

Marie De Hoa LeBlanc
(American, 1874–1954),
decorator; Joseph Fortune
Meyer (Franco-American,
1848–1931), potter

Mug, 1903
High glaze on buff clay
body, 4 x 4¹/₂ x 3⁷/₈
Gift of the Friends of
LSU MOA, 87.13

Vase, 1909
High glaze on buff clay
body, 10¹/₂ x 7¹/₂ x 7¹/₂
Gift of Mrs. R. Gordon
Kean Jr. in memory of
her husband, through
the Friends of LSU MOA,
93.1

Cynthia Pugh Littlejohn
(American, 1890–1959)
Tile, 1912
Matte glaze on white clay
body, 3⁸/₁₆ x 4¹/₂ x ¹/₂
Gift of the Friends of
LSU MOA, 94.9

Ada Wilt Lonnegan
(American, 1879–1963),
decorator, Joseph Fortune
Meyer (Franco-American,
1848–1931), potter

Mug, 1901
High glaze on buff clay
body, 4¹/₂ x 4³/₄ x 3³/₄
84.43.1

Mug, 1901
High glaze on white clay
body, 4¹/₈ x 5¹/₈ x 3⁵/₈
82.12

Gifts of the Friends of
LSU MOA, 82.12

Joseph Fortune Meyer
(Franco-American,
1848–1931)

Ali Baba jar, c. 1900–20
Matte glaze on buff clay
body, 3¹/₈ x 3¹/₁₆ x 3¹/₁₆
96.36.2
Illustrated: fig. 63
(left), p. 94

Experimental bowl,
c. 1910–27
High and matte glaze
on buff clay body,
3 x 5⁵/₈ x 5⁵/₈, 95.31.3
Illustrated: fig. 62
(right), p. 94

Experimental bowl,
c. 1925
Semi-matte glaze
on buff clay body,
2¹³/₁₆ x 5¹/₈ x 5¹/₈
95.31.7
Illustrated: fig. 62
(left), p. 94

Experimental vase,
c.1900
Matte glaze on buff clay
body, 3³/₈ x 3¹/₈ x 3¹/₈
95.31.9
Illustrated: fig. 63
(center), p. 94

Experimental vase, Olla
shape, c. 1915–27
Matte glaze on buff clay
body, 4³/₈ x 3¹/₂ x 3¹/₂
95.31.5
Illustrated: fig. 63
(right), p. 94

Mug, c. 1895–1910
High glaze on white clay
body, 4¹/₄ x 5¹/₈ x 4
95.31.2
Illustrated: fig. 62
(center), p. 94

Gifts of Dr. A. Brooks
Cronan Jr. and Diana
Cronan

Attributed to Alice Leigh
Moise (American, d. 1997,
active at Newcomb
College 1924–28)
Mailbox and doorbell
plate, c. 1925
Brass
Mailbox: 11⁵/₈ x 9³/₁₆ x 2¹/₄
Doorbell plate: 2¹/₄ x 2³/₄
Gift of Dr. A. Brooks
Cronan Jr. and Diana
Cronan, 91.7.14 a-b

May Sydnor Moral
(American, d. 1920),
decorator; Joseph Fortune
Meyer (Franco-American,
1848–1931), potter
Chamberstick, 1910
Matte glaze on buff clay
body, 6³/₄ x 4⁷/₈ x 4⁷/₈
Gift of the Friends of
LSU MOA, 85.19

Vera Morel (American, active 1904–08)
Newcomb College (Two Girls Reading), c. 1905
Woodblock print, 5 x 5³⁄₄
Gift of the Friends of LSU MOA, 93.12.2

The Newcomb Arcade
Vol. IV, no. 1, November 1911
Vol. IX, no. 1, November 1916
Vol. IX, no. 3, April 1917
Gifts of Mr. Cary Long, 97.19.2-4

Newcomb School, c. 1910
Bookplate for Clarence Sheen
Engraving, 4¹⁄₈ x 3
Gift of Mr. Cary Long, 95.16.5

Pauline Wright Irby Nichols (American, 1879–1983)

Bookbinding, c. 1915
Brown leather and linen wrapped cardboard cover, 9¹⁄₂ x 6³⁄₄ x ³⁄₈
87.9.5

Case, c. 1911
Brown linen and silk thread, 9¹⁄₂ x 9³⁄₄, 84.2.4

Paper weight, c. 1914–18
Matte glaze on clay body, 13⁄16 x 3⁹⁄₁₆ x 1⁷⁄₈, 87.9.2

Purse, c. 1911
Brown linen and silk embroidery floss, 16⁷⁄₈ x 7³⁄₄, 84.2.3

Table runner, c. 1916
Beige linen and green, red, and purple embroidery floss, 100 x 16, 84.2.1
Illustrated: fig. 69, p. 97

Table scarves, c. 1910
Beige linen with green, orange, and purple silk embroidery floss, 14¹⁄₂ x 14¹⁄₂, 85.20.1
Beige linen with green, peach, and gray silk embroidery floss, 14 x 13³⁄₄, 85.20.2

Template for table runner, c. 1916
Paper, 8¹⁄₂ x 10¹⁄₄, 84.2.2 b
Illustrated: fig. 68, p. 97

Watercolor design for table runner, c. 1916
Watercolor on onion skin, 13¹⁄₄ x 18¹⁄₈, 84.2.2 a
Illustrated: fig. 67, p. 97

Gifts of Mrs. Nina Nichols Pugh

Leona Fischer Nicholson (American, 1875–1966), decorator; Anonymous, potter
Tile, 1925
High glaze on clay body, 3⁹⁄₁₆ x 3⁹⁄₁₆ x ⁵⁄₈
Gift of Dr. and Mrs. C.C. Coles Jr., 81.13

Cecile Owen (American, b. 1898)

Daffodils, c. 1920–21
Pencil and watercolor on paper, 14 x 10, 96.9.4

Japanese Lanterns, c. 1920–21
Pencil and watercolor on paper, 14 x 10

Gifts of Dr. A. Brooks Cronan Jr. and Diana Cronan, 96.9.9

Mazie Teresa Ryan (American, 1880–1946), decorator (saucers)
Henrietta Davidson Bailey (American, 1874–1950), decorator (cups)
Joseph Fortune Meyer (Franco-American, 1848–1931), potter
Pair of cups and saucers, 1906
High glaze on buff clay body
Cups: 3¹⁄₁₆ x 2³⁄₄ x 2⁵⁄₁₆; saucers: ³⁄₄ x 4⁷⁄₈ x 4⁷⁄₈
Gift of the Friends of LSU MOA, 87.3.1 a-b, 87.3.2 a-b

Mary Given Sheerer (American, 1865–1954)
Chamberstick, 1903
High glaze on buff clay body, 5¹⁄₈ x 5 x 5
Gift of the Friends of LSU MOA, 88.10.1
Illustrated: fig. 61, p. 93

Anna Frances Connor Simpson (American, 1880–1930), decorator; Joseph Fortune Meyer (Franco-American, 1848–1931), potter

Bowl, 1910
Semi-matte glaze on buff clay body, 3¹⁄₄ x 11 x 11, 93.20

Bowl, 1918
Semi-matte glaze on buff clay body, 6⁷⁄₈ x 9 x 9, 88.34
Illustrated: fig. 73, p. 101

Plate, 1913
High glaze on buff clay body, 1 x 8¹³⁄₁₆ x 8¹³⁄₁₆, 84.10

Tea set, 1910
High glaze on buff clay body
Teapot and lid: 4⁷⁄₈ x 7⁷⁄₈ x 4⁷⁄₈; 1⁷⁄₈ x 3 x 3
Creamer: 3⁷⁄₈ x 4 x 3¹⁄₄
Cup and saucer: 2¹⁄₄ x 4³⁄₄ x 3⁷⁄₈; 1¹⁄₈ x 6 x 6
89.5.3 a-i

Gifts of the Friends of LSU MOA

Gertrude Roberts Smith (American, 1869–1962), decorator; Joseph Fortune Meyer (Franco-American, 1848–1931), potter
Pitcher, 1904
High glaze on clay body, 6³⁄₄ x 5 x 3
Gift of the Friends of LSU MOA, 82.26
Illustrated: fig. 65, p. 96

Sabina Elliot Wells (American, 1876–1943), decorator; Joseph Fortune Meyer (Franco-American, 1848–1931), potter
Teapot, 1910
High glaze on buff clay body, 3⁷⁄₈ x 7 x 2³⁄₄
Gift of the Friends of LSU MOA, 85.12 a-b

Ellsworth Woodward (American, 1861–1939)

Newcomb Chapel, 1918
Oil on canvas, 13¹⁄₂ x 10
Gift of Mrs. Nina Nichols Pugh, 97.11.1
Illustrated: fig. 28, p. 54

Newcomb College Exhibition Announcement, 1910
Engraving, 4³⁄₄ x 3¹⁄₈
Gift of Mr. Cary Long, 95.16.1

Parrots, c. 1890–1910
Pencil and watercolor on paper, 14 x 10
Gift of the Friends of LSU MOA, 90.14

Pre-Electric Lighting Devices

Bobeches, 19th century, United States
Glass
90.10.1: ⁷⁄₈ x 3³⁄₈ x 3³⁄₈
90.10.3: ⁷⁄₈ x 3¹⁄₂ x 3¹⁄₂
90.10.5: ¹¹⁄₁₆ x 3³⁄₁₆ x 3³⁄₁₆
90.10.6: 1 x 3⁷⁄₈ x 3⁷⁄₈
90.10.7: 1 x 3³⁄₄ x 3³⁄₄
90.10.9: ⁷⁄₈ x 3³⁄₈ x 3³⁄₈
Gifts of the Friends of LSU MOA

Candelabra, c. 1845–50, United States
Patinated bronze and white marble, 10³⁄₄ x 8¹⁄₂ x 4¹⁄₈
Gift of Rex Magee, Natalie W. Lamb, Jane Jackson, Lena Lanclor, John K. Griffith III, Bob J. Menard, Mr. Robert Gossard, Mr. Eugene Dominique, Mrs. Clara H. Thomas, and Shirley Marvin in memory of Dennis Thedford, 83.26.1

Candlestick, c. 1630–80, Europe
Soda lime glass, 7¹⁄₈ x 5 x 5
Gift of the Friends of LSU MOA, 78.6

Capstan candlestick, c. 1550–1600, Flanders
Brass, 4⁵⁄₈ x 4 x 4
Gift of the Friends of LSU MOA, 95.23

Chamberstick, c. 1825–70, United States
Pewter, 6³⁄₈ x 4¹⁄₈ x 4¹⁄₈
Gift of Mr. and Mrs. Richard C. Plater Jr., 81.8.3

Attributed to Cornelius and Sons, Philadelphia

Three-piece argand mantel garniture, c. 1845
Gilt bronze with faceted prisms
Center: 20¹⁵⁄₁₆ x 18³⁄₄ x 8³⁄₄
Side: 20³⁄₄ x 11³⁄₄ x 7³⁄₄
Side: 20¹³⁄₁₆ x 11¹⁄₂ x 8¹⁄₂
Gift of Mr. and Mrs. Raymond J. St. Germain Jr., 81.33.2 a-c
Illustrated: fig. 46, p. 79

Three-piece girandole, c. 1850
Gilt ormolu, marble, and cut glass
Center: 22³⁄₄ x 16¹⁄₂ x 7
Sides: 17¹⁄₈ x 6 x 4
Gift of Dr. and Mrs. C.C. Coles, 85.16.1-3

Probably Henry Hooper (American, dates unknown)
Two-branch girandole, c. 1850
Gilt bronze, enamel, glass, and marble, 13¹⁄₄ x 11¹⁄₂ x 3¹⁄₂
Gift of Dr. and Mrs. C.C. Coles, 91.22

N.E. Glass Co. Workers, Boston
Astral lamp, c. 1825–50
Glass, cast brass, and patinated tin, 16⁵⁄₈ x 3⁷⁄₁₆ x 3⁷⁄₁₆
Gift of the Friends of LSU MOA, 83.4 a-b

Pair of candlesticks, c. 1640, England
Solid cast brass, 7³⁄₄ x 5⁷⁄₈ x 5⁷⁄₈
Gift of the Friends of LSU MOA, 75.3.1-2

Pair of candlesticks, c. 1710, France
Brass, 8⁹⁄₃₂ x 4⁵⁄₈ x 4⁵⁄₈
Gift of the Friends of LSU MOA, 84.36 a-b
Illustrated: fig. 43, p. 76

Pair of candlesticks,
c. 1740–50, England
Paktong, 8³⁄₄ x 5¹⁄₄ x 5¹⁄₄
Gift of the Friends of
LSU MOA, 71.4.1.2 a-b

Pair of candlesticks,
c. 1820–35, England or
United States
Pewter, 8⁵⁄₈ x 4¹⁄₄ x 4¹⁄₄
Gift of Mrs. H. Payne
Breazeale Sr. and Mr. and
Mrs. William Tait Baynard,
71.22.23

Pair of candlesticks
(untraced JFG), 19th
century, South America
Silver, 6¹⁄₈ x 3 x 3
Gift of Mrs. H. Payne
Breazeale, 80.13.3 a-b

Palmer patent lamp,
c. 1840–55, England
Ormolu, gilt brass, enamel,
and glass, 32 x 10 x 10
Gift of the Friends of
LSU MOA, 83.22 a-b

Probably Sandwich
Glass Works, Boston
Solar lamp, c. 1845
White marble, gilt brass
overlay, blue and gilt glass,
27¹⁄₂ x 5¹⁄₂ x 8
Gift of Mr. and Mrs.
B.J. White, 82.17 a-b

Sinumbra lamp,
c. 1830–45, England
Patinated bronze, gilt
bronze, and glass,
21¹⁄₂ x 12¹⁄₂ x 12¹⁄₂
Gift of the Friends of
LSU MOA, 84.44 a-b

Attributed to Starr,
Fellows & Co., New York
Pair of single-light
girandoles, c. 1855
Gilt brass, patinated zinc,
marble, and glass,
15⁵⁄₈ x 6¹⁄₁₆ x 3
Gift of the Friends of
LSU MOA, 88.3.1-2

Three-light girandole,
c. 1840–55, United States
Gilt ormulu, white
marble, and glass,
23⁷⁄₈ x 16¹⁄₂ x 6¹⁄₂
Gift of Mrs. Mamie Henry
and Mr. and Mrs. Stephen
G. Henry Jr. in memory of
the late Stephen G. Henry
Sr., 82.22.1
Illustrated: fig. 47, p. 80

Three-light girandole,
c. 1840–55, United States
Gilt ormulu, white
marble, and glass,
23³⁄₄ x 15⁵⁄₈ x 6¹⁄₂
Gift of Mrs. Mamie Henry
and Mr. and Mrs. Stephen
G. Henry Jr. in memory of
the late Stephen G. Henry
Sr., 82.22.2
Illustrated: fig. 47, p. 80

Two peg lamps, mid-19th
century, United States
Cranberry-cut-to-clear
flashed glass and brass,
6³⁄₈ x 2¹⁄₈ x 2¹⁄₈
Gift of the Friends of
LSU MOA, 83.8.1-2

Valsin sinumbra lamp
(retailed by Vignaud)
c. 1830–38, England
Gilt bronze, brass, sheet
metal, and patinated
bronze, 37¹⁄₄ x 10 x 11¹⁄₂
Gift of the Friends of
LSU MOA, 83.19 a-b

Probably William
Fiddian and Company,
Birmingham, England
Candlestick, c. 1808–20
Solid cast brass with oak
base, 9⁷⁄₈ x 4¹⁄₄ x 4¹⁄₄
Gift of the Friends of
LSU MOA, 77.9.1

Joseph Wood
(English, active 1736–49)
Candlestick,
mid-18th century
Brass, 7¹⁄₈ x 4³⁄₁₆ x 4³⁄₁₆
Gift of the Friends of
LSU MOA, 77.13
Illustrated: figs. 44, 45
(detail), p. 77

**The Dr. James R. and
Ann A. Peltier Collection
of Chinese Jade**

Works are gifts of Dr.
James R. and Ann A. Peltier
unless otherwise noted.

Archaistic (*fanggu*) *bi* disc
Early Ming, 14th–15th
century
Nephrite with wood stand
Disc: 6¹⁄₄ x 6¹⁄₄ x ¹⁄₂; stand:
4 x 4¹⁄₂ x 2³⁄₈, 2002.17.9
Illustrated: fig. 76, p. 107

Boar
Han dynasty, 206 BCE–220 CE
Nephrite, ⁵⁄₈ x ⁵⁄₈ x 2¹⁄₄
2002.17.10

Bodhisattva Manjusri (Pusa
Wenshu) astride a lion
Late Qing dynasty,
c. 1875–1910
Jadeite, 11¹⁄₄ x 7¹⁄₄ x 4¹⁄₂
Courtesy of Dr. James R.
and Ann A. Peltier

Brush holder (*bitong*)
Qing dynasty, Qianlong
reign, 1750–1800
Nephrite, 6¹⁄₂ x 7¹⁄₂ x 7¹⁄₂
2004.6.1

Buddha's hand (*citron*)
Qing dynasty, late
18th– early 19th century
Nephrite with wood stand
Figure: 3¹⁄₁₆ x 4 x 7; stand:
1¹⁄₄ x 2³⁄₈ x 3¹⁄₂, 2003.9.5

Cabbage (*baicai*)
with grasshopper
Late Qing dynasty,
mid-19th century
Nephrite
Cabbage: 6³⁄₈ x 3¹⁄₂ x 1⁷⁄₁₆;
stand: 2¹⁄₂ x 3¹⁵⁄₁₆ x 2³⁄₄
2003.9.3
Illustrated: fig. 79, p. 110

Covered container in the
shape of a honking goose
Qing dynasty, second
half of 18th century
Nephrite,
10³⁄₄ x 12¹⁄₄ x 4³⁄₄
Courtesy of Dr. James R.
and Ann A. Peltier

Covered lobated incensor
with Buddha's rose
(*baoxianghua*) motif
Qing dynasty, Qianlong
reign, late 19th century
Nephrite,
11³⁄₈ x 12⁵⁄₈ x 9¹⁄₂
Courtesy of Dr. James R.
and Ann A. Peltier

Elephant with head
turning backwards
Qing dynasty, c. 1750–1800
Nephrite with wood stand
Elephant: 3 x 4³⁄₄ x 2¹⁄₈;
stand: ¹⁵⁄₁₆ x 4⁷⁄₈ x 2¹⁄₈
2002.17.8

Flower-gathering lady
(*xiannu*)
Late Qing dynasty to early
Republic period, late
19th–early 20th century
Jadeite, 10¹⁄₄ x 4¹⁄₄ x 2¹⁄₄
Courtesy of Dr. James R.
and Ann A. Peltier

Group of two birds
Qing dynasty, 18th century
Nephrite, 3¹⁄₄ x 6³⁄₈ x 2¹⁄₈
2002.17.1
Illustrated: fig. 82, p. 115

Group of two phoenixes
Qing dynasty, 18th century
Nephrite, 3⁵⁄₁₆ x 7 x 2⁵⁄₈
2002.17.2
Illustrated: fig. 83, p. 115

Imperial dragon-headed
rhyton with nine *qilong*
(immature dragons)
Qing dynasty, Qianlong
reign, 1735–95
Nephrite, 6¹⁄₁₆ x 3 x 4⁹⁄₁₆
2003.9.4
Illustrated: detail, book
jacket; fig. 78, p. 109

Large toad
Qing dynasty, late 19th
century
Nephrite with wood stand
Toad: 3³⁄₈ x 6 x 10¹⁄₂;
stand: 1⁵⁄₈ x 5⁵⁄₈ x 10¹⁄₂
2002.17.3

Libation cup in the
form of rhinoceros horn
Late Qing dynasty, last
quarter of the 19th century
Nephrite with wood stand
Cup: 12⁷⁄₁₆ x 4⁷⁄₈ x 6¹⁄₁₆;
stand: 8¹⁄₂ x 4⁷⁄₈ x 10¹³⁄₁₆
2003.9.6

Mountain with two
horses among pine trees in
a rocky mountain pass
Qing dynasty, 18th century
Nephrite, 13¹⁄₄ x 9¹⁄₄ x 4³⁄₄
Courtesy of Dr. James R.
and Ann A. Peltier

Pillow in the form of a
crouching boy (*wawachen*)
Qing dynasty, Qianlong
reign, 1736–95
Jadeite, 8¹⁄₂ x 12³⁄₄ x 5
Courtesy of Dr. James R.
and Ann A. Peltier

Recumbent pony
Qing dynasty, c. late
19th–early 20th century
Nephrite with wood stand
Pony: 3⁷⁄₈ x 3⁵⁄₈ x 8¹³⁄₁₆;
stand: 1¹⁄₂ x 4 x 8¹⁄₈
2002.17.12

Recumbent stag
Qing dynasty,
c. 1750–1800
Nephrite, 3¹⁄₈ x 2³⁄₄ x 6¹⁄₄
2002.17.11
Illustrated: fig. 84, p. 117

Recumbent water buffalo
Ming dynasty, 1368–1644
Jadeite, 5 x 14¹⁄₂ x 8³⁄₄
Courtesy of Dr. James R.
and Ann A. Peltier

Ruyi (scepter) as
emblem of rank
Late Qing dynasty,
19th century
Nephrite, modern
silk tassel and cord
Scepter: 16¹⁄₂ x 4 x 2¹⁄₄; tassel and cord: 24, 2002.17.7
Illustrated: fig. 81, p. 114

Seated Shakyamuni (*lohan*)
Qing dynasty, late
18th–early 19th century
Jadeite, 12¹⁄₂ x 9 x 9
Courtesy of Dr. James R.
and Ann A. Peltier

Vase after a *gu* ritual vessel
Ming dynasty, late
16th–early 17th century,
Ming Wanli reign,
1573–1620
Nephrite, 10³⁄₄ x 5 x 4
Courtesy of Dr. James R.
and Ann A. Peltier

Vase with grouping
of three boys
Late Qing dynasty to early
Republic, c. 1875–1925
Jadeite, 16¹⁄₂ x 5³⁄₄ x 3¹⁄₈
2002.17.6
Illustrated: fig. 77, p. 108

Wedding bowl on
rui-shaped feet
Qing dynasty, Qianlong
reign, c. 1750–1800
Nephrite
Bowl: 3 x 9 x 9; stand:
2 x 7³⁄₄ x 5¹⁄₈, 2002.17.5
Illustrated: fig. 80, p. 113

Yong jar with five dragons
pursuing flaming pearls
amid cloud scrolls
Ming dynasty,
16th–17th century
Nephrite, 5¹⁄₄ x 11 x 9¹⁄₄
Courtesy of Dr. James R.
and Ann A. Peltier

The Arnold Aubert Vernon Collection of Inuit Art

Works are gifts of Arnold Aubert Vernon.

Nakyuraq Akpaliapik
(Arctic Bay, Nunavut, b. 1922)
Woman Preparing Food at a Hearth, c. 1975
Stone
Woman: 3 x 1⅝ x 1¾
Hearth: 2 x 3 x 2
Trough: 1 x 2½ x 1
2002.18.18

Attributed to Angelina Angatajuak (Arviat [Eskimo Point], Nunavut, 1936–87)
Mother with Child in Hood, c. 1970
Black stone, 6 x 5 x 2
2002.18.7

Anonymous
(Cape Dorset, Nunavut)
Bird with Outstretched Wings, c. 1960
Green stone, 4½ x 5½ x 1
2002.18.11

Anonymous (Eastern Canadian Arctic)
Seated Bear, c. 1960s
Gray/green mottled stone, 3½ x 5 x 2, 2002.18.17

Luke Anowtalik
(Arviat [Eskimo Point], Nunavut, b. 1932)
Bird Sitting on an Igloo, c. 1970s
Black stone, 4 x 3 x 2
2002.18.14
Illustrated: fig. 85, p. 118

Lucy Elijassiapik (Puvirnituq, Nunavik [Arctic Quebec], dates unknown)
Mother and Child, late 1950s or early 1960s
Black stone, 7 x 7½ x 5
2002.18.3
Illustrated: fig. 86, p. 119

Evaluardjuk (Repulse Bay, Nunavut, dates unknown)
Couple, 1973
Stone, 11½ x 11 x 4
98.17.6
Illustrated: fig. 91, p. 124

Yasee Kakee
(Iqaluit [Frobisher Bay], Nunavut, 1947–2004)
Spirits Taking Flight, c. 1990s
Caribou antler, 12½ x 23 x 1
2003.2.4
Illustrated: fig. 93, p. 126

Oqutaq Mikkigak (Cape Dorset, Nunavut, b. 1936)
Falcon, c. 1980s
Green veined stone, 10½ x 13 x 15, 98.17.12
Illustrated: fig. 92, p. 125

Maudie Rachel Okittuq (Taloyoak [Spence Bay], Nunavut, b. 1944)
Spirit, 1990
Black/gray stone, 12 x 12 x 6, 98.17.2
Illustrated: fig. 75, p. 105

Anilnik Peelaktoak
(Iqaluit [Frobisher Bay], Nunavut, b. 1950)
Shaman/Caribou Transformation, c. late 1990s–2000
Black stone, caribou antler, 18 x 5½ x 5½, 2002.15.4
Illustrated: fig. 88, p. 121

Eli Sallualu Qinuajua (Puvirnituq, Nunavik [Arctic Quebec], b. 1937)
Transforming Spirit, 1978
Black stone, 9 x 12 x 6
2003.2.2
Illustrated: fig. 90, p. 123

Mikisiti Saila (Cape Dorset, Nunavut, b. 1939)
Loon, 1994
Dark green stone, 20 x 15 x 3, 2001.9.6

Aqjangajuk Shaa (Cape Dorset, Nunavut, b. 1937)
Winged Spirit with Two Faces, c. 1980s
White stone, 16 x 28 x 4
2003.2.6
Illustrated: fig. 89, p. 122

Tukai (Inukjuak, Nunavik [Arctic Quebec], 1888–1979)
Man with Seal, early 1950s
Black stone, 6½ x 7 x 4
2002.18.19
Illustrated: fig. 87, p. 120

The Charles E. Craig Jr. Collection of Global Art

Works are gifts of Charles E. Craig Jr.

Indian
Deity figure, c. 11th century
Stone, 19 x 8¼ x 3½, 98.9
Illustrated: fig. 94, p. 128

Indian
Gentleman with flower and sword, late 18th century
Gouache on paper, 6 x 4
99.8.1

Indian
Nobleman with sword, c. 1780–1810
Gouache on paper, 7½ x 4¹⁵⁄₁₆, 99.8.2

Indian
Lovers, c. 1900–25
Graphite and watercolor on paper, 9⅞ x 7¾, 99.8.4

Indian (Jaipur)
Hanuman carrying Rama and Lakshmana, c. 1780–1810
Gouache on paper, 9 x 6½
99.8.6
Illustrated: fig. 97, p. 131

Indian (Jaipur)
Shiva and Matangi with Yantra, early 19th century
Ink, graphite, and gouache on paper, 11¾ x 7⅞
99.8.3
Illustrated: fig. 95, p. 129

Indian (Rajput)
Supreme Goddess Durga Seated on a Lotus Pad, c. 19th century
Gouache on paper, 7¼ x 5⁹⁄₁₆, 99.8.5
Illustrated: fig. 96, p. 130

Mexican (Remojadas)
Vera Cruz warrior figure, early Classic period, c. 250–450 CE
Ceramic with applied *chapapote* black pigment, 20 x 10 x 6⅜, 97.17.1
Illustrated: fig. 98, p. 132

Pre-Columbian
(Costa Rica, Nicoya Culture)
Tripod vessel: human figure with rattle feet, 500–1200 CE
Ceramic with applied pigment, 16½ x 10½ x 4½, 96.41
Illustrated: fig. 99, p. 133

The J. Lucille Evans Collection of Japanese Prints

Works are gifts of J. Lucille Evans.

Kawase Hasui
(Japanese, 1883–1957)
Snow Scene at Temple, c. 1940
Woodblock print, 14⅝ x 9½, 90.16.4
Illustrated: fig. 105, p. 141

Hiroshige (Japanese, 1797–1858),
Kiyomizu Hall and Shinobazu Pond, from *100 Views of Edo*, April, 1856
Woodblock print, 13⅞ x 8¾, 90.16.14
Illustrated: fig. 101, p. 136

Hiroshige II
(Japanese, 1826–69)
Nihonbashi Bridge, c. 1860,
Woodblock print, 13⅜ x 8⅞, 90.16.16
Illustrated: fig. 102, p. 137

Japanese School
Street in Yedo, c. 1890
Woodblock print, 13¾ x 28, 90.16.3

Kuniyoshi
(Japanese, 1797–1861)

Bijin Spinning Silk with Sleeping Cat, c. 1842
Woodblock print, 14⅝ x 10, 90.16.30

Bijin Working with Silk Thread, 1842
Woodblock print, 14½ x 10, 90.16.31

Female Warrior and Two Attendants, c. 1849–50
Woodblock print, 14½ x 9⅞, 90.16.28
Illustrated: fig. 104, p. 140

Standing Bijin Carrying Bowl, c. 1842
Woodblock print, 14¾ x 9⅞, 90.16.33
Illustrated: fig. 103, p. 139

Attributed to Yoshitoshi (Japanese, 1839–92)
Courtesan Seated with Screen, c. 1868–1912
Woodblock print, 13½ x 8⅞, 90.16.34
Illustrated: fig. 100, p. 135

Contributors

H. PARROTT BACOT

H. Parrott Bacot is a Professor of the history of art at the LSU School of Art. He joined the staff of the Anglo-American Art Museum (LSU Museum of Art) as Curator in 1967, and became Director in 1983, a position he held through 2000. He earned a Bachelor of Arts, History of Art, from Baylor University, Waco, Texas (1963), and received a Scriven Foundation Fellowship to the Cooperstown Graduate Program at the State University of New York, Oneota, where he earned a Master of Arts, History of Art (1972). He received an American Friends of Attingham Scholarship for study at the National Trust Summer School on the Historic Houses of England. Bacot has presented material at numerous symposia, including the Colonial Williamsburg Antiques Forum, the National Trust for Historic Preservation Convention, the Annual Conference of the Society of Architectural Historians, and the Museum of Early Southern Decorative Arts, where he inaugurated the Distinguished Lecturer Series. He is the coauthor of *Marie Adrien Persac: Louisiana Artist* (Louisiana State University Press, 2000) and many other books and articles on the American decorative arts, and, in particular, the fine and decorative arts of the lower Mississippi River valley.

JUDITH H. BONNER

Judith H. Bonner is Senior Curator at The Historic New Orleans Collection, where she has worked since 1987. She taught art history at Xavier University of Louisiana from 1982 to 1984, and earned a Master of Arts, Art History, from Tulane University in 1984. Bonner served as Visiting Scholar and professor in art and art history at the United States Air Force Academy, Colorado Springs, in 2001–02. She is the author of *Newcomb Centennial 1886–1986: An Exhibition of Art by the Art Faculty* (Newcomb College, Tulane University, 1987), and cocurator/coauthor of the exhibition and catalogue *Complementary Visions: The Laura Simon Nelson Collection* (The Historic New Orleans Collection, 1996). She has contributed essays and reviews of southern art to several scholarly journals, including the winter 2003 *Mississippi Quarterly* special issue on artist/writer John Wesley Thompson Faulkner III. Bonner's current research on Mississippi artist Walter Inglis Anderson is forthcoming in a special issue of *Interdisciplinary Studies*. She compiles an annual bibliography on the art and architecture of the South for *Southern Quarterly*, and serves on its editorial advisory board. Bonner is also a contributing editor of the *New Orleans Art Review*.

HELEN DELACRETAZ

Helen Delacretaz is Associate Curator of Decorative Arts and Contemporary Fine Craft at the Winnipeg Art Gallery, Winnipeg, Canada, and a sessional instructor of Non-Christian Art and Religion at the University of Winnipeg. She earned a Bachelor of Arts, Art History (Honors), from the University of Victoria (1993), where she majored in non-Christian art, primarily that of Islam and China. She holds a Master of Arts, Fine and Decorative Arts, from the University of Manchester/Sotheby's Institute, London (1996), and a Master of Arts, Islamic Art, from the University of Victoria (1997). Delacretaz was the organizing curator and catalogue editor for the touring exhibition *Habitat: Canadian Design Now* (Winnipeg Art Gallery, 2002), and the coordinating curator for the Winnipeg Art Gallery's 2001 showing of *Jade, the Ultimate Treasure of Ancient China* (organized by the Canadian Foundation for the Preservation of Chinese Cultural and Historical Treasures, Toronto). Among her other recent projects and publications are *Robert Archambeau: Artist, Teacher, Collector* (Winnipeg Art Gallery, 2004) and *Grace Nickel: A Quiet Passage* (Winnipeg Art Gallery, 2002).

BARBARA DAYER GALLATI

Barbara Dayer Gallati is Curator of American Art at the Brooklyn Museum, New York, and serves on the art history faculty at the School of Visual Arts, Manhattan. She earned a Bachelor of Arts, Art History (1971) and a Master of Library Science (1972) from the State University of New York at Albany. She holds a Doctor of Philosophy in Art History from the Graduate School and University Center of the City of New York (1992). Gallati was the organizing curator and a catalogue essayist for *The Art of Thomas Wilmer Dewing: Beauty Reconfigured* (Smithsonian Institution Press, 1996). Among her other recent projects and publications are: *William Merritt Chase* (National Museum of American Art/Harry N. Abrams, 1995); *Masters of Color and Light: Homer, Sargent, and the American Watercolor Movement* (cocurated and coauthered with Linda S. Ferber) (Brooklyn Museum/ Smithsonian Institution Press, 1998); *William Merritt Chase: Modern American Landscapes, 1886–1890* (Brooklyn Museum of Art/Harry N. Abrams, 2000) and *Winslow Homer: Illustrating America* (with Marilyn S. Kushner and Linda S. Ferber) (George Braziller, 2000). She was the coordinating curator for the 2002 Brooklyn Museum showing of *Exposed: The Victorian Nude* (organized by Tate Britain, London). Gallati's most recent projects include the exhibitions and catalogues *Great Expectations: John Singer Sargent Painting Children* (Bulfinch Press, 2004) and *Children of the Gilded Era* (Merrill Publishers, 2004).

LARA GAUTREAU

In April 2004, Lara Gautreau became the first Art Education Coordinator at the LSU Museum of Art, where she develops education programs based on the museum's exhibitions for school groups, LSU students and faculty, volunteers, and the people of Baton Rouge. Gautreau has been an art educator for eleven years. She earned a Bachelor of Arts, Art Education, from Wichita State University, Kansas (1993). She began her career teaching pottery and photography at an inner city high school, and taught art appreciation at a junior college for two years. After moving to Louisiana in 1996, she taught at Bains Elementary in St. Francisville for one year. From 1997 to 2004, she was Art Education Curator at the Louisiana Art and Science Museum, where she focused on school programs and educational workshops. Gautreau is currently pursuing a Master of Arts in Educational Technology, and serves on the board of the Louisiana Alliance for Arts Education.

INGO HESSEL

Ingo Hessel has worked with Inuit art and artists for over twenty years, first for the Government of Canada as Special Projects Officer and Coordinator of the Canadian Inuit Art Information Centre of the Department of Indian and Northern Affairs, and more recently as a freelance curator, writer, and consultant. He earned a Bachelor of Arts, Art History, from Carleton University, Ottawa (1977), and has taught Inuit art courses at the University of Ottawa, lectured extensively, and published numerous articles and essays in journals and books. He is the author of *Canadian Inuit Sculpture* (Department of Indian and Northern Affairs, 1988) and the definitive *Inuit Art: An Introduction* (Douglas & McIntyre/Harry N. Abrams/British Museum, 1998). A stone sculptor and painter, Hessel has had numerous exhibitions of his work in Canada and Japan, and he is currently curating a major traveling exhibition of Inuit art for the Heard Museum, Phoenix, Arizona.

FRANCES HUBER

Frances Huber has been Registrar at the LSU Museum of Art since 2001. Previously, she was Registrar at the Indiana University Art Museum, Bloomington, and Associate Registrar at the Walters Art Museum, Baltimore, Maryland. She earned a Bachelor of Arts, Ancient Studies, Honors, from the University of Maryland, Baltimore County (1978), and a Master of Arts, Classical Archaeology, from Indiana University (1984). Huber has served as a council member and regional representative for the Louisiana Association of Museums, and as state representative (Indiana) for the Midwestern Registrars Committee.

MAIA JALENAK

Maia Jalenak has been Associate Director at the LSU Museum of Art since 2003, having first joined the staff as Assistant Director in 2003. For thirteen years, she served as Museum Curator at the Lousiana Art and Science Museum, where she organized numerous exhibitions. In 1988, she completed a curatorial internship at Biltmore House in Asheville, North Carolina. She earned a Bachelor of Arts, Art History, with a Certificate in Arts Management, from Sweet Briar College, Virginia (1988), and a Master of Arts from Louisiana State University (2003), where she was awarded the Dean's Medal from the College of Art and Design. She was the Louisiana State Director for the Southeastern Museums Conference from 1996 to 1999, and President of the Louisiana Association of Museums from 1998 to 2000.

CLAUDIA KHEEL

Claudia Kheel is the Director of American Paintings, Prints and Photography at Neal Auction Company in New Orleans. Previously, she was the Visual Arts Curator at the Louisiana State Museum, New Orleans, and Curator of Fine Arts at the Indiana State Museum, Indianapolis. Kheel earned a Bachelor of Arts, American History, with distinction in all subjects, from Cornell University, New York (1978), and a Master of Arts, American Art History, from Newcomb College, Tulane University, New Orleans (1994). Active in the New Orleans art community, she chairs the art committee and serves on the board of trustees for the St. Alphonsus Art and Cultural Center, and is a member and past president and board member of the Louisiana Art Conservation Alliance. Her articles have appeared in several art journals, including *Art Bulletin* and *Cultural Vistas*, and her publications include "From Our Illustrious Past: Antebellum Portraits of St. Mary Parish," in *St. Mary Landmarks* (Grevemberg House Museum, 2003) and "Morris Henry Hobbs and Old New Orleans," in *Nineteenth North American Print Conference* (The Historic New Orleans Collection, forthcoming in 2005).

DONNA McALEAR

Donna McAlear is Senior Associate Director at the LSU Museum of Art, where she directs the vision and organizational framework of programs and collections. Born in Montreal, Canada, she earned a Bachelor of Fine Arts, Art History and Studio Art (Honors), from Concordia University, Montreal (1978), a Master of Visual Arts, Contemporary Art, from the University of Alberta, Edmonton, Canada (1981), and a Doctor of Philosophy, Cultural Policy, from Griffith University, Brisbane, Australia (2001). McAlear's curatorial specialty is contemporary art, and her research interests include museum and cultural studies. Her recent book, *Hiram To: Don't Let Me Be Misunderstood* (Winnipeg Art Gallery, 2004), explores the photo-based work of Hong Kong conceptual artist Hiram To. She was a contributing author of *Obsession, Compulsion, Collection: On Objects, Display Culture and Interpretation* (Banff: Banff International Curatorial Institute, 2004), and coauthor of *Museums and Citizenship: A Resource Book* (Brisbane: Queensland Museum, 1996). Before joining the LSU Museum of Art in 2004, McAlear held senior management and curatorial posts in Canada, including: Chief Curator, Winnipeg Art Gallery; Senior Curator, Nickle Arts Museum of the University of Calgary; and Director/Curator, Kamloops Art Gallery.

JESSIE POESCH

Jessie Poesch recently retired as a professor of art history at the Newcomb College Department of Art, Tulane University, New Orleans. Poesch was a guest curator and catalogue contributor for the exhibition *Painting in the South: 1564–1980* (Virginia Museum of Fine Arts, 1983), shown at five major museums in 1983–84. Her articles have appeared in several art journals, including *Art Bulletin* and *American Art Journal*, and her publications include *The Art of the Old South: Painting, Architecture and the Products of Craftsmen, 1560–1860* (Knopf, 1983) and *Newcomb Pottery & Crafts: An Enterprise for Southern Women 1895–1940* (Schiffer, 2003). Her recent research focused on David Hunter Strother (Porte Crayon), a 19th-century artist/writer for *Harper's New Monthly Magazine*. With John Cuthbert, she cocurated and coauthered *David Hunter Strother, "One of the Best Draughtsmen This Country Possesses"* (West Virginia University Press, 1997). Poesch was a contributing author of *Louisiana Buildings, 1720–1940, The Historic American Buildings Survey* (Louisiana State University Press, 1997), which she coedited with Barbara Bacot.

Acknowledgements

Collecting Passions: Highlights from the LSU Museum of Art Collection links the museum's past with its future, and I am honored by the extraordinary opportunity to facilitate this connection. Our inaugural exhibition is unique because it coincides with the construction of the new museum and the relocation of its holdings. Research and preparation for the exhibition took place during the ongoing inventory and packing of objects, and a project of this magnitude could be accomplished only through the effort and commitment of many individuals from the museum, the university, and the community, both regional and national. I thank everyone who made possible the collection relocation, the exhibition, and the publication, because these undertakings were unavoidably complex and concurrent.

First, it is imperative to acknowledge LSU's longstanding contributors who grew this collection from 1959 to 2004. This book honors their foresight, generosity, and dedication. They understood well the museum's potential to become a significant cultural resource for Louisiana, and it is their unwavering commitment that truly fueled its advancement.

The museum was supported by many Louisiana professionals and institutions as staff relocated the collection and researched the exhibition. Interim storage of collection objects was provided courtesy of Secretary of State W. Fox McKeithen and the Louisiana State Archives, and I sincerely thank the following individuals for their time and advice during the relocation process: Florent Hardy Jr., State Archivist; Lewis Morris, Archives Assistant Director; Doug Harrison, Archives Manager; Melanie Counce, Archives Specialist; and Scott Thompson, Archives Specialist. At LSU, Vice Provost and Executive Vice Chancellor Chuck Wilson generously offered the museum a climate-controlled storage space at the School of the Coast and Environment.

Collecting Passions was a collaborative effort. The curatorial team consisted of me, Maia Jalenak, Associate Director, Frances Huber, Registrar, Lara Gautreau, Education Coordinator, and Sarah Morgan Griffith, Curatorial Assistant. To enhance collection research, we invited national and international scholars Sam Bernstein (San Francisco), Barbara Dayer Gallati (New York), and Ingo Hessel (Ottawa), who worked with me to select artworks for the sections showcasing the Dr. James R. and Ann A. Peltier Collection of Chinese Jade, the Anglo-American Art Museum's early acquisitions, and the Arnold Aubert Vernon Collection of Inuit Art, respectively. H. Parrott Bacot (Baton Rouge) was an invaluable resource for the outstanding decorative arts collection, advising Jalenak on the selection of New Orleans silver and Louisiana and American furniture, and Huber on the selection of pre-electric lighting devices. Judith Bonner (New Orleans) and Claudia Kheel (New Orleans) teamed with Jalenak to review the museum's nineteenth- and twentieth-century Louisiana paintings. I am very grateful for the thoughtful engagement that these collaborators brought to the research process. They enriched the curatorial

team's knowledge of the collection, and it was a true pleasure to come to know these individuals through their spirited assessments.

A private lender and three institutional lenders provided items for the *Collecting Passions* exhibition. I am grateful to Dr. James R. and Ann. A. Peltier for the generous loan of artworks from their private collection of Chinese jade to augment the museum's holdings. I thank our sister LSU institutions and their representatives David Floyd, Director, Rural Life Museum, Faye Phillips, Associate Dean for Special Collections, LSU Libraries, and Pamela Rabelais, Director, Textile and Costume Museum, for lending artworks and material culture items to *Collecting Passions*. These loans complement the museum's fine and decorative arts holdings, enriching our exhibition immensely and promising lively collaborations in the future. Community collectors, working with Lara Gautreau, shared their private collections and stories about collecting featured in the orientation and response galleries. Their enthusiastic participation was invigorating.

Following the curatorial team's selection of over 400 objects for *Collecting Passions*, the exhibition's conceptual and physical production was accomplished by many people whose combined skills were essential to a project of this scale. Frances Huber coordinated the exhibition's pre-production in an exemplary fashion. Huber, with Bobbie Young, Assistant Registrar, and Nathaniel Lakin, Preparator, located and moved artworks for research, conservation, photography, and exhibition design. Under Huber's direction, conservation experts cleaned and restored some of the museum's finer works for the exhibition. Many thanks are due to furniture conservator David Broussard (Baton Rouge), metal conservator, Ellis Joubert (New Orleans), paper conservator Margaret Moreland (Baton Rouge), frame and object conservator Blake Vonder Haar and the New Orleans Conservation Guild, and painting conservator Richard White (New Orleans) for their expert contributions to *Collecting Passions*. The curatorial team acknowledges their tremendous support.

I managed the design and production of *Collecting Passions*, working with exhibition design consultants Gallagher & Associates (Bethesda, MD) to realize exhibition layouts and casework designs. Many thanks go to the Gallagher team, especially to Cybelle Lewis-Jones and Sujit Tolat for their creative exhibition and casework design, Michael Glatting for his precise exhibition signage design, and Rebekah Sobel for her steady oversight of the Gallagher project. Several Baton Rouge firms made the Gallagher conceptual designs concrete, and I am truly grateful for the enthusiasm and excellent work of Rick Kogler, Architectural Woodworks, Monika Olivier, Louisiana Acrylics, Inc., and Ford Thomas, Benchworks, who fabricated the various elements and styles of casework for the exhibition. I thank Paul Favaloro and Ray Dudley, LSU Office of Facility Services, and Gary Cash and his team at Bob's Painting Company for executing the exhibition color plan, and Kell Johnson at Color-One for fabricating and installing the exhibition signage. The overall installation of *Collecting Passions* was supervised by exhibition production consultant Carey Archibald (Winnipeg), whose expertise and

inventiveness are unsurpassed. Such professional support from so many made this exhibition in the new museum a reality.

This exhibition would not have been possible without moving hundreds of objects from the former museum to their new home. In 2004 and 2005, Huber, Young, and Lakin were aided by numerous volunteers, LSU student interns, and part-time staff in the packing and relocation of the collection. We extend our gratitude to the following individuals for their invaluable assistance: Michael Avants, Jeffrey Paul Bennett, Susie Blyskal, Billie Bourgeois, Amber Chambers, Inga Comardelle, Jeane Cooper, Amelia Cox, Catherine Dabadie, Matthew Gibson, Sarah Morgan Griffith, Leanne McClurg, Brent Mitchell, Ann Monroe, Penny Nichols, Mark Schumake, and Holly Streekstra.

No exhibition is complete without a catalogue to document its occurrence. The *Collecting Passions* publication records this important inaugural event and reveals the considerable potential the museum's collection holds for future interpretation by curators, scholars, and students. I am grateful for the insight provided by our guest writers H. Parrott Bacot, Judith Bonner, Helen Delacretaz (Winnipeg), Barbara Dayer Gallati, Ingo Hessel, Claudia Kheel, and Jessie Poesch (New Orleans). Their essays illuminate the aesthetic, cultural, and historic significance of the museum's collection from a wide range of perspectives. It has been a pleasure to work with scholars so dedicated and willing to share their knowledge. I also thank publication editor Marnie Butvin (Ottawa) and publication designer Frank Reimer (Winnipeg) for their stellar work and easy collegiality. David Humphreys (Baton Rouge) photographed the artwork for the publication, and I thank him for his excellent and cheerful work with the museum's collection management team.

Laura Lindsay, Interim Executive Director, is the forward thinker and driving force responsible for the new museum building and the *Collecting Passions* project. I thank her for laying the conceptual foundation for the exhibition and publication, and providing me with the opportunity to lead the project to fruition. I acknowledge as well the museum staff for their unfaltering productivity, team spirit, and special humor. The curatorial team's efforts were supported in every way by the entire staff, especially Michael Robinson, Senior Director of Development, Kelly Lastrapes, Director of Development, Will Mangham, Marketing Director, and Rebecca Adams, Administrative Assistant. A special thank you goes to Russell Greer at the LSU Foundation for his willing assistance with various administrative matters related to the inaugural exhibition and the museum's opening.

Thank you to everyone.

Donna McAlear
Senior Associate Director, LSU Museum of Art